contemporary natural

text by
phyllis richardson

contemporary natural

with 345 colour photographs by solvi dos santos

contents

there is something tantalizing about the home of an artist. It is as though we feel that viewing the artist's home environment will bring us closer to the act of creation and, in some instances, to the origins of genius. We look for signs of creativity spilling over into the realm of day-to-day life. We will probably never cease to be in awe of art, the artist or those who inhabit their world. And although the definition of an artist and of art will continue to be debated, we will probably always be drawn to the idea of the artistic lifestyle, in which art and life appear to merge.

For artists dedicated to the use of natural materials, the blurring of boundaries between art and everyday existence is imperative. Wood becomes a table, a stool, a sculpture in celebration of the warmth and solidity of the material itself. Stone becomes an essay in subtle hues; clay speaks of the earth and the hand-worked forms of the artist, whether as a decorative object or as a kitchen vessel.

Every so often in the history of art and culture, the wonders of the natural world have been rediscovered, newly appreciated, praised, revered. Today, in the face of digital, video, machine-made or otherwise technologically aided art, some artists have made a conscious and passionate decision to embrace natural materials as their media – wood, stone, clay, fibre, metal. Proceeding, not with a stubborn resistance to all things modern, but rather with a new sense of energy and expression, they signal an exaltation of material and tactile

introduction

sensation, as well as of hand-worked forms. This is not a throwback to the hemp and tie-dye trends of the 1970s, nor is it a restatement of the ideals of the Arts and Crafts movement, though many of the artists here certainly believe in the virtue of carefully honed craft. The artists who appear in the following pages demonstrate a new sophistication in the creation of art through natural materials. At the same time, their work is a testament to an enduring fascination with the natural world.

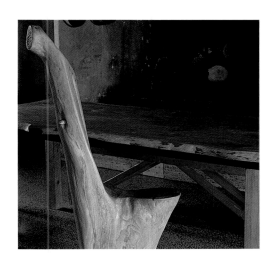

Turning to nature for ideas, forms and materials, they never find themselves lacking for genuine inspiration and new ideas.

These are ideas not only for the refined world of the artist but for everyday living. The artists revel in texture and detail and demonstrate how the sublime qualities of wood, stone or fabric can be employed to enhance, or indeed define, the aesthetic of the living environment.

In choosing common materials or recyled objects they highlight the significance of the ordinary, proving that no element is too small, practical or uninteresting to contribute to the beauty of the interior. These are ideas we can all take into our own homes and, rather than preserving them for special occasions, we can use them, as artist Michele Oka Doner says, 'to make every day special'.

There are materials in this book with which we think ourselves familiar – stoneware, wood, metal, glass – but which are employed in surprising ways. There are materials of unusual origins – pineapple fibre, spun paper yarn, the fibrous 'paper' culled from a hornets' nest. And then there are objects such as shells, seeds, cotton cord, juniper twigs and driftwood, that we might have relegated to homely arts, but which have been elevated by a vision that goes beyond normal boundaries of nature and art.

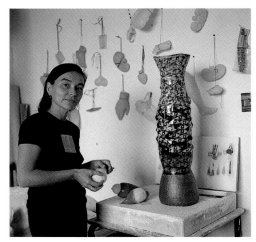
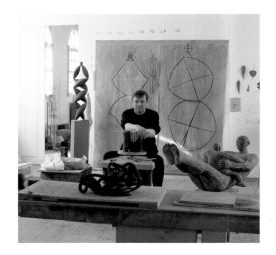

What is most satisfying about seeing these works in the home of the artist is that they do truly live there. As striking as Aboudramane's sculptures or as enigmatic as one of Bob Stocksdale's turned wood bowls would be on a gallery plinth, they are all the more compelling as part of the intricate relationship of objects arranged in the artists' own rooms.

In such an environment, the pursuit of beauty extends from the utilitarian to the purely aesthetic and includes the arrangement of personal living space. Some houses are themselves works of art, like J. B. Blunk's cabin of reclaimed wood, which he built by hand in northern California. Otherwise, Yuri Kuper's converted barn in Normandy serves as well as Gilles Hoang's converted café in Burgundy or Blott Kerr-Wilson's renovated grain mill. Michele Oka Doner's loft in a former Manhattan button factory, Mauro Mori's sleek Milan apartment, Ristomatti Ratia's Estonian island cottage, all demonstrate the limitless scope of human invention, even when it adheres to elemental resources.

Modern flats and manor houses, restored rural retreats and thatched huts are all environments in which a devoted artist can nurture creative and domestic links with nature, whether in form or material, taking inspiration from the sea, the moutains, the forest or the tropics. Artists from Italy to Indonesia, from Sweden to Senegal, have dedicated themselves to the study, understanding and shaping of natural materials. In their work and in their homes they provide inspiring examples of how natural materials can help us all to bring art into everyday living.

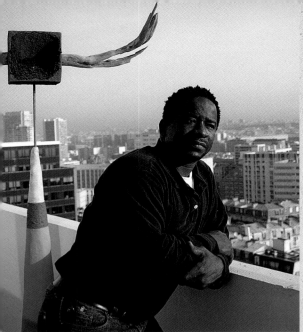

aboudramane, or Abou, as he is known, moved to Paris from the Ivory Coast in 1988 and was quickly caught up in the artistic life. His home in a municipal high-rise block of artists' studios in the city centre is filled with the colours, materials and textures of Africa.

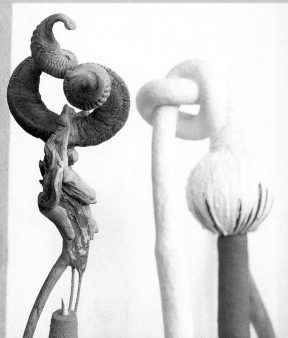

growing up in the Ivory Coast, Aboudramane Doumbouya, or Abou, as he is known to his friends, studied and worked as a cabinetmaker before embarking on his travels abroad and his artistic career. He went first to Italy, where he lived for one and a half years, and then to France. Arriving in Paris in 1988, he started to use his skills as a craftsman to build small models of African houses, which proved very popular. He became inextricably bound to the pursuit of art. 'I was quickly integrated into an artistic group,' he recalls of his early days in the city, 'I saw and learned and my creativity was awakened.'

Aboudramane has settled well into the Parisian artistic existence and, a prolific sculptor, he has exhibited widely in Europe and America. However, the new course of his life as an international artist does not mean a break with his past in Abidjan. Far from it. One of the reasons he took up sculpture, he explains, was because 'I missed my country where, even though I lived in the city, I felt close to the traditional African expression.' What began with miniature African structures has evolved into a wide-ranging oeuvre employing materials that are true to tradition and to nature.

Clay, wood, metal, feathers, leather, all are media that interest Aboudramane. He might begin with a single piece of driftwood and then will seek out the elements he feels will bring it to completion. Whatever he ends up using, the materials are always found in nature and always recall the 'strong expression' he finds in the art and everyday life of Africa.

aboudramane

For an autodidact, his influences – Jean Tinguely, Joseph Cornell, Alberto Giacometti – indicate the range of his self-education and a well-defined personal taste. The array of naturally curving, twisting and forking branches, which form the basis for many of his works, convey a real feeling of movement. There is also a sense of the work being pared down to essentials, in a way that modernists might appreciate. Then there is the thin, vulnerable verticality, achieved by Giacometti in bronze, that Aboudramane similarly creates with his whitened driftwood totems.

However, the African influences are just as evident and as intriguing. Aboudramane works with straw and ceramic in combinations that recall some of the elaborately worked African masks used in rituals and celebrations. Grass figures represent dancers in native costume, while his totems – sculptures made from driftwood combined with horn, metal and found objects – display human traits through their ornament and colour.

Another link to his native land that Aboudramane is keen to preserve is having a home which is, as he says, 'open to the world…Coming from a big family, I live according to the generous African tradition,' which means that it is a place of welcome for friends and fellow artists, but most importantly for Aboudramane's two school-age sons who sometimes stay with him. Entering his home, a visitor is immediately struck by the vivid tones

and lively works of art that make the whole environment an oasis of colour, of texture and of pattern.

His apartment on the seventeenth and eighteenth floors of a modern building is one of the municipality's residences for artists and includes studio space for him to work in. With interventions ranging from the placement of his artworks to the painted walls and interior details, Aboudramane has transformed his domestic rooms into an artistic and cultural nest floating above the traffic and street life below.

Red coral walls create an overwhelming sense of warmth, helping to recreate Aboudramane's vision of home. Brightly patterned textiles, ethnic and modern furnishings contribute to this exotic and yet comfortable atmosphere. Whereas the living space holds a deep, enveloping colour, Aboudramane's studio is an airy white space in which his work seems to proliferate happily, awash with natural light.

This is not to say that there is no depth of feeling in the work. His sculptures are remarkable for their spiritual intensity, which is translated into the home environment through the details in pattern and colour. His design scheme is a bold statement of both his origins and his determination to celebrate them in a place that speaks vividly and passionately of a faraway home.

Previous pages: a Morrocan bench and Aboudramane's wood sculptures represent his 'mix of styles'. These pages: the painting (right) is by Gösta Claesson, the sheild is by Aboudramane. Left top: a sculpture of clay, glass and feathers. Below: *Young Woman* made with raffia, horn and metal.

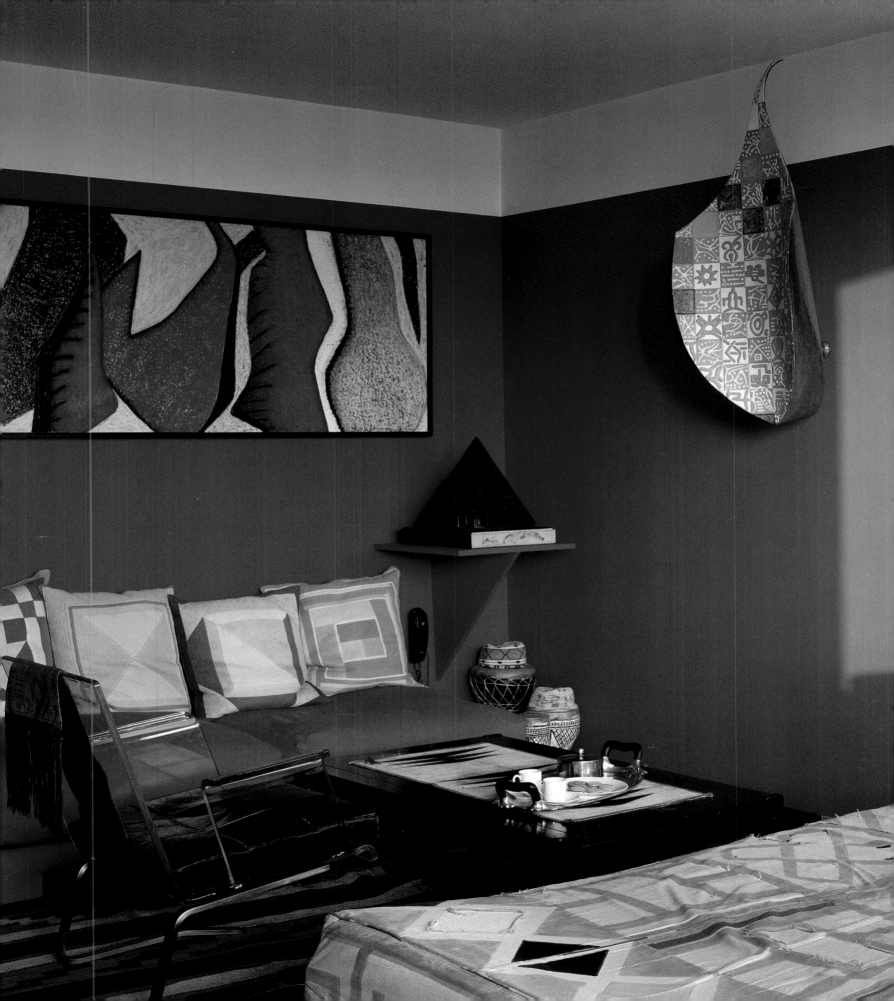

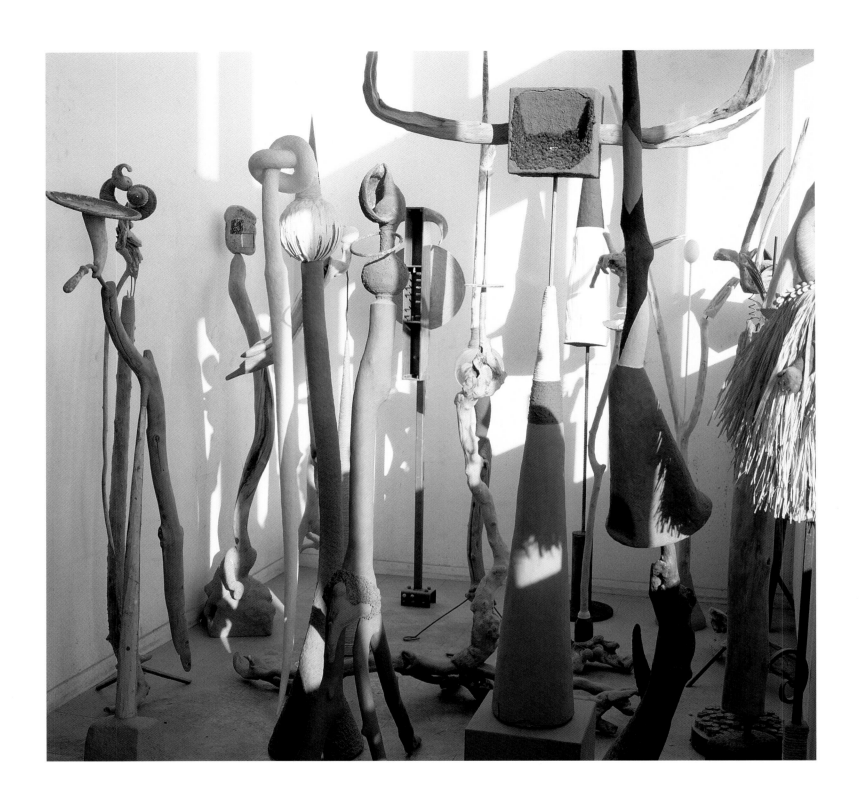

14 ABOUDRAMANE

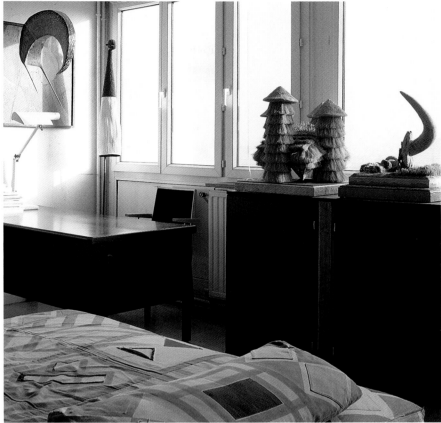

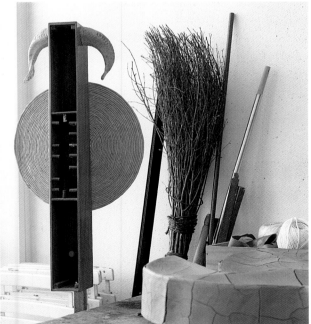

Opposite: in Aboudramane's studio, a proliferation of driftwood totems gather against a white background. Left, top and bottom: Aboudramane's pieces display a range of natural materials. Above: in a bedroom, geometrically patterned fabrics recall African motifs, while straw 'dancers' sit in the window.

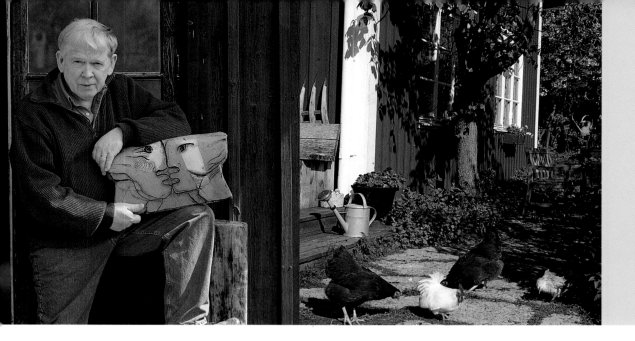

henrik Allert is known for faces: the faces he produces in his sculpture, which are fashioned in clay using hands that wring the shapes from his chosen material. A sculptor whose work exhibits a genuine fascination with the natural world, Allert is the son of farmers whose initial aim in life was to preserve and maintain the family farm near the town of Skövde in southern Sweden.

After a year spent at sea at the age of sixteen, during which he travelled, among other places, to the Persian Gulf and to Greece and visited the startling forms preserved in the ruins of Pompeii, Allert came back home to make a go of farming. For several years he toiled as his ancestors had, while at the same time discovering the joys of working native clay, which he dug from his own fields, into animal faces. Because, as he explains, 'I had to follow my nature and become an artist', he gave up farming to study sculpture at the School of Arts and Crafts in Gothenburg, Sweden, in 1962, aged twenty-five.

As one of Sweden's leading artists, Allert still concentrates on re-creating something of the animate life-force he senses in the creatures he adores and studies so faithfully. Translating the appreciation of nature from agriculture to artistic representation seems an unlikely step, but for someone who demonstrates such a keen understanding of his subjects and, what one critic has called 'an ability to see and feel the unexpected', it is a fitting and fortunate evolution.

Ängen, the farm where Allert lives with his wife Gerd, a textile artist, is Allert's birthplace and was home to generations of family farmers. It has also evolved from a utilitarian agglomeration of one kind to another, less ephemeral, but not less consuming purpose. Animals still wander the fields of Allert's youth, but stables have been converted into studios and the farmhouse and outbuildings are now home to an internationally famous artist and serve as lodgings for distinguished guests.

Henrik Allert (above) converted some of his farm's outbuildings into studio space and guest quarters. Opposite: wood-panelled walls and rustic wood furniture maintain the country feel of the house. One of Allert's animal sculptures stands unceremoniously on the bench, at home among farm implements.

henrik allert

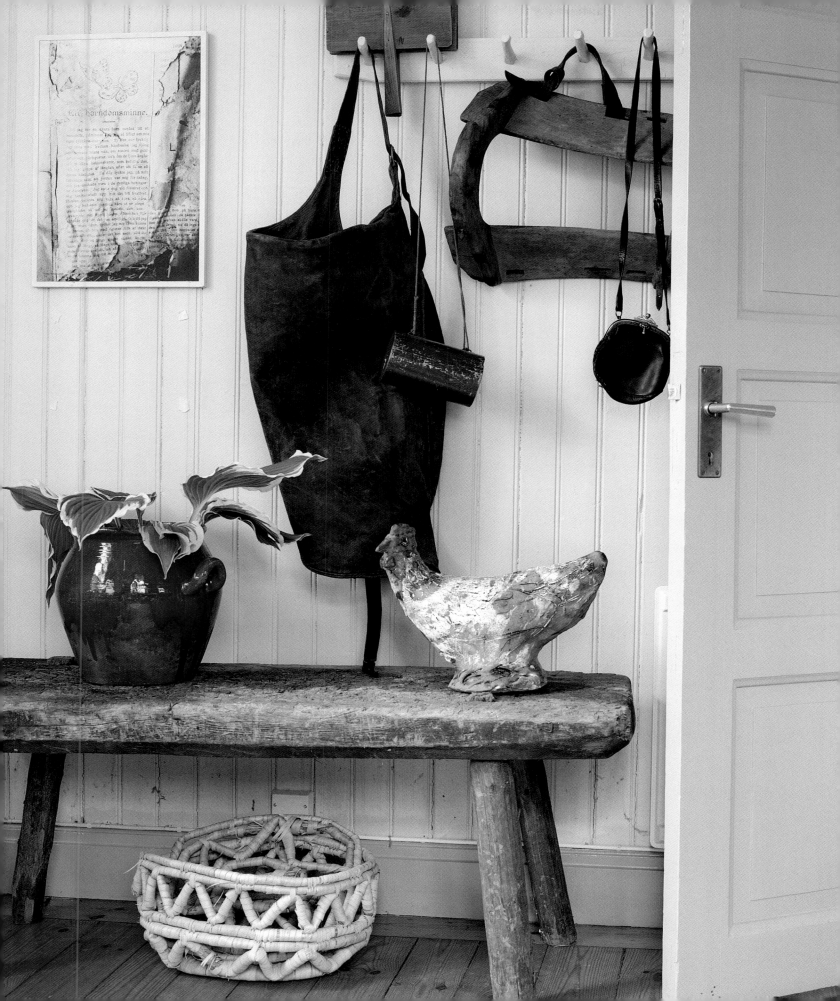

The animal inhabitants of the farm are still part of its function, perhaps even more so, as Allert continues to sculpt in ceramic the heads of sheep, cows, horses and sometimes combinations of human and animal faces, which are haunting in their lifelike expression. A critic at the sculptor's first show at the Petra gallery in Stockholm, 1971, noted that Henrik Allert's ceramic birds confronted the viewer with 'a mélange of presence and uneasiness. His way of using the clay to create these almost spontaneous forms underlines the fragility of nature but also the violence.'

A somewhat more serene air pervades the Allert studio/house/farm complex. The arrangement of traditional, red-painted clapboard cottages lends an impression of ideal tranquillity. The farm was partly built in 1790 and completed in 1850. The restoration that Allert undertook in 1970 was entirely sympathetic to the Swedish period style, and buildings continue to be restored or, as the artist says, 'repaired in a gentle way'.

This kind of response demonstrates that, however unsettling the faces he creates, Allert purposefully maintains this idea of settled calm in his living/working complex where family traditions and a continuum of past and present are able to coexist peacefully with the artist's other-worldly exertions. Allert's eldest daughter also lives in one of the cottages with her family.

Working in different clays, stoneware and porcelain to give his work its 'expressive surface', Allert takes a very physical approach to his art. It is a method in keeping with the former life of the artist and his home. His pieces are perhaps all the more engaging because they are worked by the same hands that stroke and care for the animals they represent.

The interiors and exteriors of the house and studio reveal the same reverence for natural textures and expression. Wood predominates: rough and smooth, stained, painted white or just weathered to a silvery grey. His preferred medium is ceramic: Allert mixes his own and often achieves a remarkable surface quality that gives the appearance of carved driftwood or petrified bone, so that sculpture and built forms merge into a cohesive story of art and living.

Parts of the house do exhibit a more refined Swedish period style, with burlwood chests and inlaid cabinets adorned with blue-and-white china, but the quiet presence of the sculpture or of bold paintings hung on the walls still suggests that this is a household concerned with something beyond the purely decorative. These hand-wrought faces and forms possess a rough-hewn quality that makes some resemble fossils, others tribal masks or talismans. Seeing them in the context of the natural setting that nurtured and inspired the artist renders them all the more resonant, but revealing the origins of an artist's work usually has the two-pronged effect of allowing the viewer both to discover a source of inspiration and to marvel anew at the artist's ability to translate life into art.

The kitchen of the main house still exudes a traditional Swedish simplicity and has been little altered except for some restoration. Above: the red clapboard structures are common to the area. The colour was once a by-product of the historic local copper industry. Right: one of Allert's lifelike forms graces the garden.

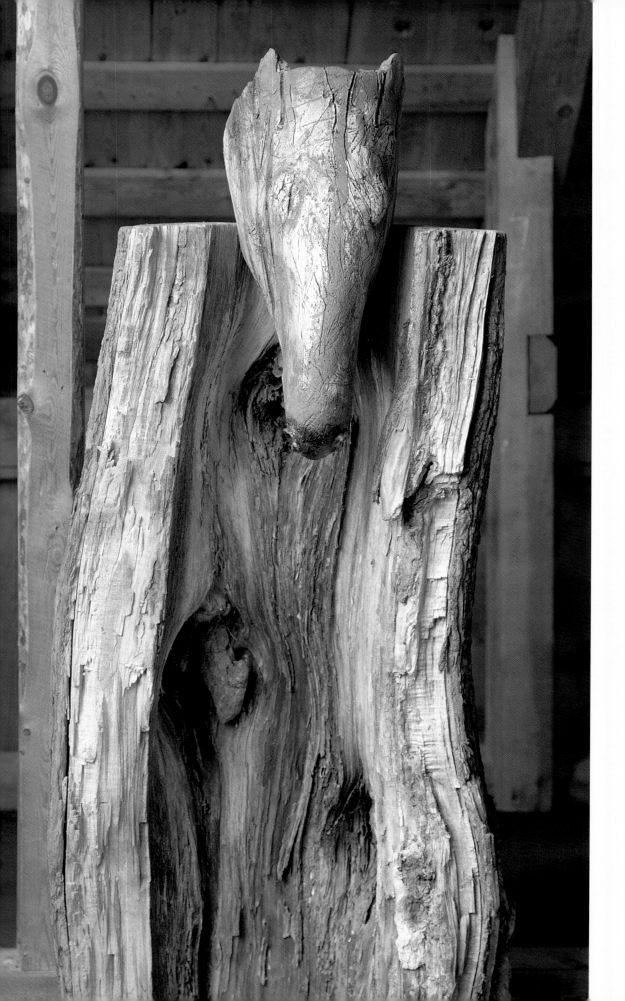

Henrik Allert works in stoneware and porcelain and often mixes the two, creating remarkable surface textures that resemble naturally occurring elements. Using a variety of glazes and finishes he often gives his ceramic pieces the appearance of wood or fossilized bone. Grey-brown hues add to the impression that these are real bone or wood and allow them to them blend in with the natural wood surroundings.

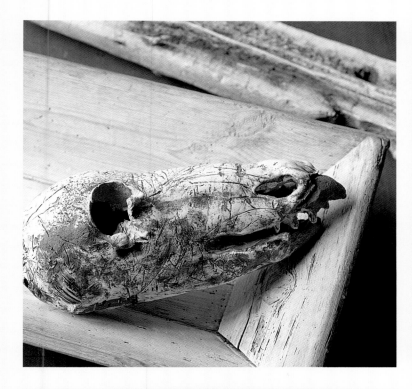
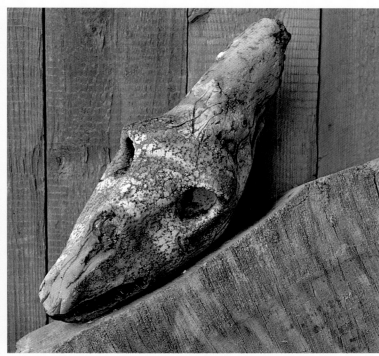
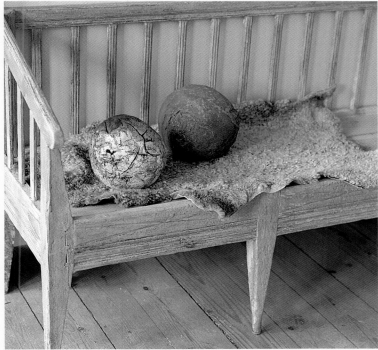
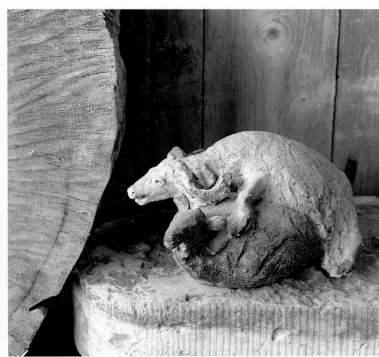

21 HENRIK ALLERT

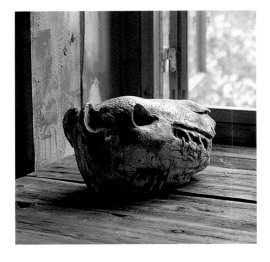

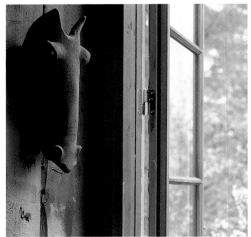

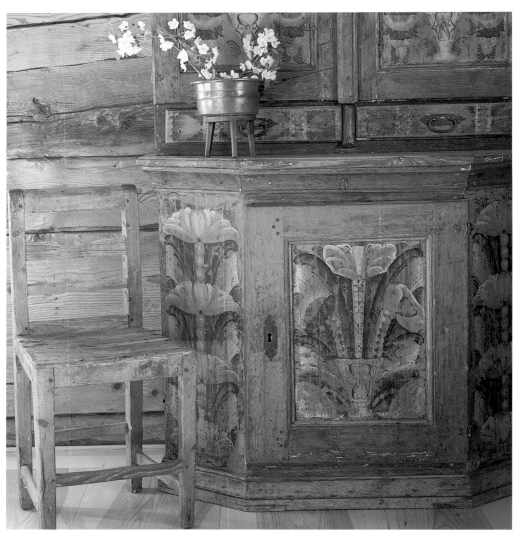

With an abundant use of wood, the interiors are spare but warm. The eighteenth-century inlaid wood dresser (left) is a family heirloom and imparts a slightly more genteel feeling that contrasts with the rough wood furniture and wallboards. Above: Allert's sculpture blends with the wood surfaces. Opposite: Henrik Allert's 1997 painting *Alter Ego* hangs over an eighteenth-century Swedish table.

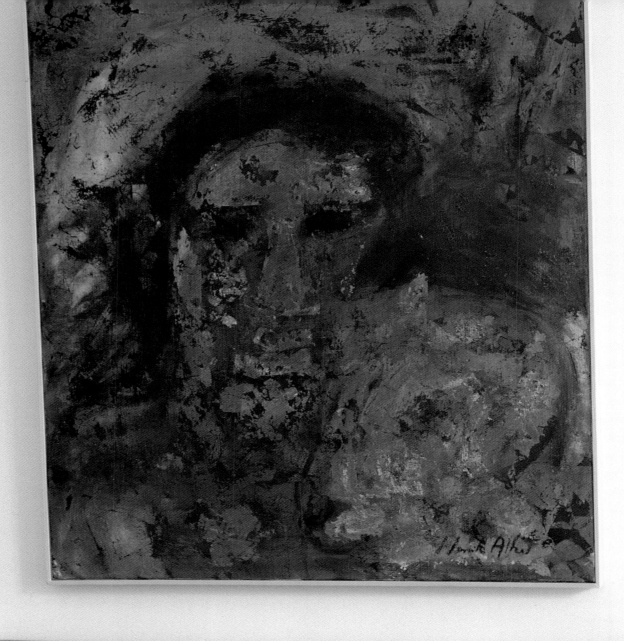

christian astuguevieille is an artist, a furniture and jewelry designer and a fragrance consultant. Since 1991, he has lived and worked in a nineteenth-century Parisian flat, which is filled with his own furniture, sculpture and artworks made from natural materials, such as bent chestnut wood, cotton cord, hemp, paper and linen. His refined approach produces classic forms with surprising textures.

Above: at a drawing table in the artist's studio a chestnut chair bearing a Chinese motif features a hemp seat. Opposite: a table of polished chestnut is accompanied by chairs of bent chestnut covered in dyed cotton cord. The combination creates a classic look that belies the unusual structure and material. The thick fibrous floor covering and polished wood mantelpiece continue the theme of contrasting rough and smooth elements.

christian astuguevieille

Paris is still the city in which most people envision the artistic life: an image appears of the bohemian painter in his garret, cramped and cluttered, but with a magnificent view of the Seine. It still exudes a holistic experience of art.

Christian Astuguevieille has lived and worked in the same apartment building in Paris for the last ten years, trading a smaller flat for the more spacious apartment on the first floor, which he shares with his partner and fellow artist, Georg Dressler. It is neither cramped nor cluttered, but filled with the striking creations of an artist constantly sampling from a palette of both colour and texture. In the sunlit rooms of this nineteenth-century building near the Parc Monceau, Astuguevielle designs the signature pieces of furniture and objects that have been exhibited and collected around the world.

The collection 'Bois & Forêts' (woods and forests) features great chunks of pure, unpainted wood chosen for stools, tables and chairs, as well as bentwood furniture made using the method perfected by Thonet, of steaming and bending barked and unbarked wood, usually chestnut from the Limousin. His idea that we all have a childhood fascination with forests, 'a land of youth and discovery', is conveyed through furniture that retains some of the aura of the forest.

Astuguevieille, however, manages to nurture this aura without sacrificing artistic sophistication. For the artist, natural does not mean shades of beige and brown, though these appear in his hemp and cord furniture, but an abundance of textures and hues. The sophistication in his works is derived from a concern with the many aspects of an object: touch as well as smell are important to the artist, whose early work led to the creation of a 'multi-sensory experience' which concentrated not only on visual art, but on touch, smell, sound and taste.

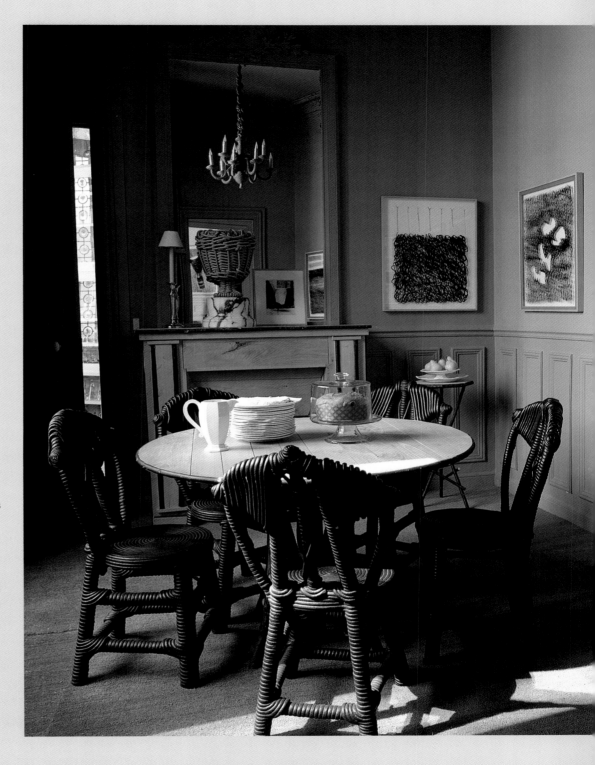

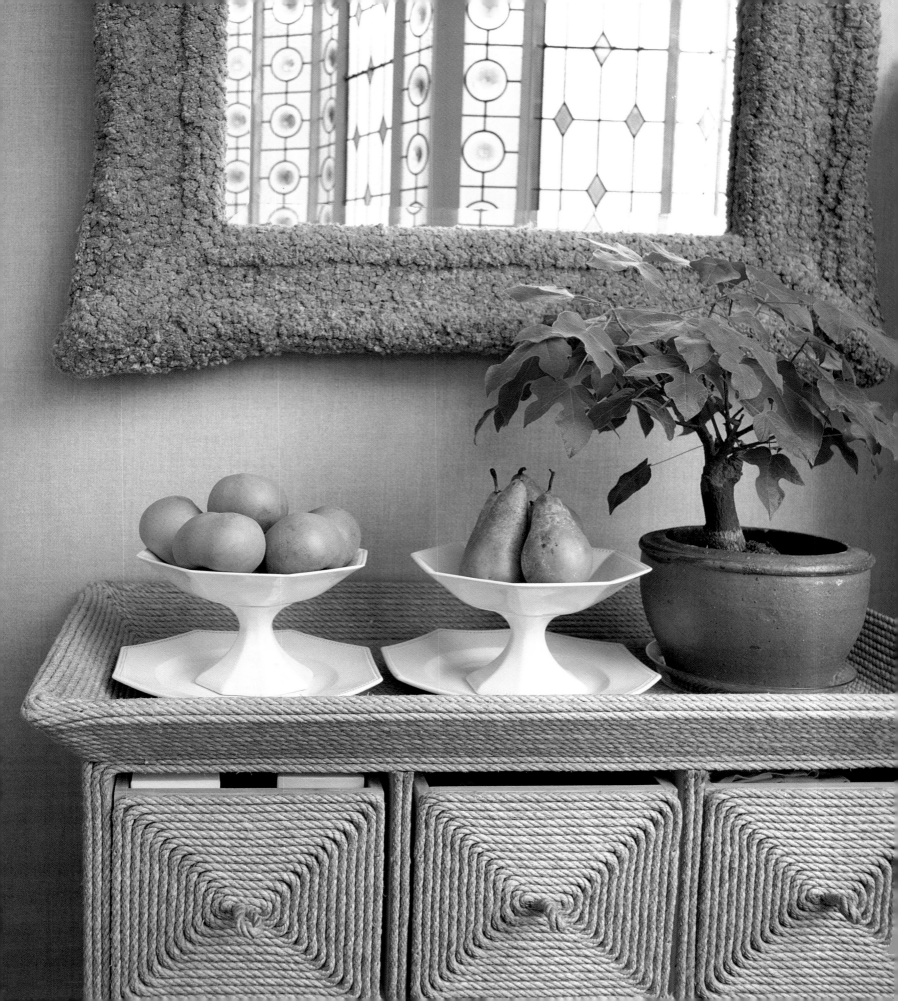

After having studied pedagogy at the Sorbonne, Christian Astuguevieille was asked to contribute to a research project on teaching children. He created two objects that were seen and touched by one group, and then described by that group to people who could not see the pieces. It was, he explains, 'a way of making people more aware of the sense of touch…of making them feel things with more sensitivity'. In this work he discovered 'the language of touch', which has inspired his fervently tactile approach ever since.

Another means of conveying beauty through touch was explored in the jewelry that Astuguevieille began to create after spending some time travelling abroad, researching as curator for exhibitions at the Musée des Arts Décoratifs. On his return to Paris, he opened a boutique, Le Comptoir du Kit, with the idea of selling simple but beautiful materials from around the world, which customers could then assemble into their own designs. But it was his own creations that were in demand, and his ethnically inspired pieces were taken up by some of the leading names in fashion.

Astuguevieille then began experimenting with craft from another culture: *origami* and *furoshiki*, the Japanese arts of folding and wrapping paper. These were the precursors of his *Imaginary Civilization*, a study in the objects that constitute a culture – from utensils to ritual pieces, to samples of 'ancient' writing. These he managed to imbue with the air of familiarity combined with mystery that makes ancient artifacts so alluring. He was described as being 'halfway between the ancient cultures and ultra-modern style', something that pleased Astuguevieille, as did the categorization of him as 'researcher-artist-scientist'. Both descriptions reflect his sensitivity, not only to the natural world, but to human perceptions and impact upon it.

It is partly the connection with the past that inspires Astuguevieille to explore the creative use of what he terms 'noble' materials, such as the hemp rope or painted cotton cord with which he wraps some of his wood pieces. 'It has always been used', he says of the cord, 'it is an ancient material, so I wanted to work with it to make something else, something new. Wood has always been used for furniture so I wanted to create new things in that material.'

Though his designs are remarkably bold and innovative, they also emphasize the inherent qualities of the materials. In his Paris flat, a bent-twig chair draws attention to the raw chestnut; a 'fuzzy' cabinet covered in cut hemp rope begs a light stroke to appreciate its texture, as does a chair wrapped in painted cord. The interior furnishings encourage the observer, not just to see, but to feel.

It is a lifestyle of engaging the senses that interests Astuguevieille the most. This passion precedes the experiments with touch, to a time when he worked for the famous perfume house Molinard, and which continues in his work as adviser on fragrance design for Comme des Garçons. From the brightly painted, linen-wrapped constructions, to the cord- and hemp-covered chests and chairs, to the 2,750 hand-painted perfume bottles, the elements of Christian Astuguevieille's work and living space that you touch, see and smell, are an enchanting, carefully blended piece.

Opposite: one of Christian Astuguevieille's signature cord-wrapped pieces. A solid chestnut chest of drawers has been meticulously wrapped in natural cord. The 'fuzzy' mirror frame has been created with his cut hemp rope. He uses a single source for the hemp rope because, he explains, 'this is the only person who still does it the way they have for the last three hundred years.' Right: another piece displays unusual lines and details.

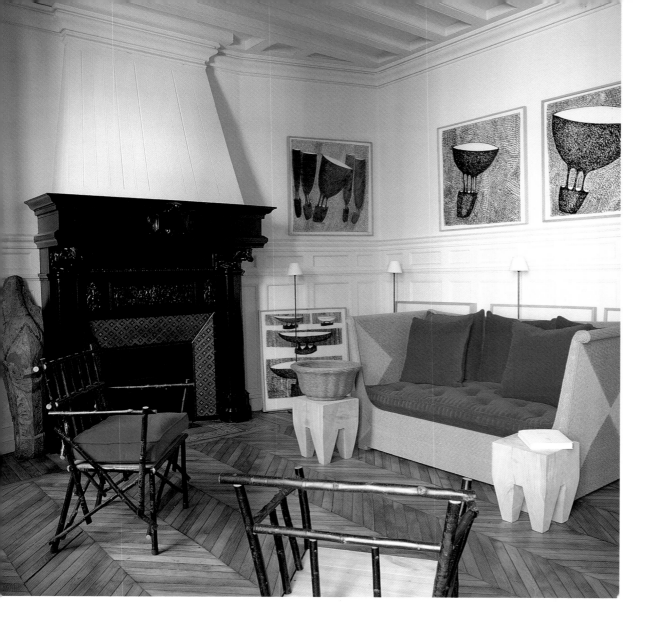

Above: a sitting room reveals Astuguevieille's penchant for bold colour. The inlaid floor, cream-coloured walls and period fireplace and mouldings are enlivened by unbarked chestnut chairs, an unusual high-backed faceted sofa and a bright splash of deep-red upholstery fabric. Right: a cord-wrapped chair is painted bright red to add visual, as well as textural, surprise. The pieces on the fireplace, shapes wrapped in dyed linen, are also by Astuguevieille.

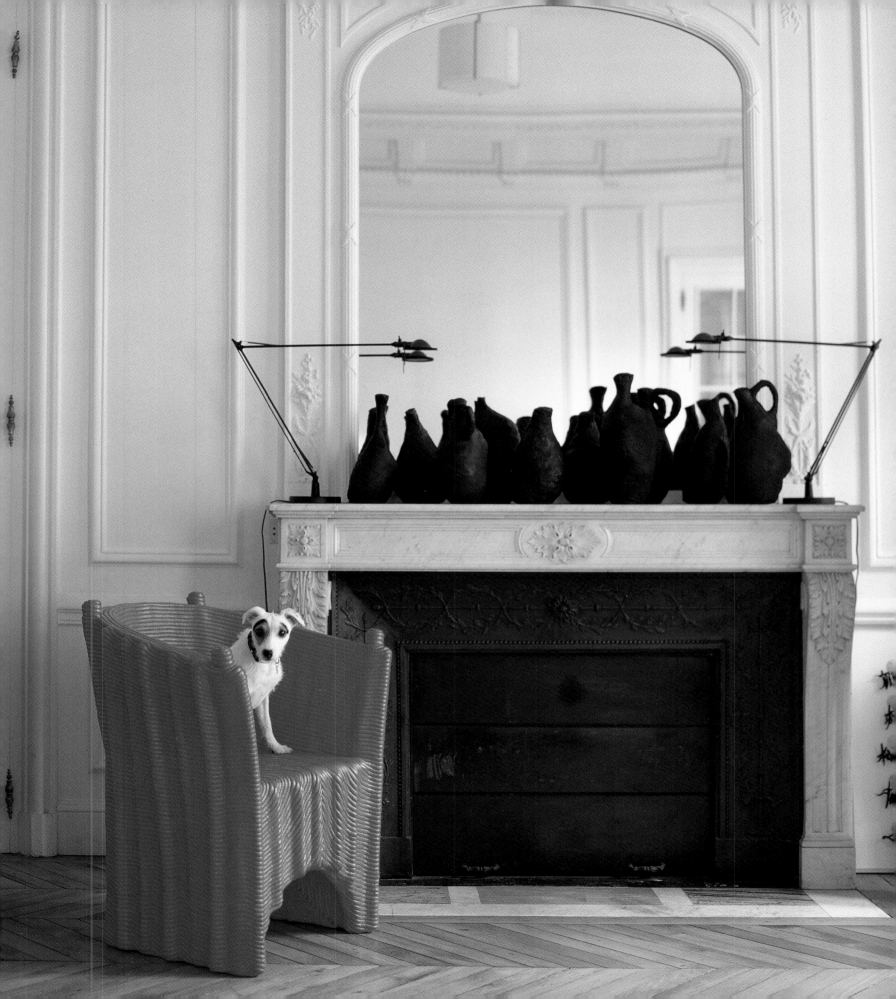

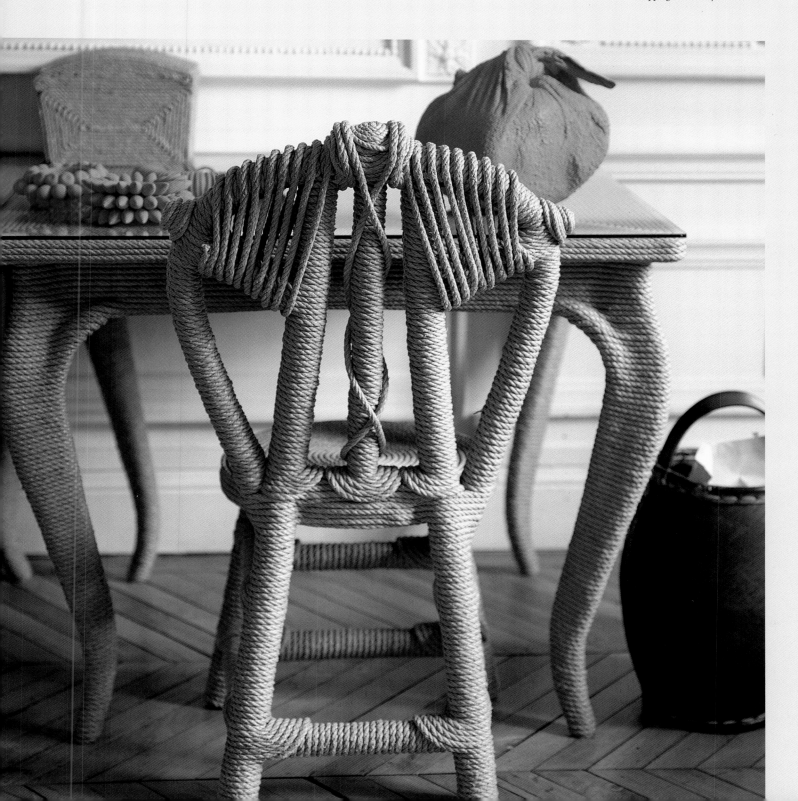

Unbarked chestnut and cut hemp rope, fashioned to an extremely refined texture, create pieces that question preconceived notions of natural materials. Christian Astuguevieille deliberately chose these 'because they are materials that have always been used and I want to use them in a new way'. Below: cord has been left in its natural colour, whereas the linen wrapping has been dyed a vivid hue.

Left: a bedroom reflects a natural inclination towards classic simplicity, offset by a bold statement of colour in one of the artist's sculptural pieces. Elsewhere, in the library his taste does not exclude classic modern design. A chestnut and block-wood table displays some of Astuguevieille's pen-and-ink drawings.

j. b. blunk began building his house by hand in a wilderness area of northern California, using only pieces of recycled or discarded wood. A sculptor and furniture maker known for his massive pieces of public art, some weighing over three tons, as well as for his handmade chairs and tables, he finds wood a source of infinite inspiration.

Wood is not just a theme in J. B. Blunk's mind, it is a way of life. In the bathroom the sink is made from hand-carved cypress. The walls are wood, inside and out. A master of adaptation and recycling, Blunk made the window out of an old door frame.

take great slabs of California coast redwood, planks from a chicken coop, warped pieces of unwanted lumber and old pine beams, once used to construct ways to slide ships into the sea, add a sink of carved cypress, a window made from a reused door frame and other assorted recycled pieces, put them together and place the creation on the crest of a ridge, at the end of a dirt road overlooking protected forest, then stand back and breathe deeply. The recipe may not inspire awe, but the result, as achieved by sculptor and furniture maker J. B. Blunk, certainly does. The house, rising unobtrusively from a setting of wild grass, huckleberries and trees, brings to mind the cabins of the American frontiersmen, the pioneers who tamed a harsh landscape with their bare hands.

In the hands of J. B. Blunk, nature is mystifying, surprising, anything but harsh. Blunk is renowned for his other large-scale works. One piece he created

for a San Francisco restaurant (Greens, Fort Mason) in the 1970s weighs over three tons, and he has made other sculptures from tree trunks measuring twenty feet in diameter. Most of his work has been created from found redwood and redwood burl, but he is not one to shy away from other less majestic finds, such as black walnut, cypress and bay.

Using rather inelegant tools – a chainsaw and an angle grinder – Blunk produces stunning tributes to his material, as sweeping expanses of polished wood seem reawakened by his pruning and polishing. Blunk explains that he gradually 'reveals the theme of each piece'. In other words, he does not have grand designs, though his works are certainly grand and the design is visible in the end result. In giant public pieces, such as his nine-foot-square *Magic Boat*, made for the California Orientation Center for the Blind, his reverence for the wood and his desire for people to share that feeling are made manifest.

j. b. blunk

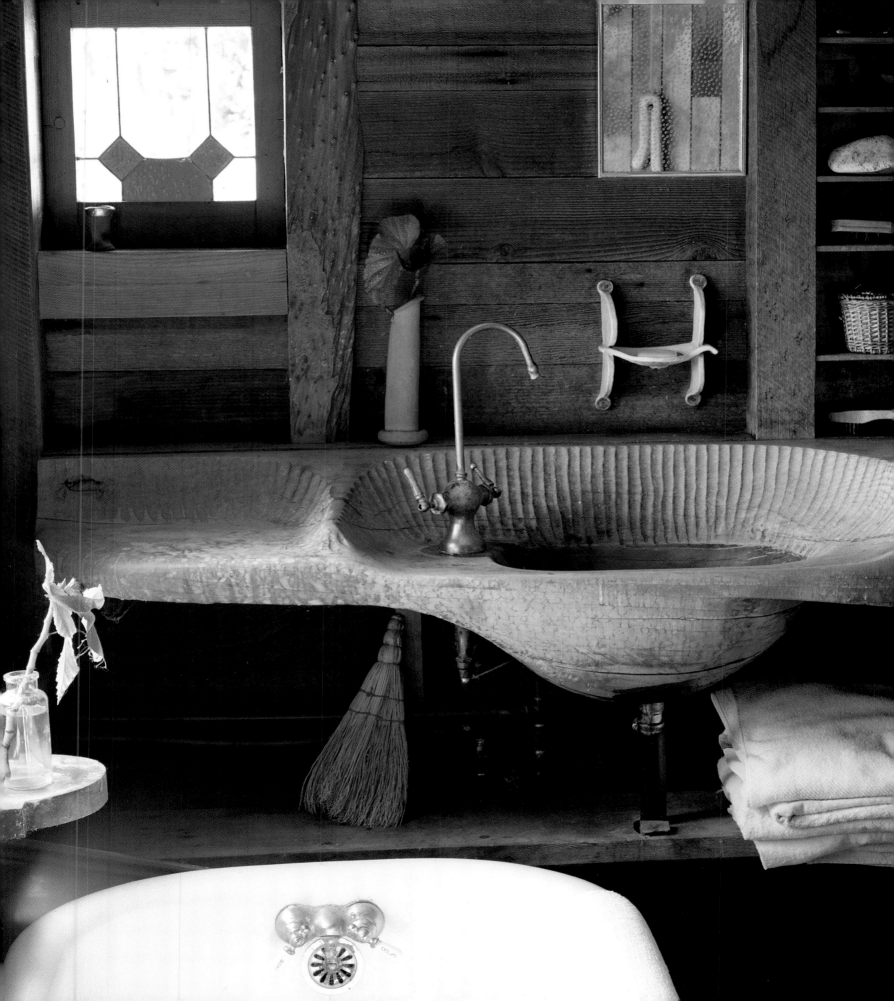

'J. B.'s medium is the earth and it's endless gifts,' a friend and curator of his work once commented. He began his artistic career in pottery and studied with Japanese masters in Japan in the 1950s. Back in California, he began building his own house and was consulted on the house of neighbouring artist, the English expatriate landscape painter, Gordon Onslow Ford. Soon afterwards, Blunk embarked on his sculpting and furniture-making career, though he continued to work in ceramic, as well as in stone, bronze, jewelry and painting.

He is fascinated, he confesses, by the 'opportunities for surprise' that wood offers, as when cutting reveals hidden 'unexpected qualities, faults or voids'. What his work achieves is the splendid opportunity for others to explore these qualities first-hand as they explore the solid forms. The idea is to apprehend the material in all its glory with as many senses as can be tuned to it.

This is certainly how one must feel living in Blunk's cabin, which he shares with his partner Christine Nielson and to which she, his sons and their daughter have added their own touches.

A walk around it presents a modest, weathered exterior of redwood planks. It is set amid a sprawling, uninhibited landscape of bay trees, pine and scrub oak where totemic sculptures jut out of the long grass and look quite at home in the wild. Blunk himself appears every bit the rugged pioneer and his fearless approach contributes to the image, but his aim is less to vanquish nature than to revel in it. Inside the house, it is as if the consummate master has endeavoured to get inside his cherished material, to be completely surrounded by the splendours of time-worn textures, tones and grain.

A living-room wall made from a mosaic of leftover pieces of wood is one example of how his unconscious pursuit of a theme has obtained a pleasantly ordered and aesthetically rich work. Elsewhere, the carved basin and furniture, walls and floor form a comforting, womb-like environment, a place of retreat and regeneration. He has been creating since 1954, time enough for wood to age and for a hand-built house to settle into its rightful place, a place to sit back and breathe deeply.

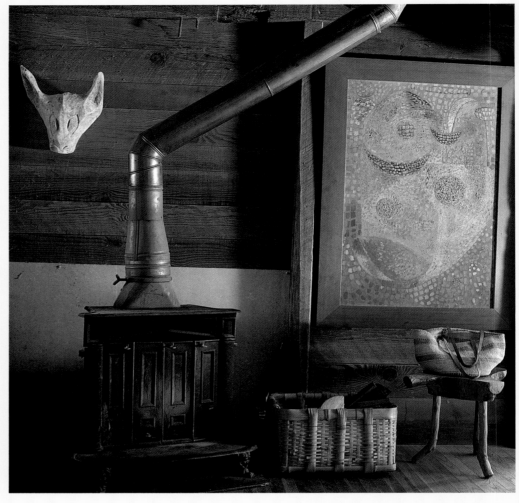

Top left: Blunk discovered a stone worn into a near perfect sphere on the banks of the Stanislaus River. Centre left: the chest in the entrance hall was given to Blunk by Gordon Onslow Ford. The wool rug is natural dyed indigo and was woven by Blunk's partner. Bottom left: The wall of the main room is made of wood fitted together like crazy paving; the gourd is from Oaxaca, Mexico.

Right: the house has a rustic simplicity tempered by the delicate craftsmanship, a few artifacts and Blunk's own sculpture. Blunk made the chair into a rocker when his partner, Christine Nielson, was pregnant with their daughter. Above: a wood-burning stove sits between a painting by Wolfgang Paalen and a mask from the Huaves indians in Oaxaca, Mexico.

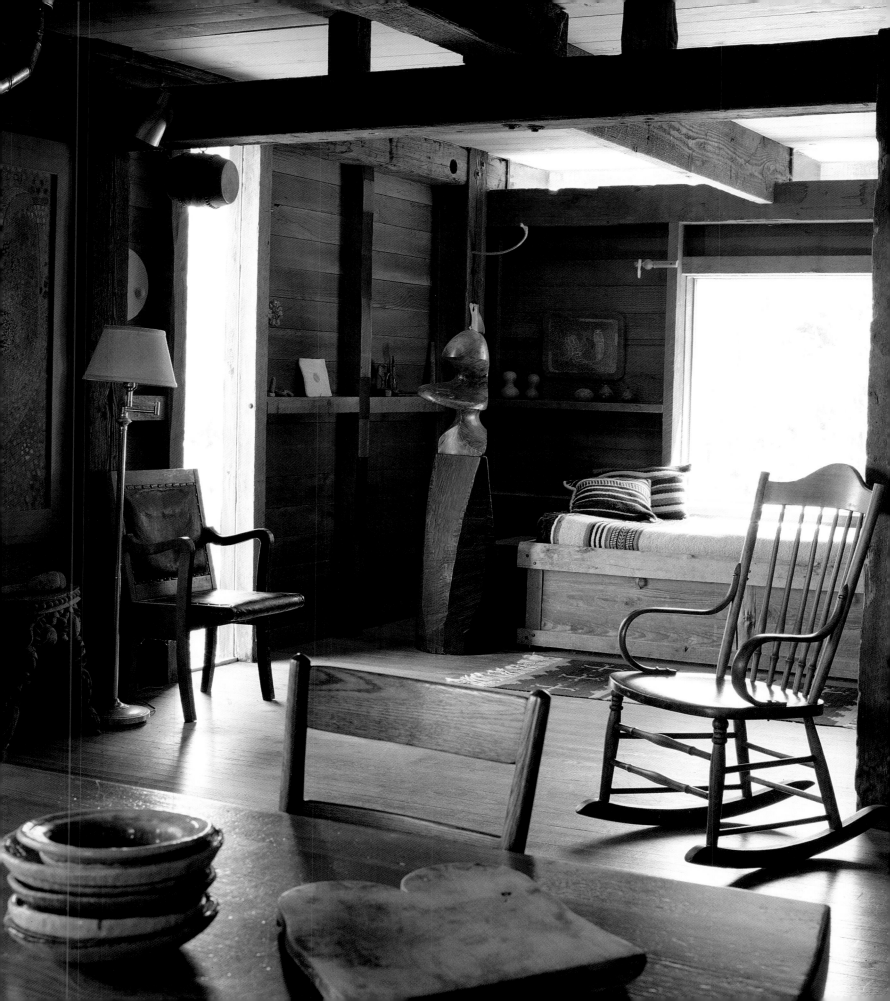

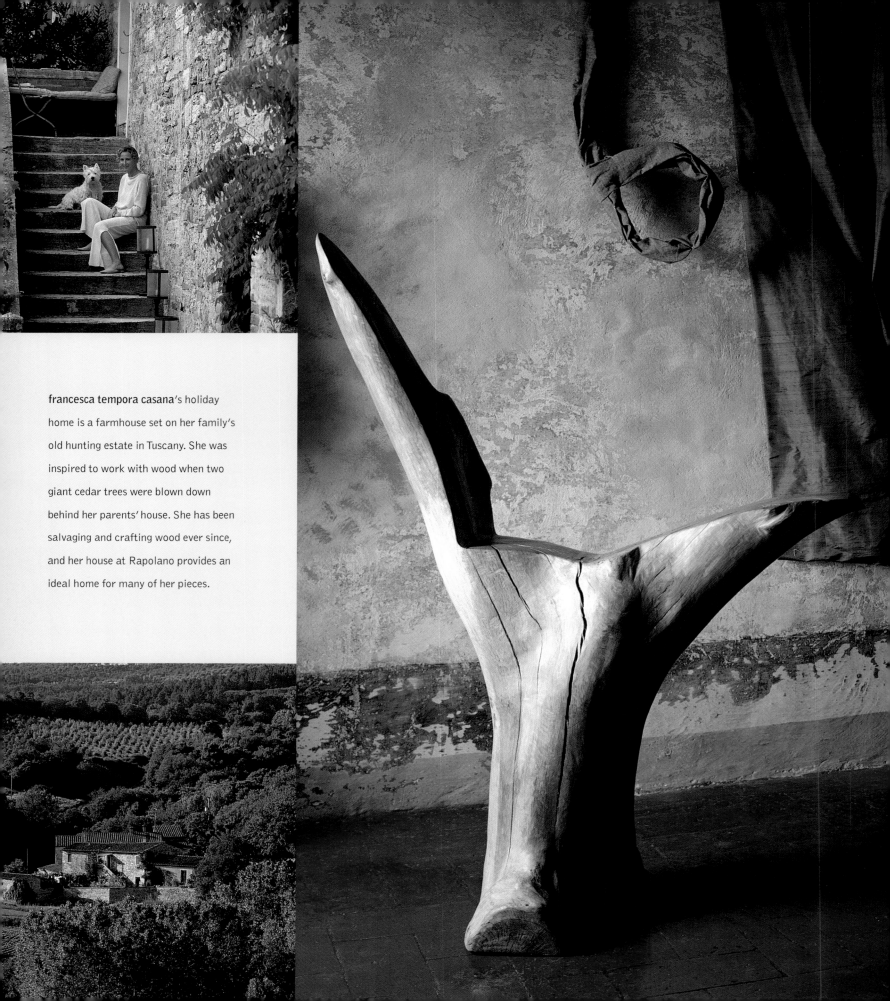

francesca tempora casana's holiday
home is a farmhouse set on her family's
old hunting estate in Tuscany. She was
inspired to work with wood when two
giant cedar trees were blown down
behind her parents' house. She has been
salvaging and crafting wood ever since,
and her house at Rapolano provides an
ideal home for many of her pieces.

It all began on Christmas day in 1994. Two ancient cedars of Lebanon were dramatically blown over in the garden of her parents old Tuscan manor house. Looking at the venerable landmarks, Francesca Tempora Casana knew that she had to preserve them. That visceral reaction to the fallen trees led her on a path that she continues to tread happily today. 'Attracted to the form, the grain, the smell, I began to work with wood from that day forward,' she says. Her idea was to create something useful, yet beautiful from the wood, while preserving as much as possible the natural shape and texture.

Now she fashions a host of objects from a variety of woods. A native of Tuscany, she favours Tuscan cypress for its strong aroma, and olive trees, of which she likens the grain to 'water stirred by wind'. Her poetic feeling for the material translates to her chosen method. Using only her hands and a small grindstone, she creates tables, chairs, shelves and sometimes pure sculpture, and the purity of material is never a constraint on her imagination. She often adds iron for support, which she might paint a vivid red to contrast with the glossy caramel brown of the polished wood.

It is an intriguing transformation for an artist who began with the more delicate media of painting and textiles, to begin dealing with such solid and seemingly unwieldy material. But Casana sees it as a worthwhile creative enterprise, something she is drawn to do, no matter what the medium. Though she now prefers wood to most other materials, she says, 'I don't have anything against chemical or synthetic materials. But in my house I prefer things that are natural.'

francesca tempora casana

A natural and unforced attitude is also evident in the care with which she restored the Tuscan farmhouse on her family's old hunting estate. There have been minimal intrusions on the original style and design. The most dramatic changes consisted in opening up a window and adding modern conveniences. Her husband Carlo points out that the new amenities 'just make for a pleasant surprise' in what would otherwise seem a rustic country retreat. He emphasizes that the restoration of the house resulted in a home that looks rustic on the surface, but in comfort is anything but. He credits his wife with the restoration project and explains that it was guided by 'a philological principle' of maintaining the vocabulary of a centuries-old country house, while restoring and modernizing.

The house is a holiday home away from their main residence in Milan. Located between Siena and Arezzo, Castiglioni was a small fortified medieval village. The house in the Rapolano estate, is probably early seventeenth century and carries the unmistakable air of Tuscan history. And that is precisely the way Carlo and Casana want to keep it. 'On the exterior there is a respect for all the typical aspects of the Tuscan construction,' Carlo continues, 'even in the rendering of the plaster and the selection of plants.' But inside, the gentle intrusions harmonize not only with history, but with art.

A self-taught artist, Francesca Tempora Casana was greatly influenced by her father, an engineer who was constantly creating objects in terracotta, iron and wood. 'Even in his technical work,' she says, 'he succeeded in imparting an artistic aspect, and in his artworks there is an unequivocally technical aspect. Art and technique together.'

For someone who chooses to work with large chunks of solid wood, there is an obvious necessity for technical mastery, of cutting, treating, polishing,

which Casana has embraced as heartily as her more romantic activities. However, romance wins out when she is choosing a piece; it is a decision based on falling in love with the texture, shape or smell of the wood, rather than a critical consideration of its suitability. This is perhaps why the objects she has created for the Rapolano house sit so audaciously and yet so comfortably within the traditional framework of the building.

Stone floors, plaster walls, age-old ceiling beams form an utterly appropriate context for a wall sculpture of cedar root, a naturally knotted sycamore stump used as a console table, and a chaise longue made of solid oak. The weightiness of the wood somehow balances with the equally solid Tuscan stone walls, and both are lightly enhanced by Francesca's colourful textiles and wall hangings.

What Francesca Tempora Casana has added to her house and to her art is a true appreciation of the immediate environment, its living present, as well as its history, a history that must now include the memorable Christmas of 1994.

Previous pages: the house has been restored and slightly modernized. The chair is made from a single piece of oak. Left: beds are kept high off the floor to avoid drafts. The wall hanging is by Francesca Tempora Casana. Right: books rest on a table made from a chestnut root that came from the garden of a Piedmontese castle.

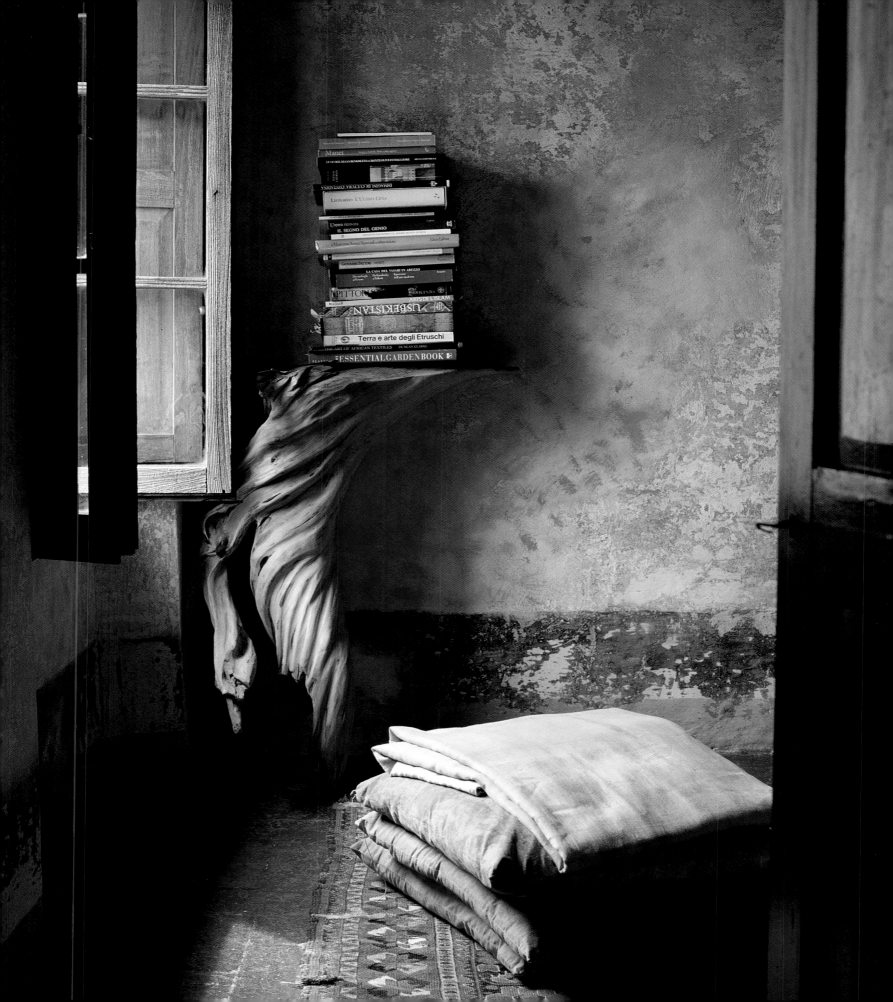

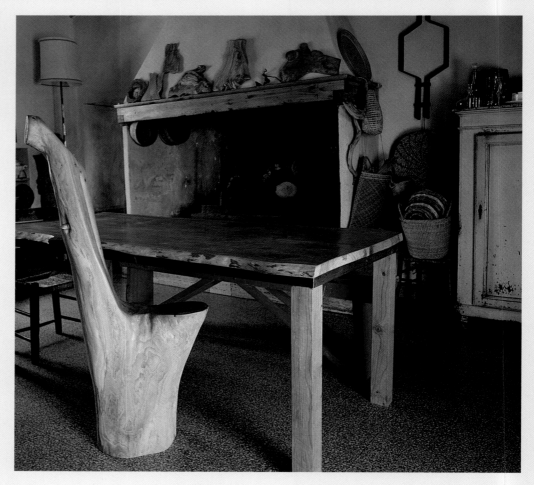

The typical Italian country kitchen is enhanced by Francesca's own designs. The sculptural form above the low shelf is a piece of cedar root which she 'cleaned up' and polished. The column (top right) was cut from the trunk of sycamore and carefully pruned to preserve the protuding knots. The cedar table is 'for breakfast and for cooking'. The chair is also made of a 'chunk' of cedar. Far right: a low table made from cedar root is brightened with red-painted iron legs.

45 FRANCESCA TEMPORA CASANA

axel cassel sculpts in wood, clay and metal, producing figures that are both human and abstract. In 1990 he and his wife, the painter Malgorzata Paszko, bought a disused ribbon factory and house in Normandy, where they now live with their three children. The factory has been converted into studio and gallery space.

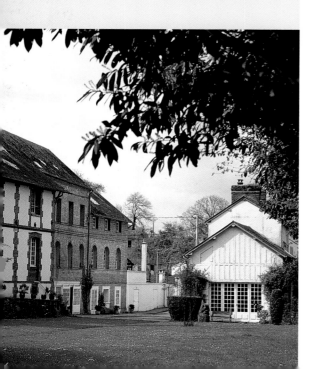

the phrase 'art imitates life' begins to take on new meaning when you are confronted with the work of Axel Cassel. Whether in ebony, ash, iroko or bamboo, his sculpture exudes a quiet appreciation of the hues, tones, patterns and textures of living nature. And though he is not afraid of dynamism or expression in his work, there is an overall sense of serenity, a peaceful flow from the natural world into the artfully man-made.

He finds form in nature, large and small, in the shape of the revered ginkgo or bamboo leaves, or in a coconut pod. But his work does not end there. The basic, naturally inspired shape or pattern is used to build a more complex, if visually minimalist, piece that can then evolve, grow, or progress to a series of works.

Born in Germany, Cassel was raised in France, where he began studying law. This did not engage him and he turned to what did excite him, art. At the Ecole nationale supérieure des Beaux Arts in Paris he worked mainly on graphic art and etching; the move to sculpture came later, in what he calls an 'amusing story', which determined a path he would follow for many years. On one occasion, Cassel was invited to a friend's house and, while he was there, he watched his friend working with clay, making a small model. Cassel decided to give it a try and has been sculpting ever since.

His interest in sculpture coincided with a deep admiration for the works of the twentieth-century Romanian sculptor Constantin Brancusi. At the same time, he became a frequent visitor to the Musée de

axel cassel

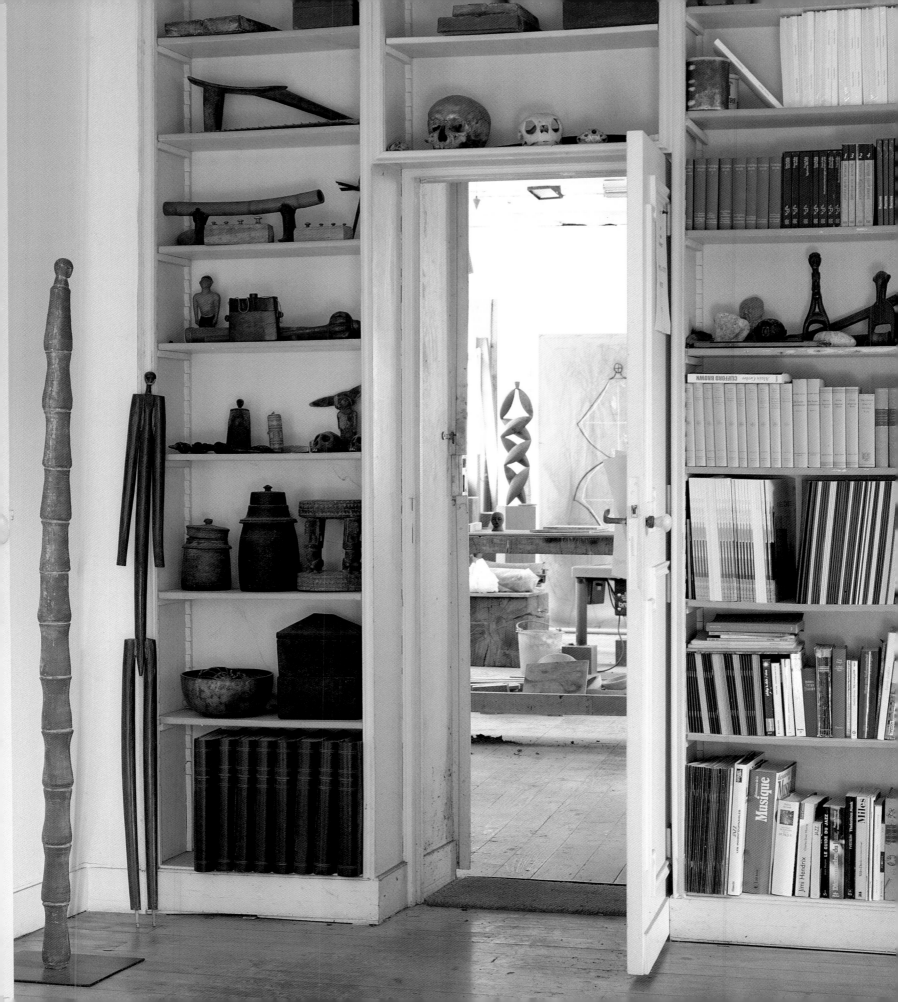

l'Homme and was overcome with a desire to see the world. In New Guinea, Java, Bali, Burkina Faso, Togo, Bénin, Nepal and India, Cassel absorbed the diversity of people, landscape, vegetation and through it all became fascinated by the force of life, which permeates his work to this day.

It begins with the wood being carefully worked by hand until Cassel achieves the form that he is looking for. A friend once tried to convince him to use power tools, claiming Cassel's method was passé, 'but it has no feeling,' Cassel argues, 'so I work very traditionally.'

But even when the wood has reached its delicate form, Cassel only achieves the fulfilment of his idea in the final patina, in which he takes the most satisfaction. 'I have a lot of fun with that,' he says, 'not the carving, which you have to do, but to make the "skin" of the sculpture. You can imagine the same sculpture,' he points to a figure cast in bronze and treated to have the same brown hue as wood, 'but the expression can be very different, like if this

were in chrome, like something by Jeff Koons, for example, the sculpture would have the same form, but a very different meaning.'

The meaning is conveyed through an array of finishes on wood, bronze and clay. Though Cassel obtains the surface effect employing natural methods – wax or smoke instead of paint, 'so the wood can breathe' – he also enjoys creating ambiguity. Wood is made to look like bronze and bronze is cast with a chipped surface that suggests roughly chiselled wood.

The touch of the material is important even before it is fully formed. He describes his first work in clay as 'this kind of ectoplasmic thing, very spontaneous', which caused him to marvel as it took shape in his hands. With clay too, the final surface is deliberate and is achieved through the temperature of the firing (ranging from salmon pink, to yellow, to white with increased heat) and hand-rubbed pigment. In 1990 Cassel and his wife, painter Malgorzata Paszko, moved to a disused ribbon factory in

rural Normandy, where they now live with their three children. The house and factory building, now converted to studio spaces, date from the nineteenth century and seem well suited to such a prolific pair.

Outside in the garden, Cassel's wood and bronze sculptures seem to stand in deep contemplation. The apparent calm inwardness of these pieces represents and stands in contrast to, Cassel says, 'a way of perceiving the frenzy of our Western world'. Their still countenance symbolizes Cassel's attempts to reconcile two opposing aspects of the human condition. Since change is the one constant in life, he believes, the 'stillness' that he achieves is therefore 'an illusion' and his desire for 'silence, calm, to sit and watch the snow fall', is not as natural or easy as it seems. 'I see myself as a being until death and so I seek to merge this day of reckoning with nature through empathy.' It is, he continues, 'a way of being conscious of my existence.' It is also a way of discovering moments of beauty.

Previous pages and left: Axel Cassel's sculptures share space with ethnographic objects and artworks, many of which were obtained during his travels in Africa. Right: an acrylic work by Cassel's wife, Marlgorzata Paszko, adorns the wall of a sitting room, while Cassel's sculputres reach up eloquently from a shelf on the left. The house is linear in shape, allowing windows to line every room.

Right: terracotta and bronze sculptures from Cassel's series, based on the shape of a child's spinning top, provide an audience for guitar practice in his studio. Below left: leaves and the human form are a source of more inspiration. Below centre: the sculpture in the mirror has a snakeskin-like grain, 'so I made a snake in a tree,' says Cassel. 'I couldn't find the right place for it until this bathroom was built.' The sculpture is a single piece of wood and the roots inside were only revealed on shaving away the exterior. Below right: the 1950s-style kitchen. Opposite: pieces inspired by coconut pods line the mantelpiece. Following pages: Cassel's large bronze figures are a profound presence in the garden where he grows fourteen species of bamboo.

53 AXEL CASSEL

michele oka doner lives and works
in a converted button factory in
Manhattan. She is known for creating
grand pieces of public art, such as her
Radiant Site, made of eleven thousand
gold lustre tiles, for the Herald Square
subway complex in New York. But she
is as happy designing serving utensils
and delicate pieces of fine jewelry.

You are trudging through Miami International airport, whether suffering from jet lag or from the anticipation of a long journey ahead, and suddenly you find yourself walking in shallow surf, the water so clear that you can see not only the sand beneath, but distinctive sea forms and microscopic organisms enlarged for the naked eye.

This is the concourse measuring 22,000 square feet – later englarged to 35,000 square feet – that is testimony to the ability of sculptor Michele Oka Doner to connect, in a figurative and a literal sense, people and places in a time and nature continuum. Some three thousand bronze pieces, each meticulously shaped as sea creatures and marine plants, stretch out for half a mile between gates and waiting areas in the dark brilliance of charcoal grey terrazzo. Glittering clouds of mother-of-pearl, like scattered handfuls of moonlit sand, negotiate the separate spaces, rendering her *Walk on the Beach* a truly inviting experience in one of our less than inviting, modern mass-meeting places.

Making art welcoming in everyday experience is something in which Michele Oka Doner heartily believes. As an artist who studied during a period that she describes as 'the end of art history as we know it', that is, when geometric abstraction and machine-made works dominated, she began to 'look elsewhere' for inspiration. And she did not have to look far, since she sees the natural world, in all its minute and grand manifestations, as sufficiently awe-inspiring, as well as fundamental. Her childhood spent on the Miami seafront has something to do with both her dedication to the city's image and with her fascination with things sea-bound.

The forms that move her are not just the organic matter of everyday life, but the smaller, less visible shapes of proto-life: DNA, sodium molecules, diatoms, and the delicate tracery of sea foam when viewed under a microscope.

'I am always looking at microscopic photography, I like to bring to the eye what we can't see so readily,' she explains. And then there is the fascination with the fragmented whole that is nature: 'so many forms are fragments washed up on shore, like a puzzle. The beach is nature's great puzzle.'

Oka Doner began working with clay, which she feels is 'almost like Latin in that it's the mother tongue. The use of soft, wet material informs everything I do.' This includes her current preoccupation with metals, which she works first by creating models in wax in order to feel the texture and lines of each piece.

'Welding and machining have dominated in our lifetime,' she observes, 'but I've taken a different approach. That's how I make the forms organic and soft. It's pretty terrific to get your hands dirty again. It's a natural thing and we need not to forget. A work is lacking in texture if it's not touched, but it's much more than texture.'

From the intricacy of her designs, which range from grand public art to small pieces of jewelry, it is not hard to grasp Oka Doner's holistic vision of art and nature, which extends into her living environment. For nearly twenty years the artist has made her home in a Manhattan loft, part of a nineteenth-century button factory. Maintaining cast-iron columns and original radiators, Oka Doner employed a design concept that could accommodate her own work and allow a free-form

Michele Oka Doner's loft space is a clean-lined, modern environment for living, working and displaying some of the many prototypes developed for her works. Opposite above: a bronze sculpture entitled *Burning Bush* is made to hold candles; below, a silver tray with a coral pattern and gilded bronze rim, and the bronze 'Celestial' chair (with 'galaxy' back and 'whirlpool galaxy' seat), all display the artist's gift for interpreting and recasting natural forms.

michele oka doner

style of working and living. In the lower level of the flat a continuous space 'differentiated by use, not by walls', Oka Doner likes her art and life to blend.

Furniture of her own design is also very much part of the living area. Finely worked metal pieces, such as the 'Palm Cosmos' chair share space with a solid, circular bench and table and delicate shell-like sculptures. These pieces, which she keeps in her home, 'are the prototypes with the mistakes, the ones you learn on, the ones that have what I call birthmarks. The next one is always better because it doesn't have the seams, but these pieces have the "ah-ha" moments.'

Experiencing these kinds of moments in daily life is to Michele Oka Doner not just enjoyable but imperative and is something she feels is lacking in Western culture. 'The Japanese know that the spoon is important, the cup, they understand exquisitely the ritual of everyday life. It is much richer than ours. We tend to have Sunday clothes and good china, but I always wanted every day to be special like that.' Living with her sublime works inspired by nature would certainly make it so.

While private rooms are divided upstairs, an open-plan main floor allows for a free flow between living and working, where utilitarian objects are mixed with her own creations. White planes leave ample space for creativity. Left: a bronze table and circular bench are prototypes from the *Science Benches* series that Oka Doner created for the University of Michigan. The cast bronze sculpture is taken from a Florida palm.

Left: the *Soul Catchers* are some of Oka Doner's early works in porcelain. Right: a large cast-silver bowl sits on the grey marble dining table. The kitchen is part of the main space in which Oka Doner also works. Tall windows are kept free of decoration to allow maximum light. The cast-iron columns displaying neoclassical details been preserved, along with the old radiators.

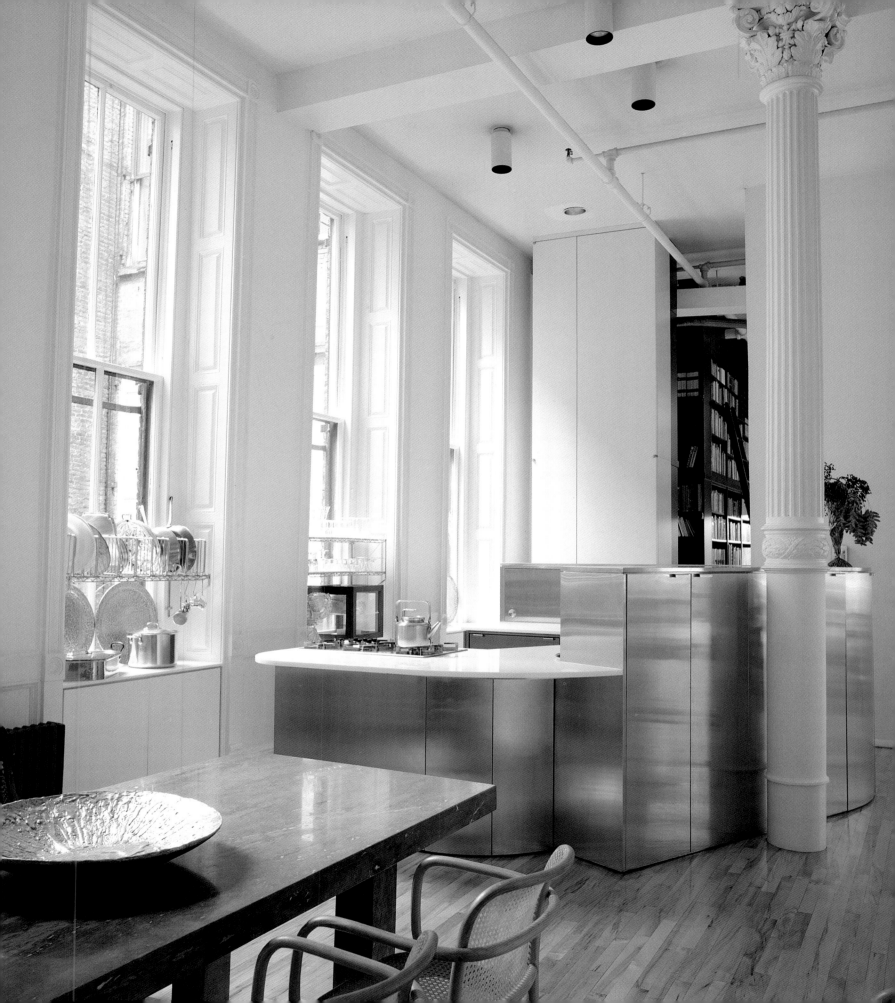

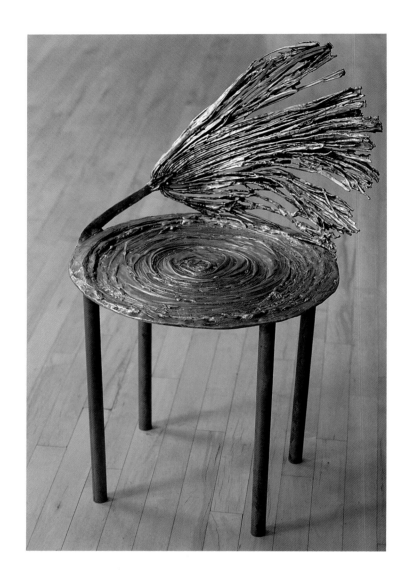

Above left: the incised clay sculptures are works from the early 1960s. The bronze chair (left), the silver 'Palm Cosmos' chair (above) and bronze chair with coral-shaped back and web seat, are invested with intricate detailing inspired by organic forms. The gilded bronze feet (opposite) are cast from the artist's own.

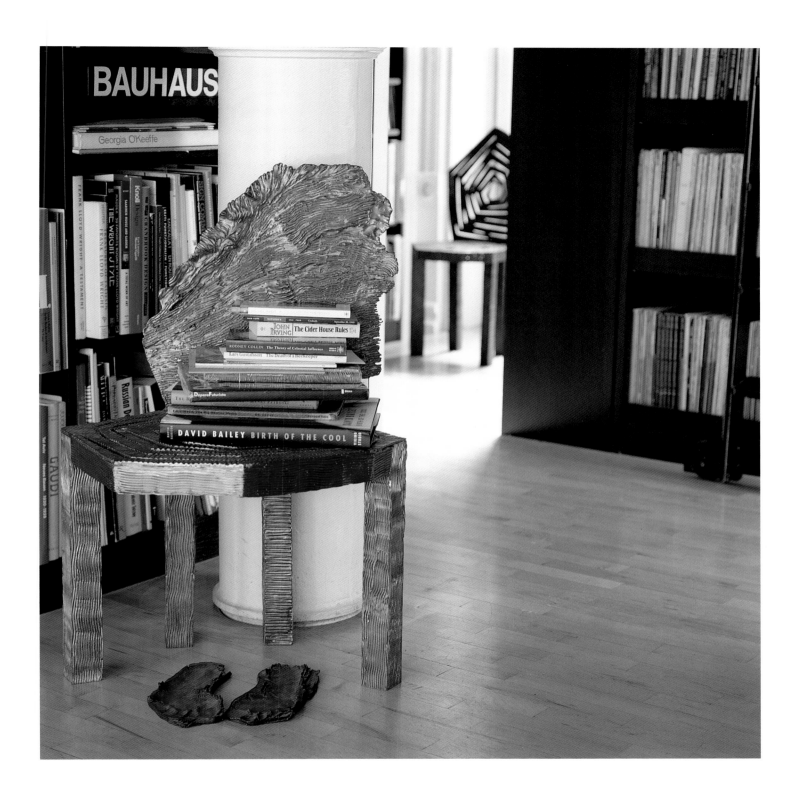

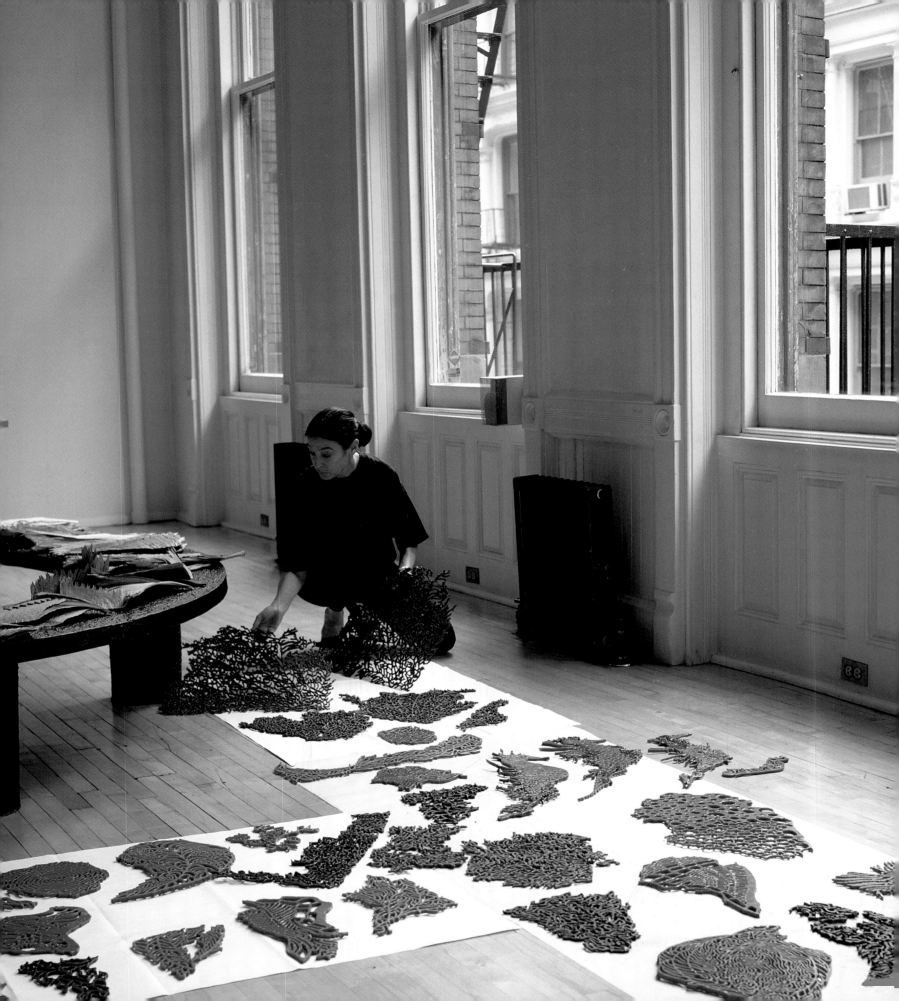

Left: Michele Oka Doner lays out wax models for bronze elements that she will create for a large-scale piece. Above: silver 'Celestial' utensils forged from miscast pieces. Above right: the 'coral reef' bracelet is made of bronze and diamonds.

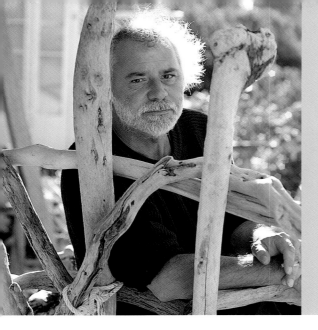

pierre fuger was a dancer with the Paris Opera, a jazz teacher and choreographer before he moved to Corsica in 1994 and began making furnishings from driftwood. Now he lives on the island in a house that opens onto the sea and distant snow-covered mountains.

Pierre Fuger's house in Corsica is filled with the driftwood furniture he creates from materials he finds on the beaches and in the island creeks. Above right: an original shower installation. Opposite: a mantelpiece, side table and settee demonstrate his versatility.

'When I saw this place I said to myself that this was where I wanted to live forever,' says Pierre Fuger of his mountain home in Cap Corse on the northernmost tip of Corsica. It is an understandable sentiment. Whether gazing out over the Ligurian Sea from his stone-flagged terrace or taking in the snow-covered peaks of the mountains, you get the feeling that life really does not get much better than this. Except that for Pierre Fuger it has, in that he is also able to earn a living from his hilltop eyrie doing what he loves – making furniture from the island's driftwood.

'I work in the house in the sun. It's a magical place,' he continues happily, showing no signs of longing for his former life in Paris. Previously, his career was on the stage, first as a dancer with the Paris Opera for thirteen years and then as a teacher of jazz dance and later as a choreographer. So the move to Cap Corse involved not only a radical change of setting, but also of lifestyle. Rather than entertaining theatre audiences, Fuger now spends his days scouring the beaches or paddling the local creeks in a boat looking for pieces of wood. 'The people here think I'm mad,' he laughs, 'collecting wood they would only use to burn in the winter'. But Fuger has much greater plans for the naturally cured and whitened branches, trunks and sticks. After lugging his carefully chosen materials home, Fuger sets to work, creating his unique armchairs, benches, shelves, picture frames and even four-poster beds. It is isolated employment, but Fuger finds the natural beauty and quiet self-sufficiency idyllic. 'In the beginning I made things for myself because I didn't have any furniture, then my friends started commissioning pieces from me,' he explains. But his commissions have now gone far beyond friends and acquaintances. His furniture is sold in Italy, France, Germany and elsewhere on the continent, as well as in the United States.

When Fuger discovered his ideal island house, he found that, despite its age, it did not require an inordinate amount of work to make it habitable.

pierre fuger

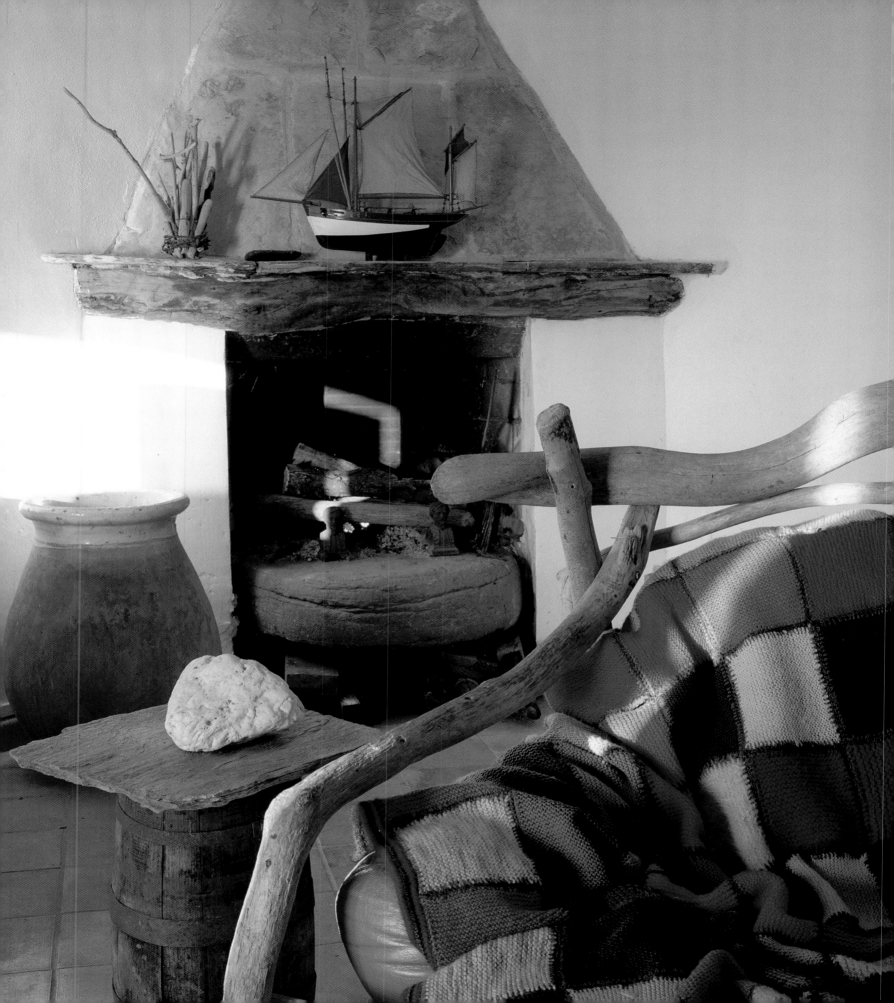

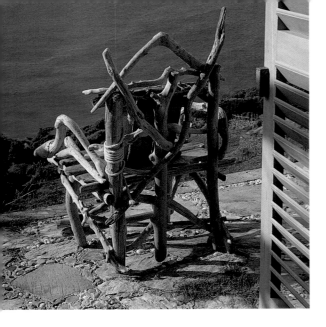

forge an almost animate connection with the natural environment.

In its unpainted, unchanged state, driftwood is charged with the strength and beauty of nature; it would be hard to mistake it for anything machine manufactured. And Pierre Fuger is not interested in transforming the material into something unrecognizable, as he lets the natural twists and curves lead him. 'You have to find the piece of wood that inspires you to make a table or chair, and that's what determines the form it will take,' he says of his method. It is a quiet, unhurried process that makes sense in a place like Cap Corse.

Pierre Fuger discovered the area when he 'toured with friends, musicians, singers', no doubt in more lively company than he now lives. These days, he has given himself over whole-heartedly to the rhythms of the island, where he enjoys 'taking time to live, to look, to breathe in the sun, the sea, sailing, not being accountable to anyone, and solitude'. It is a long way from the dance halls of Paris, but Pierre Fuger seems to have found something more satisfying than the roar of the crowd and he is in no hurry to go back.

'I haven't done anything special to this house except to salvage the cellars which look out over the vineyards and the sea.' Inside, the house is modestly furnished with his own creations arranged against whitewashed walls and tiled floors. Crystalline sunlight penetrates the rooms, lightening the white walls and bleached wood even more. Perhaps in deference to the majestic site or to his own works of art, the colours are soft and neutral with hints of more vivid tones in painted furnishings or fabrics. Though there is a mix of old and new, handcrafted and ready-made, nothing jars. All the elements, inside and out, blend softly in tone and texture like the remarkable light and gentle sea breeze.

There are some who might scoff at the idea of turning driftwood into elegant, designer furniture, but in this context it becomes clear how and why Fuger was drawn to such a pursuit and that he has succeeded in combining artistry and craft to transform this abundant, wholly natural raw material into something special. The sun-bleached, salt-dried wood is appropriate in the island setting, with its natural vegetation, the sea and mountains ever-present in the periphery. In these Edenic surroundings, the thoughtfully composed tangles

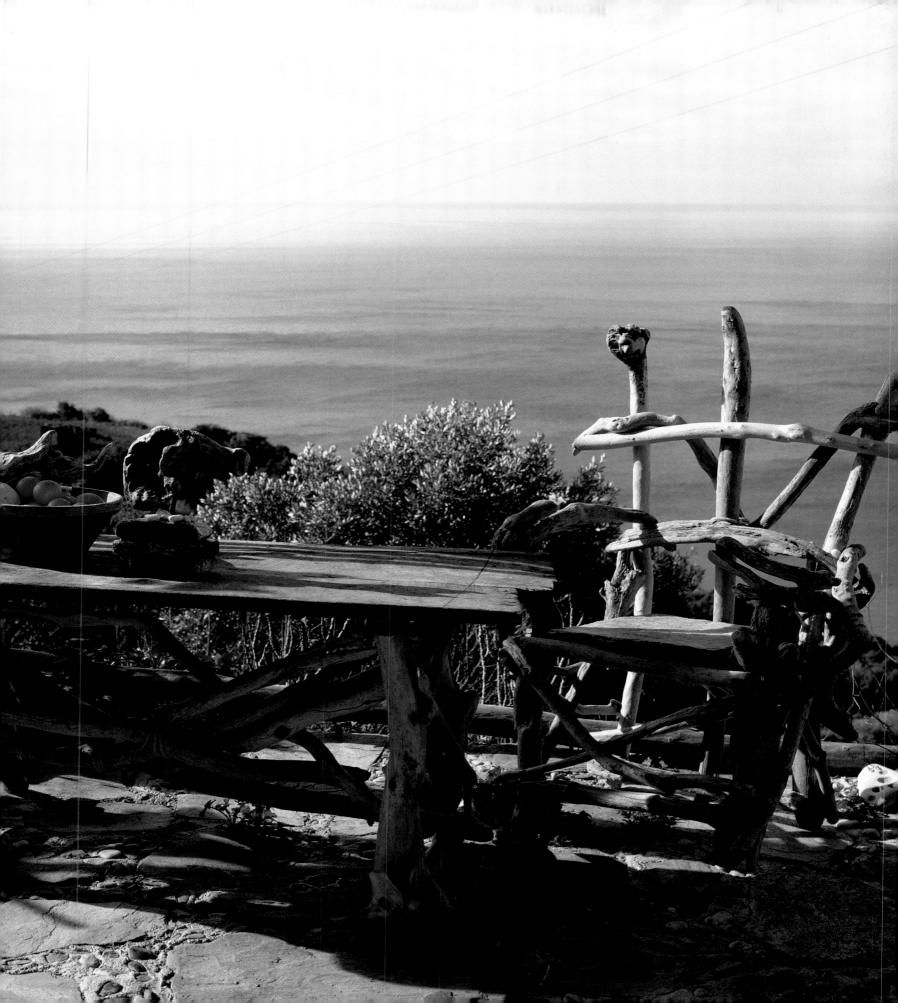

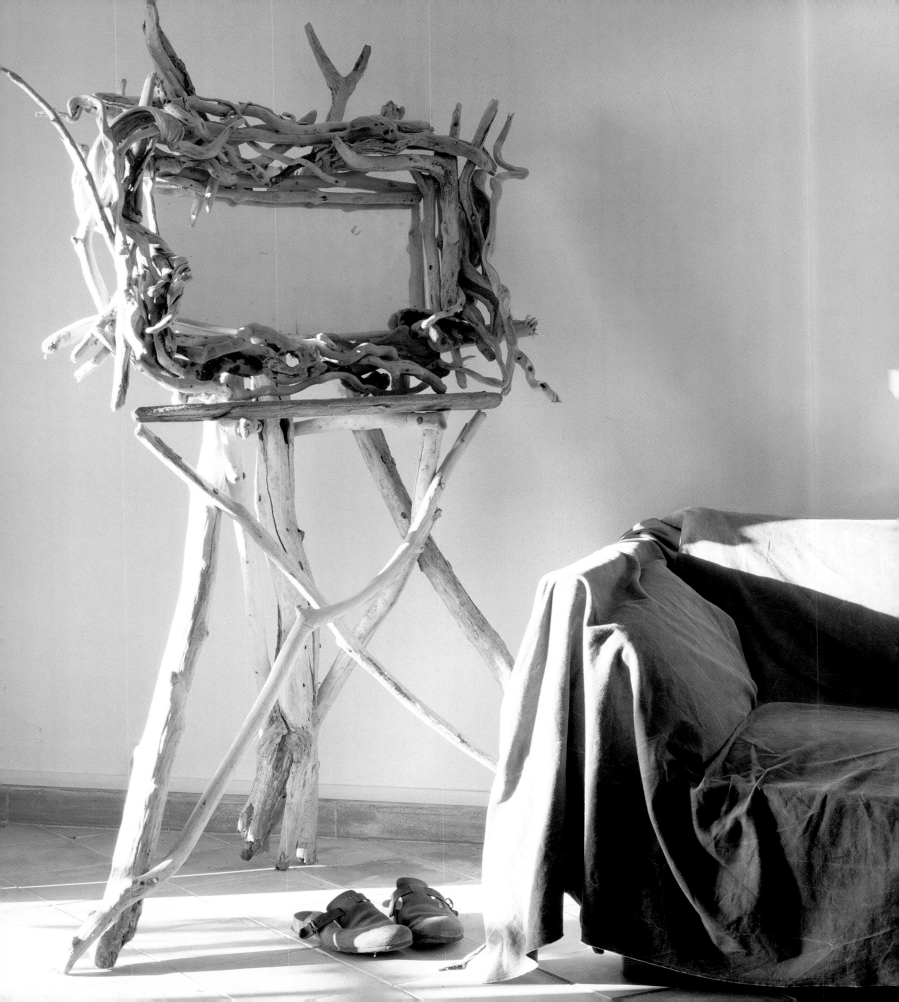

Previous pages: Fuger's house is 'probably a hundred years old' and takes in an unimpeded view of the sea. Driftwood makes an ideal material for outdoor furniture, being particularly suited to the sea air. Opposite: a tripod picture frame is one of Fuger's more unusual creations, as is the structure for the toilet (below). Right: Fuger's bedroom chair and bench provide pleasing rustic accents alongside an iron bedstead and painted wardrobe.

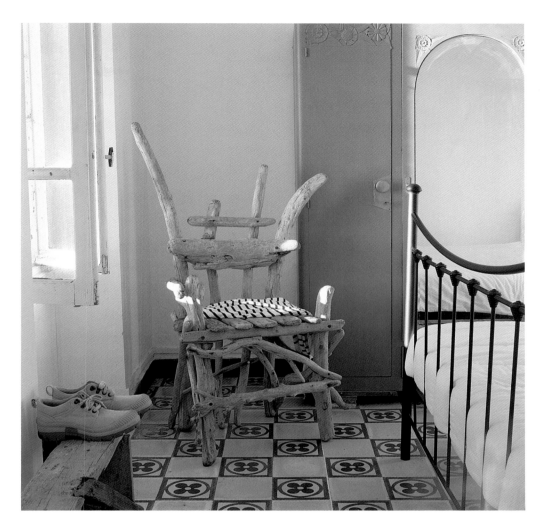

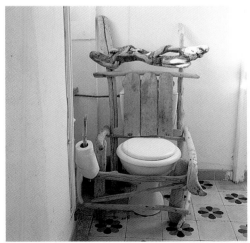

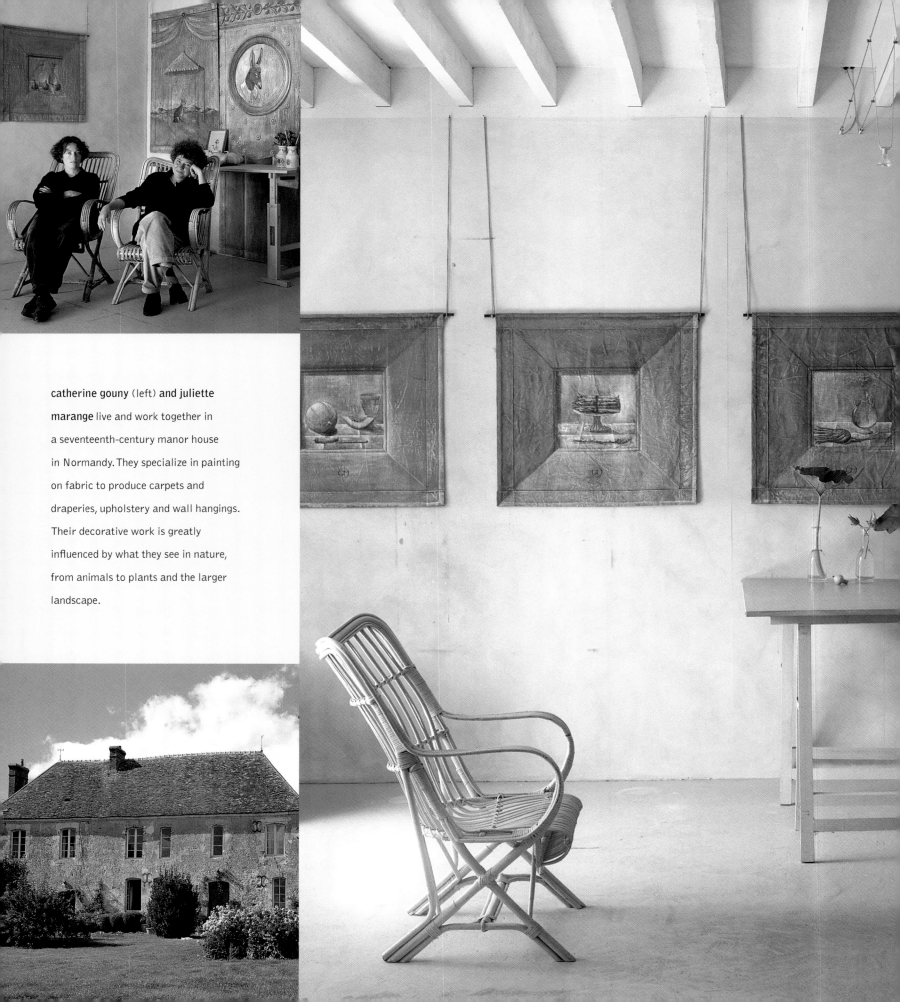

catherine gouny (left) and juliette
marange live and work together in
a seventeenth-century manor house
in Normandy. They specialize in painting
on fabric to produce carpets and
draperies, upholstery and wall hangings.
Their decorative work is greatly
influenced by what they see in nature,
from animals to plants and the larger
landscape.

'We've worked together for eight years and paint with four hands,' says Juliette Marange of her partnership with decorative artist Catherine Gouny. If ever there was a fruitful pairing, Gouny and Marange are that. Before forming their artful union, both had studied in Paris, where they were introduced at an exhibition of the painter Gérard Garouste in 1993. It was like a meeting of the minds: the first cloth they created together was 'to our eyes, magical'.

Since then, they have combined their styles to produce designs for cloth, faïence, stationery and a host of other objects. With Marange offering the more painterly approach, and Gouny, who worked in stage design, informing pieces with architectural elements, they create images that are part still life, part *trompe l'oeil* fantasy.

'We share the creation totally,' Marange adds. 'We consider ourselves not so much artists, but like the artisans in the pursuit of an aesthetic that is our own.' Their avowed aesthetic is directly influenced by nature in both material and subject matter. They have expanded with the popularity of their offerings to a variety of media, but their preferred material remains linen. 'Have you ever seen a field of flax in flower?' Marange asks. 'The blue is incomparable. This is just one reason for using this material.' Their other favoured hues include burnt sienna, yellow ochre, red pozzolana (volcanic ash), charcoal and ultramarine from Greece.

With this earthy mix they have recreated the natural beauty that surrounds them, particularly in the seventeenth-century manor house they are restoring in Normandy. 'We like to paint fruits, vegetables and all the vegetation that we have planted. It's a constant give and take of culture and painting.' But this is not to imply that their work is devoid of more sophisticated themes. Both are passionate about the

catherine gouny & juliette marange

painting of the Italian Quattrocento. 'Carpaccio, the background landscapes of Piero della Francesca, the rocks of Giotto or Fra Angelico…,' all find their way into Gouny and Marange's compositions and add to their rich layers of meaning.

The effect is sometimes surreal, which may be due to another focus of their joint admiration: the metaphysical paintings of Giorgio de Chirico. Their depictions range from simple patterns of vegetables to more complicated panels showing still lifes or animal portraits, arranged among ornamental props (columns, arches, swags) or set in the foreground of a receding landscape. These works straddle the boundaries of the artistic and the purely decorative, of modern product design and historical allusion.

From their Normandy base at Les Joncherets they work in idyllic seclusion. Inside the house they have concentrated on decor 'rather than on the possession of beautiful furniture', and 'painting is present everywhere'. They are conscious of trying to re-create an idyll. But they are determined to have it so – their philosophy, Marange maintains, 'is that the whole house should be one tableau'. Having a seventeenth-century manor house in which to hang their distinctive paintings, helps with the illusion.

They are also aware of cultivating an especially romantic depiction of nature, looking to 'the landscape that moves us, one of dreams' and finding 'through imagination a nature before industrialization and large-scale urbanization'. Some might see this as an unrealistic goal, but as Gouny and Marange demonstrate in their depictions, reality is not always what it seems.

In furnishing and decorating Les Joncherets, Gouny and Marange say 'our philosophy is that the whole house should be one painting. We have restored the house in the spirit of painters and are more focused on the decor than on the possession of beautiful furniture.' Their touch is evident in the many painted fabrics which serve to add warmth, interest and a sense of humour.

Catherine Gouny studied painting and interior architecture and Juliette Marange begain painting and exhibiting as a teenager. Together they create scenes of the natural world accented with fanciful architectural details and decorative flourishes. Their favourite material to work with is linen, both for its inherent quality and for their love of the flax plant.

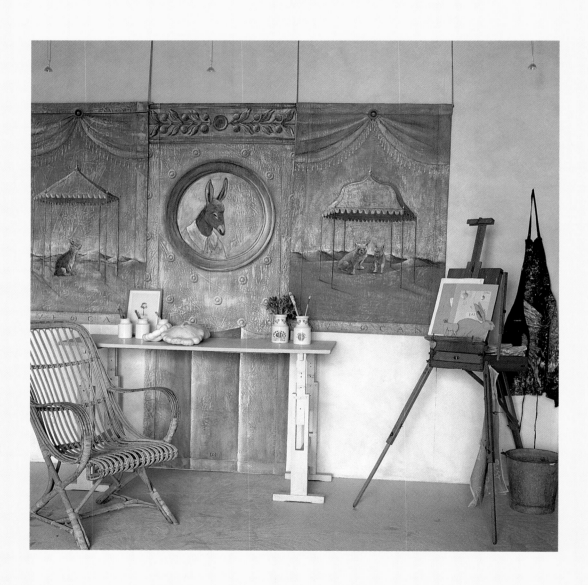

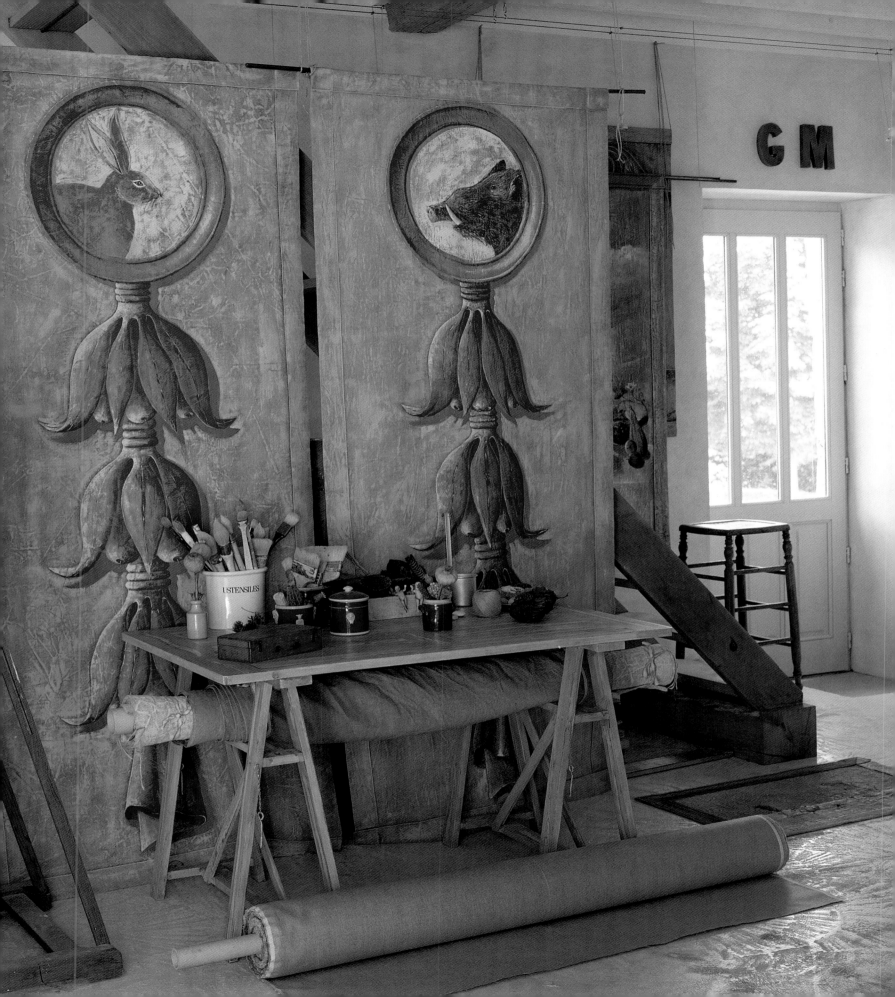

The exposed beams, bare plaster walls and stone floors of the seventeenth-century manor house leave plenty of room for Gouny and Marange to exercise their talents. Traditional wood furniture is chosen wherever possible, complemented by the occasional pieces decorated with their own designs, which they have extended to include a wide range of products for the home.

gilles hoang constructs furniture with mystical associations at his home in a café building in the Burgundy countryside. He relinquished a career in decorative arts to work with reused wood from existing pieces of furniture. He now works in the old dance hall, while his partner, a painter, has a studio in the space previously used for the café.

A late-seventeenth-century building presented Gilles Hoang with the environment he needed to change jobs from decorative and display work in Paris to a career devoted to recycling furniture. The cart at the door is named 'Gypsy Woman' and is made from three pieces: a boat, an armchair and a garden cart. Right: his 'Rebouteux' (bonesetter) chair is made with the legs of a billiard table.

gilles hoang

When Gilles Hoang studied at the Ecole des Beaux Arts in Versailles he could not learn fast enough. Painting, life drawing, sculpture, all held their appeal, but Hoang had his own impatient ideas. One was a labour-intensive, hand-crafted children's book containing three-dimensional images, 'like puppets in a theatre,' Hoang adds. It was called *L'Oiseaux des bois* (Birds of the Woods) and was 'about the seasons, nature and metamorphosis'. He devoted himself to creating this singular piece and then moved on in his work, if not completely in his thinking.

Though he pursued a career in commercial design, creating theatrical decor and furniture designs, the ideas of metamorphosis and nature remained with him. In 1997 he and his partner, painter Laurence Malval, left Paris and moved to the countryside of Burgundy to pursue quieter aims. There they found a two-hundred-year-old café and restaurant building, which they converted into a home and studios.

Hoang works in the space that was once used for dining, dancing and 'travelling cinema shows, when a man would come to town bringing a film and all the equipment to show a movie. The people sat in my studio to watch films.' Laurence now paints in the old café and their two-year-old daughter Anaïs has the run of the whole place.

Once Hoang had made the transition he adjusted his focus in both style and material. He uses wood, consisting mainly of old pieces of wood furniture discovered in a *brocante* or flea market, which he will

'cut and mix' to create a new piece of furniture. 'I mix any wood I find,' he says, and is less particular about the kind of wood, but than about what the piece suggests to him. Though his carved pieces may be resonant of Chinese or African tribal art, Hoang remarks, 'I don't look for these designs because I don't want to be influenced by them. Those [pieces] are beautiful and pure and I want my work also to be beautiful and pure.'

What he does look for in the pieces is a spiritual connection, and not simply in the form of inspiration, but in an indication of the end result; for Gilles Hoang's weighty armchairs are meant to recall the mysticism in Western culture. With titles like 'Le Sourcier' (the water diviner), 'Le Guérisseur' (the healer) and 'Le Chaman' (the shaman) and elements gleaned from farming and household implements, there is a distinctive presence about these pieces, which makes them more than just furniture.

Hoang regards them as figures in themselves. 'I make armchairs because they are very close to human beings in form – the seat, the arms, the back – when you see an empty armchair it suggests the person.' What these chairs suggest is a person clad in many guises, but possessing a universal strength of spirit that rests in the great chunks of wood. This connection with the earth, Hoang affirms, is intentional. There are often elements, such as an upturned half-circle, or bowl shapes, that reveal an association with 'the sky and up above,' he explains, 'but one must also have roots, a sense of equilibrium.' The chairs are not made for specific people, but grand and ornate, they inspire the artist with the image of the shaman or the healer enthroned, receiving visitors and dispensing their mystic charms.

Because Hoang's creations are made up of recycled parts – a horse's halter, a goat's harness, legs from a billiard table or an Henri II-style chair – they combine the spiritual with the everyday, as a traditional medicine man would produce a cure from common ingredients. A multitude of allusions are united in one comforting form, which is achieved through the artist remaining true to one material, wood, and only including metal or leather if it is already part of the object he is working with.

Though he starts mostly from ready-made pieces, Gilles Hoang is strongly attached to the wood itself. 'When I am faced with a piece of wood, it speaks to me of what it should become, even though it has had a life before and was the work of another person. Before that, it was a living tree, and it is still alive.' And their is our own attachment to and reliance upon nature. 'I think that when you touch wood, it's the nearest thing to touching the earth.' In a very physical sense, Hoang's throne-like chairs impart a sense of grandeur to being seated firmly on the ground, while dreamily contemplating the sky.

Left: the house's wooded setting provides Hoang with new raw materials to work and experiment with in his sculpture. Right: the dining room features old tiled walls and Hoang's 'Medicine Man' chair, which has legs from an Henri II chair and a backrest framed by pieces of a carved hat rack from India.

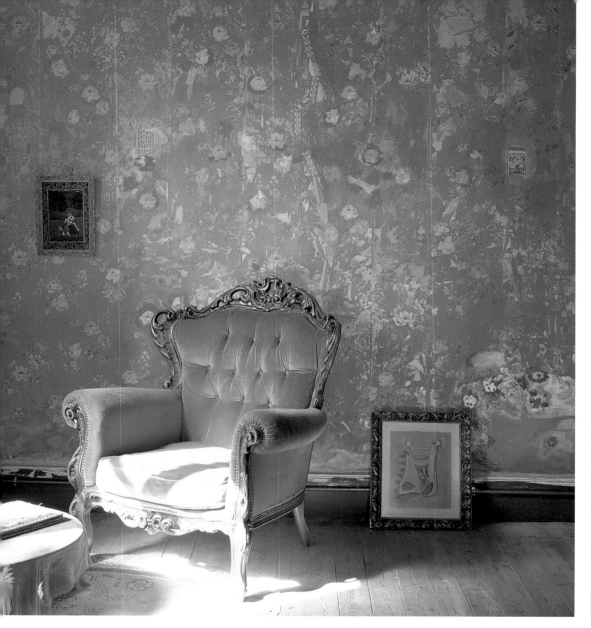

Hoang and his partner, the painter Laurence Malval, made necessary improvements to the house. In a sitting room they attempted to remove the wallpaper and discovered vivid red paper beneath. They liked the colour so much that Laurence deocrated the wall to disguise the damage they had caused in removing the top layer. Above: brightly decorated shoes belonging to the couple's daughter Anaïs.

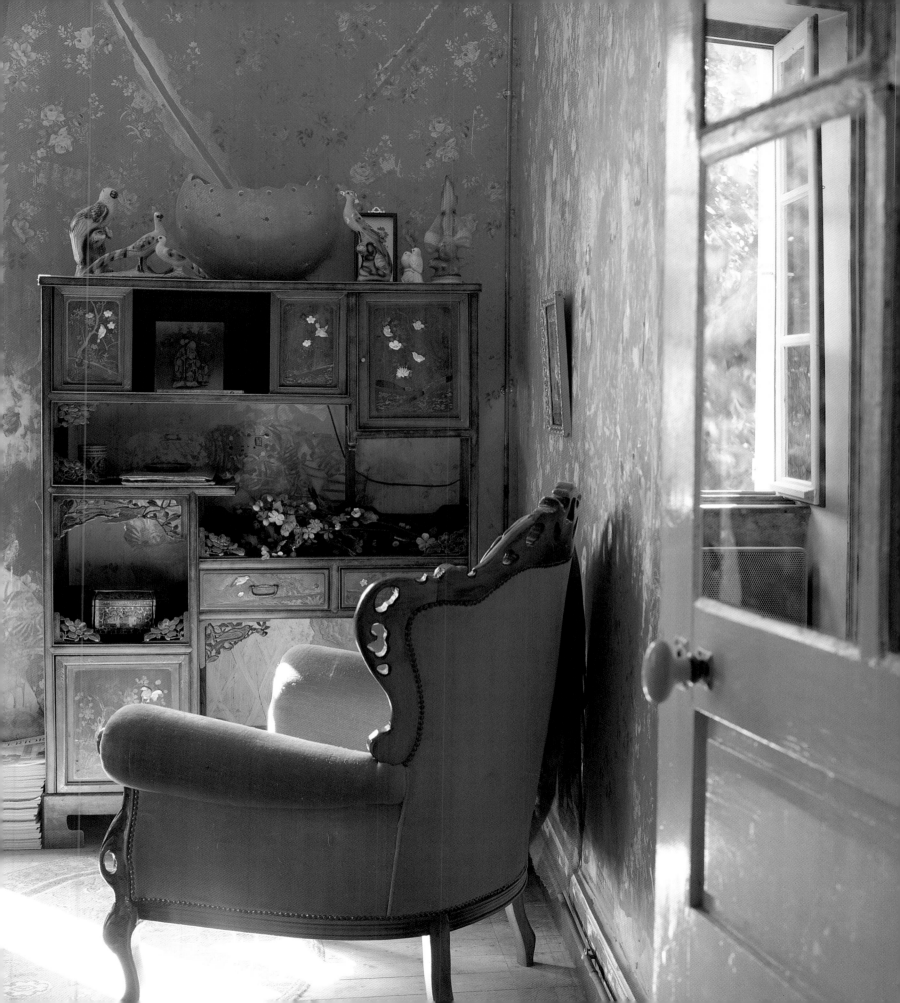

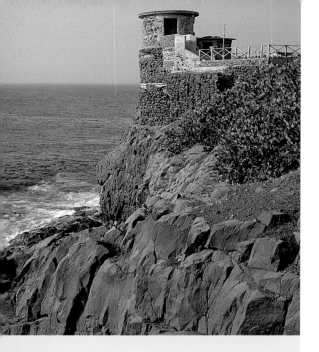

gabriel kemzo has lived in the isolated *fort portugais* off the coast of his native Senegal since he first went there to study under the artist Moustafa Dimé in 1994. The fort sits on a promontory on the island of Goré, from where Kemzo can take in the view of the sea, the harbour, the boats and the people, all inspiration for his paintings and sculpture.

from a small outcropping on the coast of Goré Island off Senegal, Gabriel Kemzo ruminates on the state of the world. Using modest materials collected locally, pieces from old fishing boats, discarded metal and clothing, he attempts to give expression to universal ideas, such as 'human evolution' and the necessary existence of good and evil.

Kemzo also gathers objects from local villages and the mainland during the occasional periods when he is not spending isolated weeks or months in his *fort portugais*. 'Everywhere I go I find material that talks to me and represents something important about human beings and how people live. I choose it and after long reflection I make a decision about how to turn this particular material into sculpture.'

The quietude of the surroundings suggests ample room for thought, and Kemzo's sculptures of recycled and natural materials complement rather than confront the rugged cliffs. Inside, works of metal, wood and cloth sit comfortably against the stone and whitewashed walls of his home.

The young Kemzo studied painting at the national art school in Dakar. He was granted an apprenticeship with another of Senegal's prominent artists, Moustafa Dimé, who sparked his interest in sculpture. After his mentor died, Kemzo stayed on, with the permission of Dimé's widow, in the fort studio. Today it is filled with Kemzo's anthropomorphic creations, which seem to break through the solitude. Though his works address serious themes they manage to retain a playfulness; perhaps it is the use of recognizable recycled goods that lend a comforting air of pragmatism, or the fact that for all of their abstract representations, Kemzo's figures are all too human.

gabriel kemzo

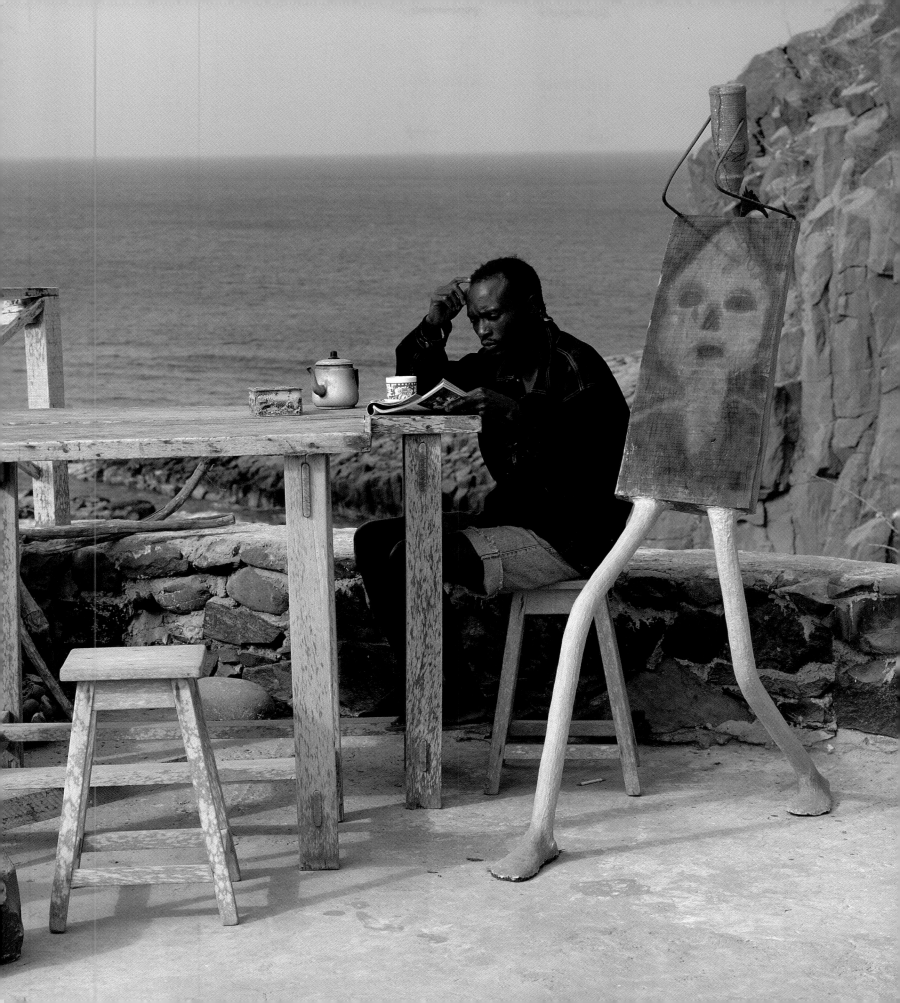

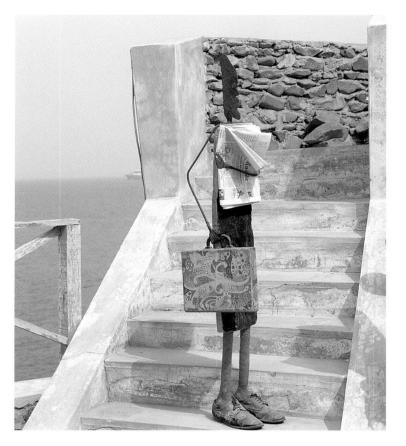
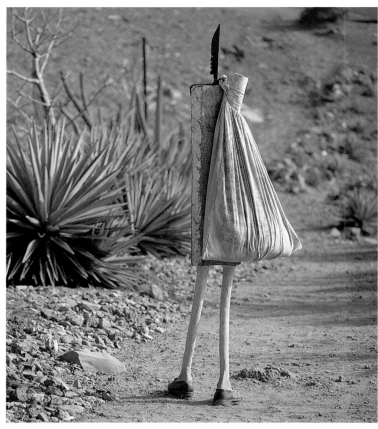

The rocky cliffs of Goré Island
provide a striking backdrop for
Kemzo's sculptures which he creates
from discarded wood, metal and
clothing. Despite his apparent
isolation, he maintains, 'I am
influenced by what's happening
in the world.'

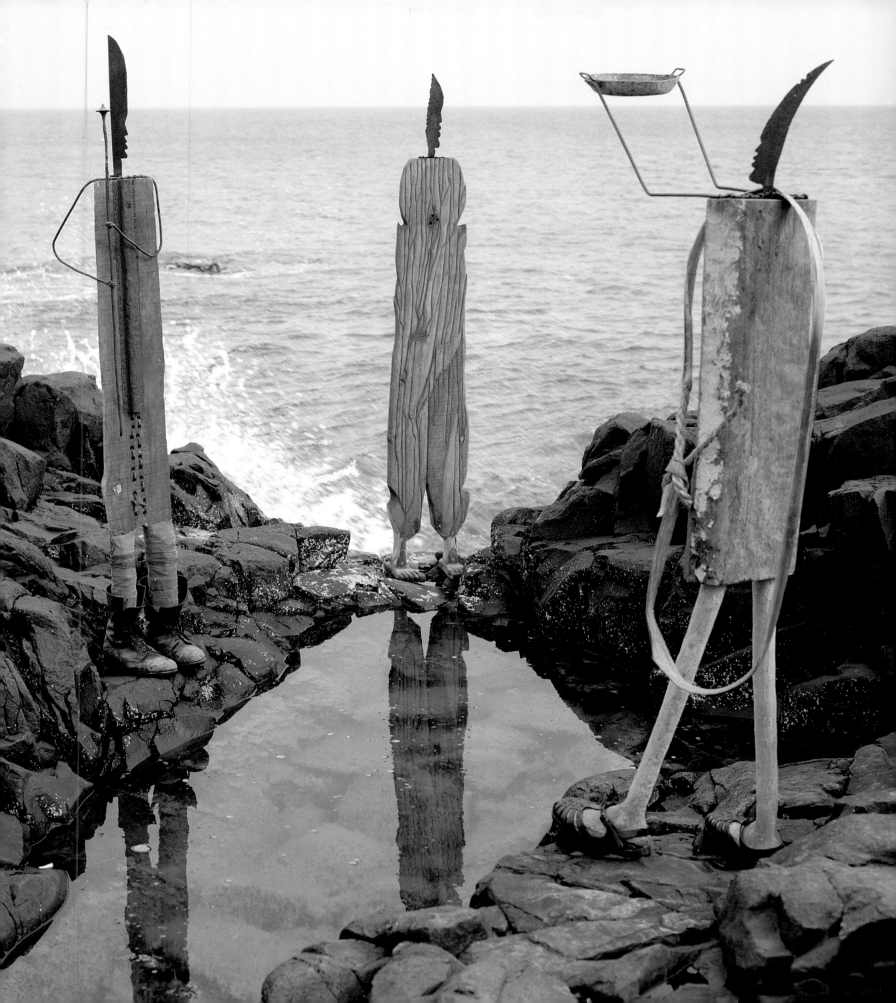

blott kerr-wilson, a shell artist who specializes in mosaics, began with the design of her own small bathroom and was soon commissioned to create her shell fantasies for numerous clients. She lives with her husband and two young sons near La Rochelle, France. The mill, built in 1870, and the house have been completely refurbished by the couple.

Right: a hall in the mill building with a ceiling rose created by Blott Kerr-Wilson visible against the wall. When they bought the mill it was 'a mess', recalls Kerr-Wilson, 'full of grain sacks, rats and rat droppings'. Now, much improved, the mill is used by the family during the summer, as it has no heating.

there is a danger in calling yourself a shell artist, as most people will immediately be beset with visions of conch ashtrays and sand-dollar wind chimes. But Blott Kerr-Wilson has been braving the aesthetic frontiers ever since she first created a total shell environment in her own bathroom in a council flat in Peckham, London, which won an interior design award. Since then, the commissions have come in so thick and fast that you would think she no longer worries about the state of her art, but she does.

'You have to be very careful working with shells,' she says referring to the kitsch factor that has haunted the material, most noticeably since the 1970s. She keeps to designs that are true to the character of the shells and avoids the figurative. Still, when she was studying for her art degree at Goldsmiths College in London, she was forced to keep her real artistic passion to herself, while she studied the more acceptable medium of sculpture.

'They were horrified', she remembers of the faculty when they learnt of her work with shells. 'Even though I'd already won this competition doing the shells, it was never discussed at college. What I did there was completely different.'

Like any hidden passion, Kerr-Wilson's desire to work with shells survived the scepticism, and she continued to work with the material that she adores. Her preferred shells are mussels – 'the best shell in the world because they work so well in the light and offer such strength of colour' – clams, cowries, scallops and the unfortunately named 'asses ears'. The vocabulary expanded as news of her work spread and people began sending her shells, either so she could create something for them, or simply because they thought the shells would interest her.

Kerr-Wilson's present occupation with this material came from a knack for gathering elements that interest her into a workable whole. 'As a child,' she

blott kerr-wilson

recalls, 'I always loved grottoes and follies, any secret place in the garden. And then I went to cookery college and my interest in shells, gardens, food all came together.'

When she says that the shells 'lead the way' in her designs, it is not just romantic fancy; the shells dictate not only colour, but direction, as bivalve shells, such as mussels, have a left and a right half. The resulting compositions give an illusion of movement, shells sweeping in one direction and then reversing, all achieved through careful placement of left and right halves. One of the most startling aspects of some of Kerr-Wilson's work, and one that helps to define her art, is the graphic quality she manages to achieve using, for example, a circle of purplish-blue mussel shells next to waves of miniature white abalone. From a distance, the effect is striking; only on nearing the piece does the viewer discover the medium, but even then, so carefully have the shells been arranged to effect changes in motion, that some doubt remains as to what you are actually seeing. 'It's the light,' she observes, 'it's all to do with how the light plays on the piece.'

In the home that she and her photographer husband have made with their two small children in a disused nineteenth-century mill near La Rochelle, France, light has been restored, with windows reinstated and heavy equipment dating from the 1960s taken away. Here, Kerr-Wilson has ample room to experiment with colour and patterns, which are inspired by natural elements, such as leaves, but also by her collection of books on tapestry and knitwear. 'Fabric is important,' she explains, 'how it's woven into patterns; knitting fascinates me.' When she first started out, Blot Kerr-Wilson had no choice but to use a material that was, as she says, 'free' – shells and sometimes pebbles, which she collected on English beaches. Yet, even today, as an established artist with her work in high demand, she is not tempted to search for more exotic or elevated materials, and she never uses coral or rare shells . As well as an increased quantity of shells (which she now orders ready cleaned from a supplier) she also uses a greater variety. And though they all need to be in good condition, she does not feel the need to alter what she considers is an already finely crafted piece. 'I never varnish or paint them,' she says, 'I just leave them.'

This, however, belies the perfectionist who will not hesitate to tear down an unsatisfactory wall of mosaic and begin again. But her sense of perfection is aesthetic rather than regimental, and like any good cook, gardener or artist, she knows instinctively when to coax her materials along, and when just to stand back and admire them.

Blott Kerr-Wilson created one of her dynamic wall mosaics using mussel shells and miniature white abalone in the orangery. The structure had been used as a repair workshop for industrial machinery, such as tractors and JCBs, and required a lot of cleaning up, as well as the installation of new windows.

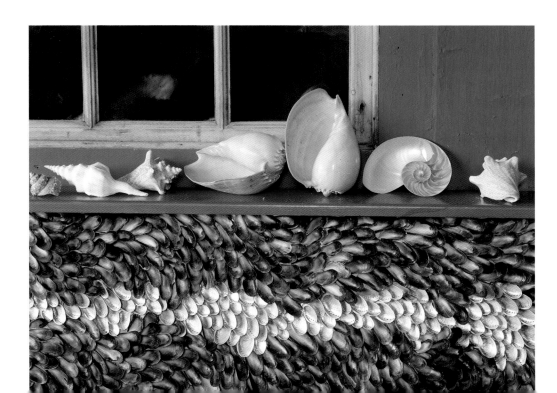

Left: the large, bare walls of the orangery beckon one of Kerr-Wilson's creations. The solid, circular wall design is composed entirely of purple mussel shells, which Kerr-Wilson favours, she says, because they have a left and a right half and 'by changing the direction of the shells, you get a different pattern and texture.' A few pieces of patio furniture make the room a pleasant spot to relax on a sunny afternoon, with space enough for the children to ride their tricycles.

A bedroom in the small millhouse features an intricate shell window surround. The family live in the millhouse during the winter and move into the more open spaces of the mill building (above left and right) in the summer. A spare bedroom in the mill building displays a shell bedspread and painted wall clock. Right: a cosy corner has been created in the mill building with a shell-decorated curtain, a colourfully dressed wrought-iron day bed and a brightly patterned rug.

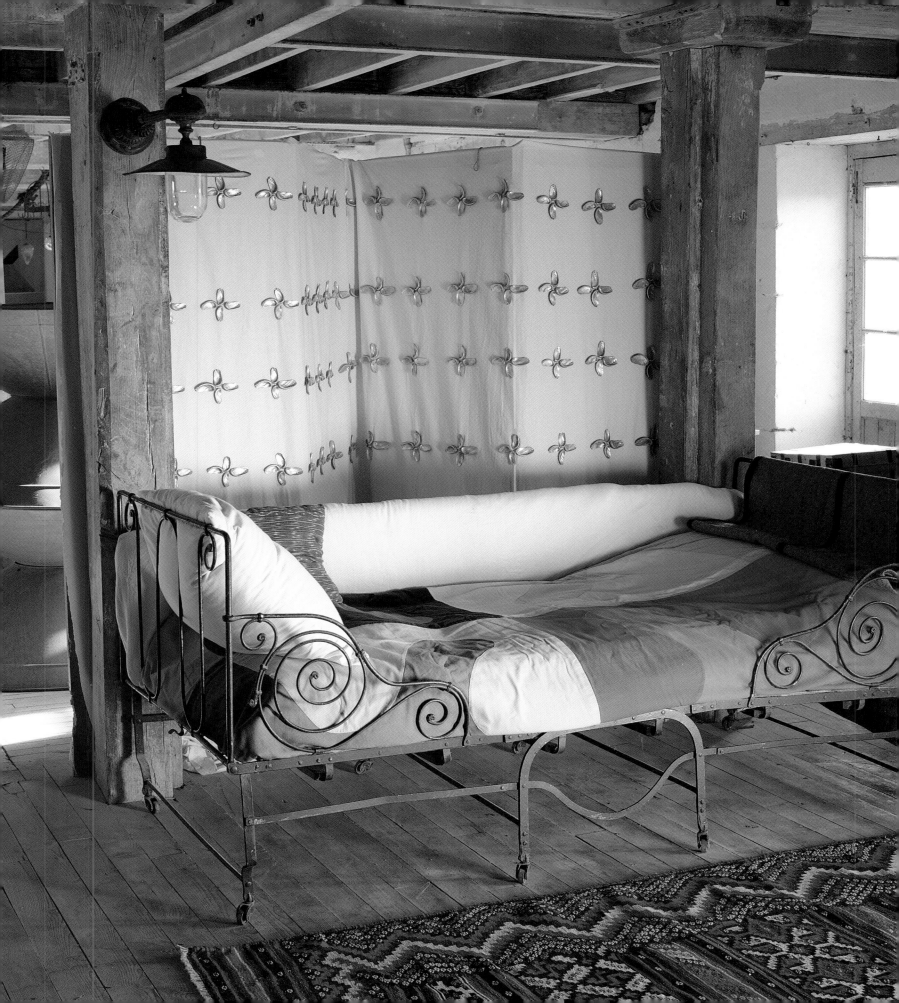

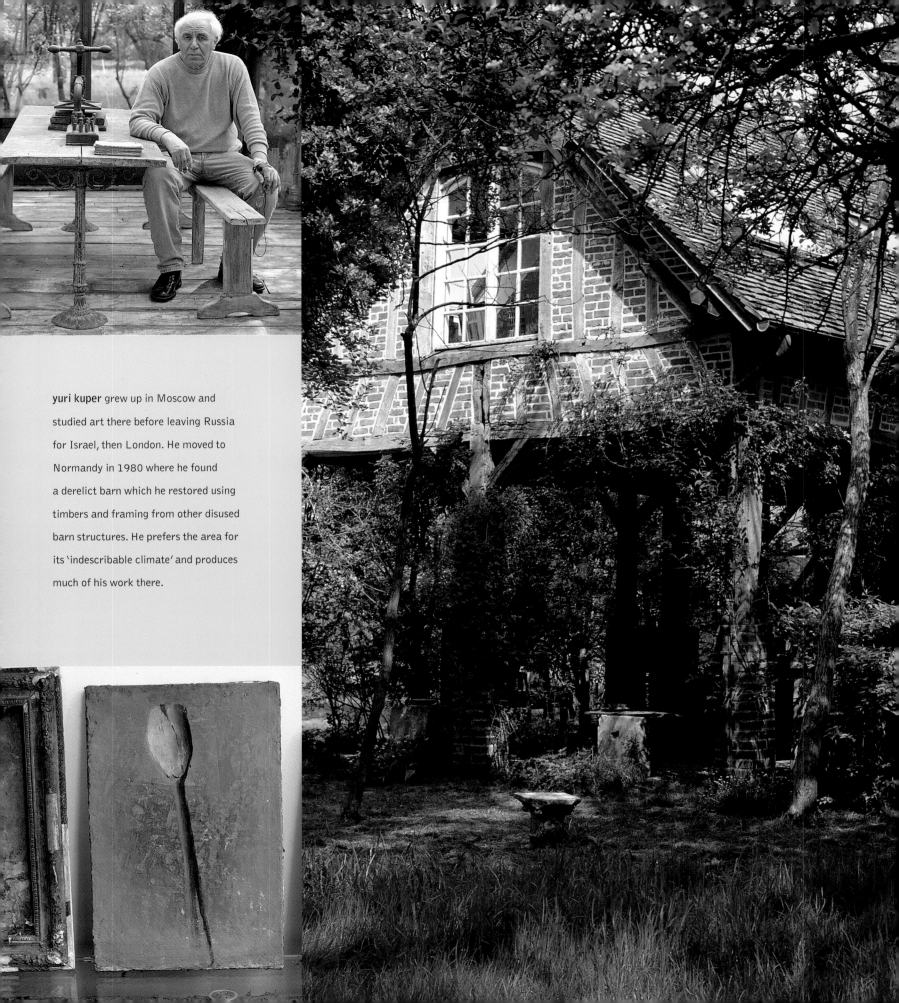

yuri kuper grew up in Moscow and studied art there before leaving Russia for Israel, then London. He moved to Normandy in 1980 where he found a derelict barn which he restored using timbers and framing from other disused barn structures. He prefers the area for its 'indescribable climate' and produces much of his work there.

russian artist Yuri Kuper settled in the Normandy countryside in 1980, establishing home and studio in an old barn that was less habitation than hovel. Kuper converted the dilapidated structure using reclaimed pieces of timber from another nearby barn. The building's overgrown brick-and-timber exterior belies a soaring, light-filled interior and an ideal artistic work space.

Kuper first came to prominence as a painter, and many of his paintings on canvas, photographic plates, metal and wood, grace the walls of his Normandy barn-house and sit in pale array along the floor of his studio. But his more recent passions are sculpture and assemblages of found objects and wood. Negative impressions of tulips, carved from weathered wood plaques, line a rough-hewn wooden table, and everywhere wood – on floors, beams, chairs, easels – carries an aged, silvery patina. It is a deliberately muted tone that Kuper achieves, as he reveals, using 'white or silver emulsion the way that zinc was used in the Renaissance' to temper the colour. It contributes to an atmosphere that speaks of a calm and creative haven.

It is not so much natural materials as natural decay that fascinates Kuper, for whom the weather-beaten appearance of objects represents layers of history and meaning. 'It is like looking at Rome or Venice,' he comments, contemplating the aged surface of a piece of wood, 'and seeing all of its different epochs.'

Kuper was born in Moscow and began his studies at the Moscow Academy of Art in 1957. He emigrated first to Israel, then to London and later to Paris in

yuri kuper

the 1970s and currently keeps a flat in the capital, while spending most of his time in the Normandy house. 'I like this region,' he says of his Normandy base, 'I hate north and south, I like the middle, indescribable climate, it rains, a little snow.'

He is a purveyor of textures, surfaces and reuse, employing found objects to create new visual and tactile meaning. Discarded treasures, such as old signs, farm implements, wooden crates, are given a new artistic role, even, in a somewhat postmodern approach, the tools of the artist – old paint tins, brushes, easels – appear in construction and collage, amalgamated to reveal a different perspective.

His softly abstracted paintings have been referred to as Japanese in style and 'autumnal' in mood. His treatment of wood and metal (and often wood that is made to look like metal, and vice versa) challenges perceptions of objects and materials, but in a gentle manner, as a conscientious reassembly and reassessment of parts gleaned from common things. It is, Kuper argues, 'the change of material and dimension' in the representation that makes it art. 'If you do not change material and leave things the same size, it means you do not understand; there must be some transformation.' His works, already altered by age and disuse, could be regarded as having at least undergone a second transformation when he applies his own vision. 'I use anything,' he confesses, 'rusty metal, old wood', as well as tools, kitchen utensils and old pieces of cardboard.

Kuper describes his work as multimedia and himself as someone who is in touch with the physical world, a description very much borne out in what he produces, which has appealed to galleries and collectors around the world. His theatre and costume designs for directors, such as his friends

Robert Altman, Marcel Maréchal and Mikhail Kov, betray a similar fascination with the faded, rusticated and worn. 'They always call me when they need some miserable surface or background,' he half jokes.

Yuri Kuper's farmhouse is a surprisingly bright setting for his exploration of basic form and material, where humble objects provoke a new look at everyday objects in isolation and in the context of distempered tones. Ideas and forms are reawakened by a touch of paint or careful juxtaposition. It is not just a space for living and working, but for discovering and rediscovering the beauty of things.

In his paintings, collages, furniture, assemblages, jewelry and stage design, a connection with the natural world is not always immediately evident, but it is nevertheless conveyed by the gesture of salvaged objects and 'honest' materials. It is nature in the everyday. His work is redolent with the mercurial quality of nature itself, fundamental and yet limitless in variation over time.

Light and more light fills Yuri Kuper's converted barn. The ground floor is an open working and living space where works in painting, sculpture and found objects share space with simple wood furnishings. White walls heighten the attention to the wood and provide a clean backdrop for works in progess.

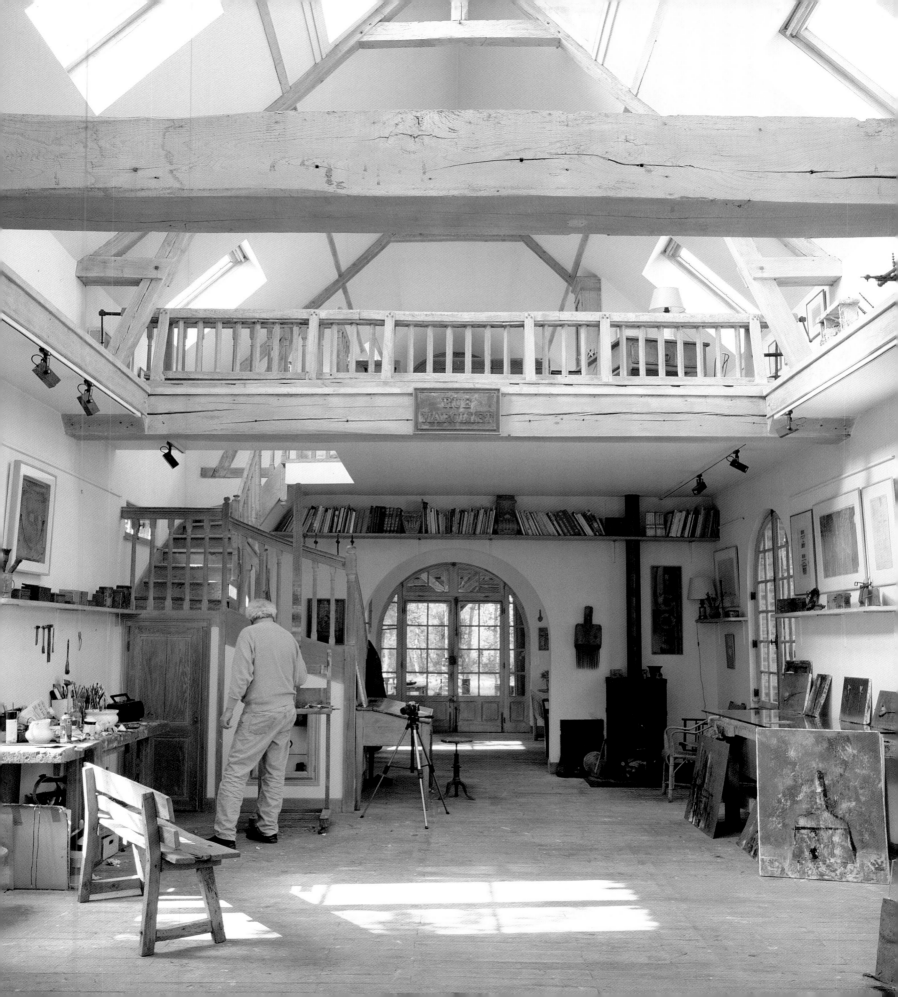

The silvery tones of the unpainted
wooden beams, floorboards and trusses
are achieved through Yuri Kuper's own
particular method, but modelled on the
Renaissance practice of using zinc to
lighten the colour of wood. In an upstairs
bedroom, the old beams of the A-frame
construction are visible.

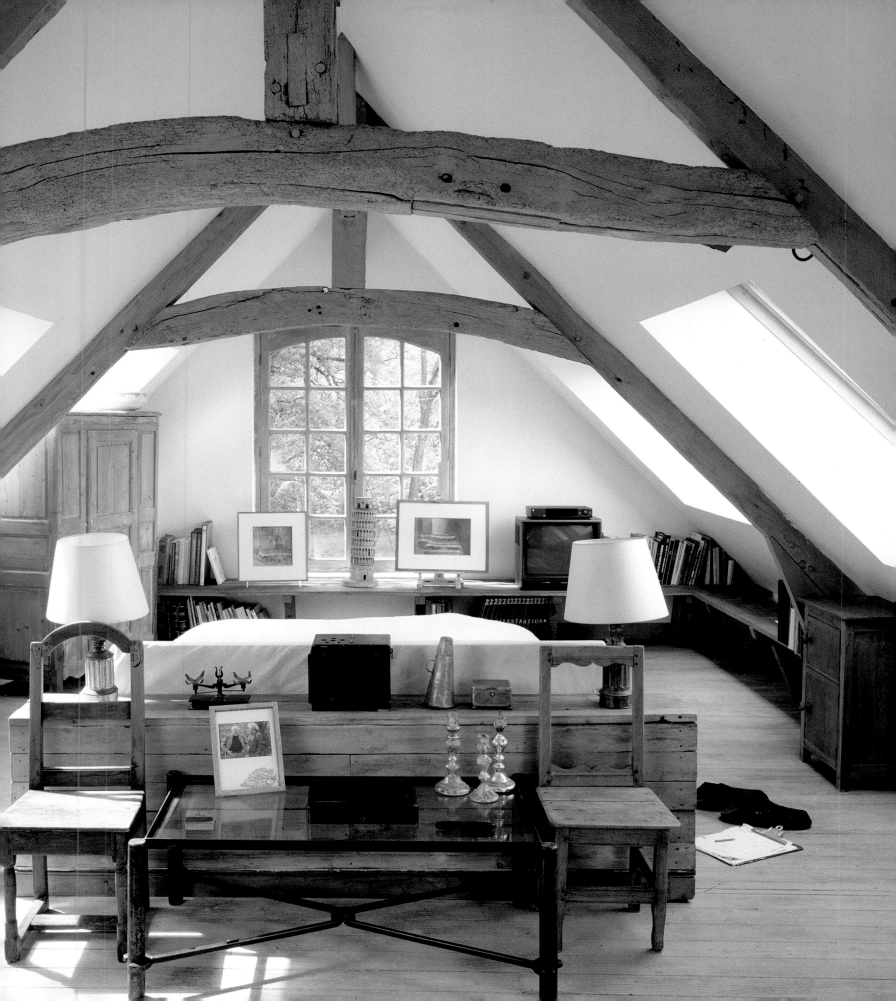

The kitchen area on the ground floor opens onto a covered patio, increasing the sense of the indoor rooms blending with the outdoors. Kuper's works are found not only in the studio, but throughout the house and around the patio and garden.

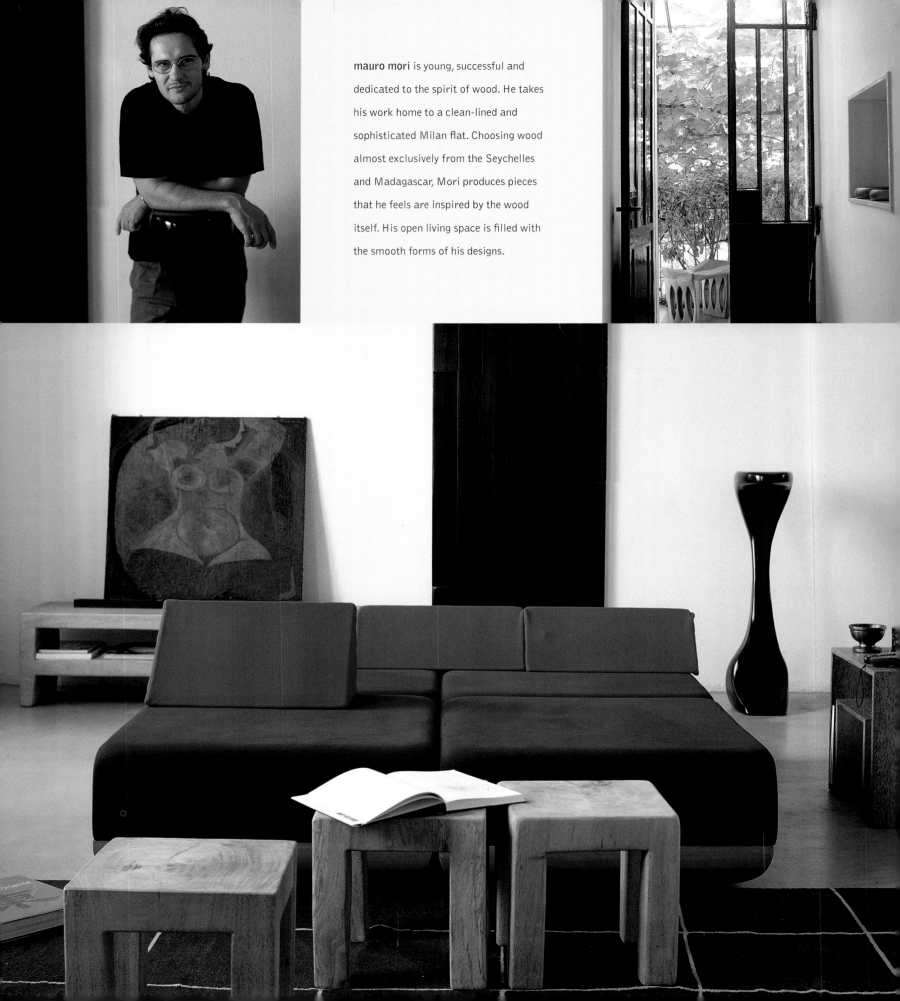

mauro mori is young, successful and dedicated to the spirit of wood. He takes his work home to a clean-lined and sophisticated Milan flat. Choosing wood almost exclusively from the Seychelles and Madagascar, Mori produces pieces that he feels are inspired by the wood itself. His open living space is filled with the smooth forms of his designs.

ᴘink albizzia, dark lagatie, purple ebony, African ebony, cat-tail reed, black Belgian marble, white carrara marble, oxidized aluminium: these are the materials that inspire Mauro Mori to create objects of utility and beauty. Committed to hand-craftsmanship and to natural materials, because he finds them more supple and sensual than artificial ones, Mori is determined to make every creation a singular expression of his vision.

It is wood that is Mori's particular passion, a material that he first began truly to appreciate when he was commissioned to create a series of important pieces for a house in the Seychelles. It was then he discovered the pink albizzia that he finds both stimulating and beguiling. In the Seychelles and Madagascar the variety of woods available beckoned to his own emerging talent: a talent for seeing the potential of the distinctive properties in each material, as well as for working it to that end.

He still chooses woods from these areas, as well as from Africa and South America, avoiding anything that is protected or endangered. The material presents a lesson in arboreal science. The pink albizzia, which belongs to the acacia family, is a parasitic plant rampant in the Seychelles and is thought to deter the growth of other trees and plants. Those that are cut down are carefully selected as part of a deliberate programme of forest preservation and management. The albizzia that Mori selects is treated locally for termites and then sent to Italy to be sculpted; only wooden 'spines' are chosen for assembly, rather than any screws or nails. His benches, left in their rosy hue or given a sleek blackened ebony finish, retain some of the feel of the albizzia in its natural, sinuous state.

Mori prizes the albizzia for its medium density – thus workable solidity – leading him to form it into a chaise longue with one leg, 'as if to defy the law of gravity'. He favours lagatie for hardwood, crafting a thick angular dining table, a staircase and also picture frames.

Working the characteristics of the wood, Mori aims to 'make hardwood sharp, like the edge of a spade' and 'make softwood become as malleable as wax'. With metals he works towards a range of patinas, always seeking to uncover the hidden qualities that are not otherwise immediately apprehended.

This approach might not seem so remarkable espoused by a seasoned wood crafter. But this is the philosophy of a young designer who has made his name in fashionable design circles and regularly creates pieces for the international furniture makers, Cappellini. His work has also been exhibited to great acclaim at galleries and fairs around Europe.

Such successes, however, have not prompted Mori to expand into less pure and perhaps more forgiving materials. If anything, the achievement makes him more determined to imbue his materials with fresh energy that, in turn, reveals their marvellously complex essence. His aim is not to 'exhibit stylistic virtuosity, but to highlight the qualities of natural materials, to unveil the magic in them'.

Beginning usually with a solid block, Mori struggles for a balance, as he explains, 'experimenting with yin and yang, the sphere and the cube, masculine and feminine.' All the labour is accomplished by hand, with finishing traces and colour changes considered 'part of the soul of the material' and therefore not defects, but evidence of the life of the material.

Mori concentrates not only on making furniture that is useful and beautiful, but which has more than one purpose: tables serving as benches or, in his own apartment, a cooking unit with a fold-down lid that provides smooth, golden counter space that anyone else might deem too precious for everyday use.

Many of Mori's creations are 'one-offs' that will never be exactly reproduced. Left: the vivid red sofa highlights the rich, golden colour of the wood tables and shelves. The wood floor is also enhanced by deep red in the geometric carpet. The plinth is carved from black Belgian marble.

mauro mori

Left: from the open stairs, the low profile of the living-room furniture maintains a serene atmosphere. The bowed sculpture is actually a bench when laid horizontally and is part of Mori's private collection. Below: the table and staircase are made from lagatie wood from the Seychelles, one of the artist's favourite materials. The benches are both made of pink albizzia wood, though the black one has an ebony finish.

Mori's Milan apartment is filled with items that call out to be touched, but exhibit such supreme, almost forbidding, refinement. But this is not how Mori views his craft. It is meant to be appreciated at close quarters, rather than from a safe distance.

According to critic Cristina Morozzi, Mori's accomplishment is to make us 'rediscover the sensorial experience that, by touching our skin, goes straight to our hearts and minds.' That much is evident in the numerous pieces that he puts to everyday use. His home is a proving ground that style and comfort, natural beauty and refinement are all achievable within one creative environment. Indeed, to touch one of Mauro Mori's pieces and not to feel something beyond the immediate physical sensation seems almost unnatural.

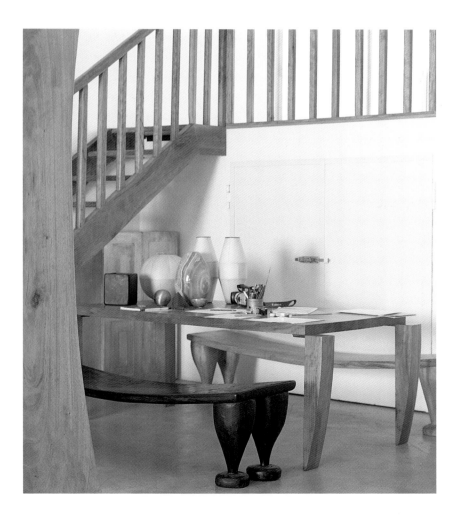

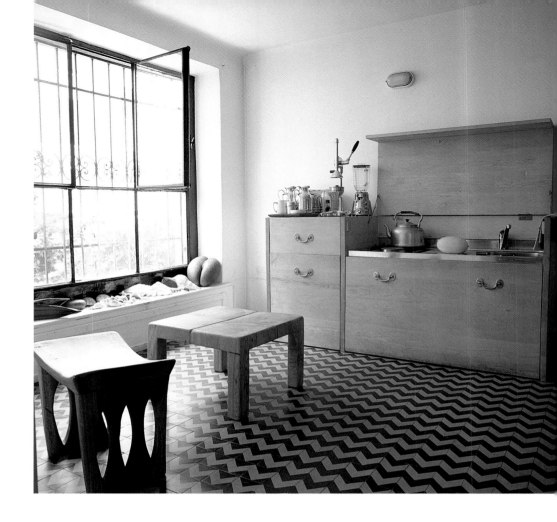

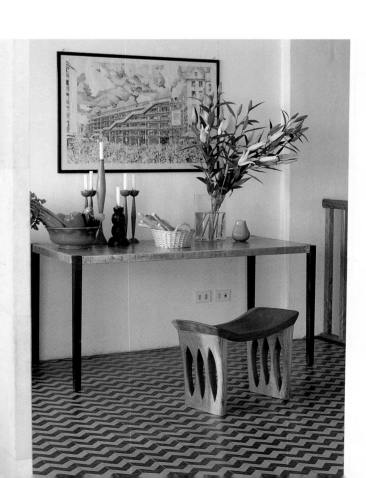

Above left: circular picture frames bear the hallmarks of Mori's pure forms. The stool with the concave seat (above and left) is from a breadfruit tree. The kitchen unit is called a 'kitchen trunk' and Mori designed it for himself using Canadian maple wood. Right: the sliding doors of the wardrobe are framed in mahogany. The bed is constructed from unmilled takamaka wood posts.

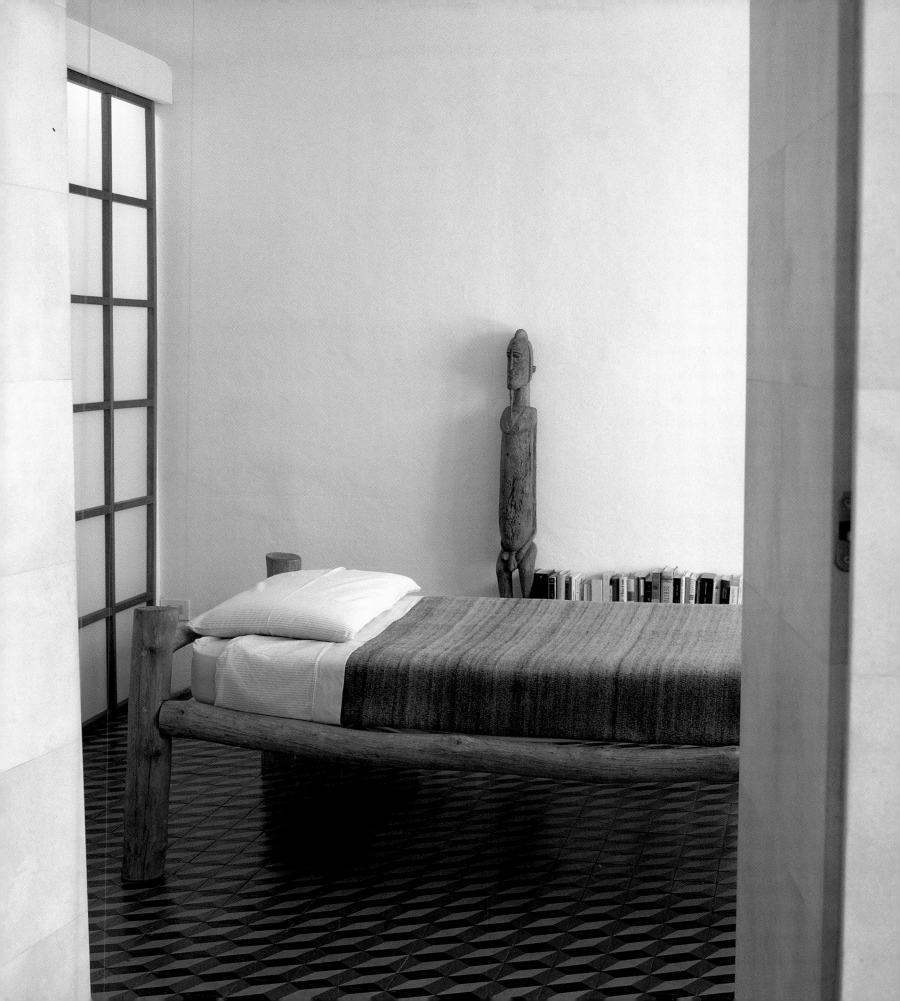

rosa nguyen grew up in London with her French mother and Vietnamese father. She still lives in the city in a Victorian flat that she shares with her partner and young son. An artist working mainly in ceramics, Nguyen finds her life and work permeated by the 'connectedness' of nature.

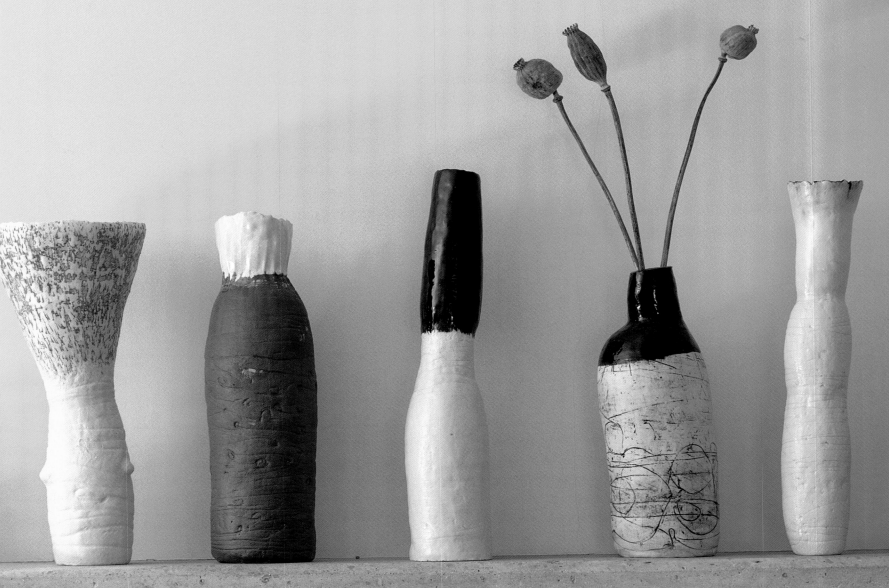

'Perhaps all of my work is to do with food, and nurturing,' Rosa Nguyen laughs, referring to the impressions of knots imprinted on some of her handmade platters to denote hunger. The artist's fecund and diverse output is matched only by the models in nature she finds so inspiring.

Pods, seeds, fruits, vegetables, plants, animal and human bodies, bloodlines, all are reflected in the bounty that is Rosa Nguyen's oeuvre and all are, she feels, inextricably and spiritually linked. A practitioner of Shiatsu therapy, which is rooted in Chinese medecine, she finds the connection between nature and art not only an attractive concept, but a vital part of her work.

Big Idea, an installation at the London multimedia design studio, encompasses a complete, regenerative cycle of this thinking. Starting with piles of seeds, which she used to make graphic prints, she moved on to hand-sized vegetable and organic shapes, such as human organs, in a variety of clays and glazes. The vegetable shapes, she explains, were inspired by markets in Asia.

'I have always loved the idea that human beings have contact with nature on different levels, feed your body then feed your spirit.' Nguyen has also travelled in Vietnam, her father's native country, where she related strongly with 'the culture where you go to market and buy things and then go to the temple to have it blessed and then bring it home and share it.' Creating her vegetable shapes has provided her with a way to re-create that kind of contact. 'In England you can't pick up vegetables without someone telling you off,' she jokes.

Following her line of thought from vegetable forms to tactile clay objects is easy when you hold one of her highly sensual shapes in your hand and shake it to hear the soft rain of seeds inside. They are the same seeds she used to make her prints, recycled into another form. The form reaches an apotheosis in the large vases that rise from a plain base to textured neck and blossoming shapes at the top.

These too have strong vegetal and bodily affiliations. Tall and graceful, yet naturally dynamic, the vases combine organic shape and inspiration with her recent foray into computer technology. Though she considers herself a non-technical artist and one who is thoroughly enmeshed in the natural cycle of things, she nevertheless recognizes that making pots, even employing sticks and clay, is a form of technology.

Now, despite her own trepidation at the idea of using computers, and with the help of her graphic designer hosts, she has, in her words, 'made a crossover from hand process to digital technology. Technology itself doesn't interest me,' she states, 'but I found that there is a place for technology for people who work with clay and things.'

Working in 'a direct and simple way', Rosa Nguyen found that she could 'feed' her organic forms to a computer, a scanner, a video and the result would be something still well within her

Nguyen's sensual organic forms adorn her personal living space where she also sometimes works. She keeps a shrine to the god Ganesha in the fireplace with small plates which she calls 'poppadom' plates, because 'they're made as quickly as you make a poppadom, and they're very fine porcelain.'

rosa nguyen

realm, but developed in a new dimension. Hence the seeds were transformed into stunning large graphic prints, a basic finger or bladder shape was made into enamel transfers, which she then applied to her large vases, and then, in her trademark spirit of continuity, the same shapes were changed into magnified waves of colour for a video installation partly based on the Chinese theory of bodily fluids and energy paths.

In this heady mix Rosa Nguyen remains a serene centre, constantly finding new links and revelling in the interrelations. Her aims are transformation and dynamism, since one of the art forms she most admires are sculptures in shrines, which are constantly being laden with offerings of fruits and incense. The sculpture is static but, according to Nguyen, 'people would continuously put things on them, so they were living'. If one had to encapsulate Nguyen's work, it would be this nexus of the art object and the living world.

Such a union is apparent in the work she keeps and makes in her home in South London. The Victorian flat that Nguyen shares with her partner, artist David Blamey, and their young son, Kai, contains a fair sampling of Nguyen's work and philosophy. The fireplace holds a shrine, complete with a statue of Ganesha, and the knot-printed plates; the knot referring not only to hunger but to Buddhist iconography.

The shrine, along with smaller versions of the duo-toned and textured vases, handmade necklaces and graphite drawings, contribute to a nurturing, creative, as well as spiritual atmosphere. Of course, practicalities must intervene. Though she owns a studio, Nugyen often does not have time to travel there to work and so makes pieces at home, leaving them to dry on the radiators. 'My home isn't tidy,' she insists, but it is a place where many connections are made, many hungers satisfied.'

Right: on a bathroom mirror hang necklaces that Nguyen made for a fashion show from clay pieces strung together. Opposite: Nguyen executed the drawing from a leaf that her boyfriend brought from Cuba. The sticks are made of porcelain and tied with a knot, one of Nguyen's favourite symbols. 'I thought of the *I Ching* and throwing sticks and trying to find a connection spiritually.' Following pages: plants, woven furniture and unpainted wood demonstrate a natural approach, while a bright yellow wall highlights the artist's work.

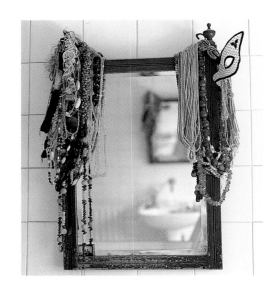

113 ROSA NGUYEN

nils-udo is a 'land artist' whose primary aim is 'to work in and with nature'. His compositions of plants, flowers, trees and water are created in the landscape, using the natural beauty of the surroundings to inform and enhance his work. His large open-plan house in Upper Bavaria is only four kilometres from the foot of the Alps which provide constant inspiration.

The lush landscape allows plenty of room for Nils-Udo's outdoor installations, while the interior is home to his painting and photographic work, all on natural themes. Following pages: 'The house is made of wood, inside and out,' says Nils-Udo proudly. Large photographic prints of his installation work, some mounted on aluminium, grace the walls, while furnishings are kept plain. Outdoor terraces and large, unadorned windows encourage interaction with the outdoors.

If one needed proof that limiting your art to nature and natural materials was more expansive than restrictive, then Nils-Udo has it. His work ranges from paintings to over thirty years of installation pieces that represent, as he says, his strong desire to 'work in and with nature'. A twelve-metre-wide 'nest' of swirling bamboo, even a pile of snow moulded to the side of a tree, all present authentic natural phenomena gently coaxed by the artist into something that we can perceive as art.

Though it may seem a whimsical way to create, for Nils-Udo his method represents a deliberate attempt to encourage appreciation for, and participation in the landscape. His outdoor installations are natural in many senses. 'I use all natural materials and I find them wherever I am. There is no plastic, no iron, nothing else, only what I find outdoors.' He will take leaves, twigs, shrubbery, even mature trees, and create something on site that is stirring both in its simplicity and in its poignancy. He makes bold statements of deep colour with a necklace of red berries encircling a group of spring-green conifers or with a rack of delicate twigs hung with clumps of vivid fuschia. His arrangements are made beneath the forest canopy, in a leafy enclosure or in a blooming meadow and appear as the work of some enchanted woodland being.

Between the two, art and nature, it is difficult to discover which he loves more, though it is quite clear that his ardour is uninhibited. 'What I am doing is to introduce my artwork into nature in order that it becomes a part of nature and lives and dies with the seasons along the years. With my artwork, I also bring myself closer to nature.'

The nature he engages with is not only the land of his native northern Bavaria but any land he visits. Having completed works in twenty-six countries, he says he does not work with preconceived ideas. 'I go to a place and then I respond to what is there.' Since he feels so at home outdoors, it is hard to

nils-udo

imagine Nils-Udo's ideal living space indoors. After ten years spent in the urban wilderness of Paris, he returned to Bavaria and bought his house in the upper region, four kilometres from the Alps. He describes it as 'out of time', not very old, but made of stone and wood. But being Nils-Udo he was drawn more to the natural setting than to the house's domestic appeal. 'I chose this because of the beautiful landscape…It has a wonderful view of the land, the mountains, the meadows.'

The interior is as uncluttered as possible, but also a lively paean to the artist's many muses, as Nils-Udo's photographic prints of plants, trees and flowers in near abstraction dominate the walls and refocus attention on the colours and shapes of nature. Large windows constantly draw the eye to the spectacular mountainous view and to the wood-decked terraces which function as extended rooms of the house. Having begun as a painter, he has returned to it in the last ten years and hopes to dedicate more time to it, once the demands of his schedule allow it. Whenever that might be, the house in Bavaria will be waiting beneath the mountains with more quiet inspiration.

119 NILS-UDO

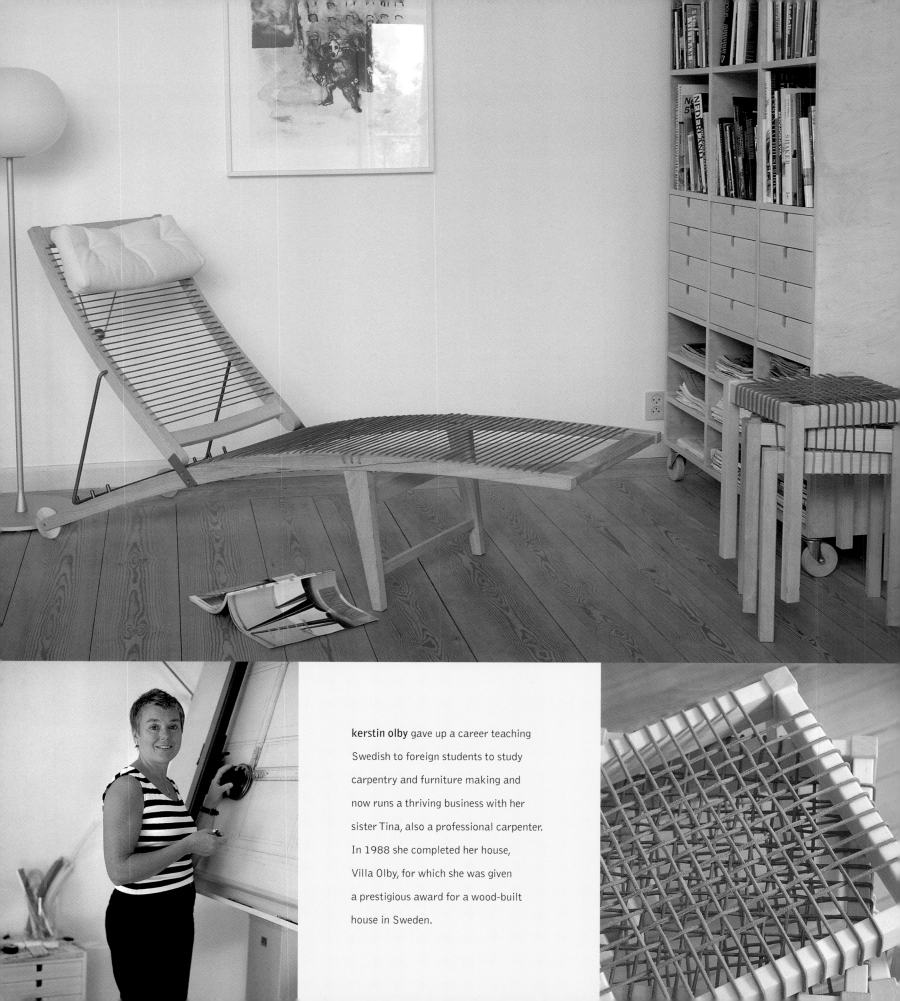

kerstin olby gave up a career teaching Swedish to foreign students to study carpentry and furniture making and now runs a thriving business with her sister Tina, also a professional carpenter. In 1988 she completed her house, Villa Olby, for which she was given a prestigious award for a wood-built house in Sweden.

Making a career change can involve a certain amount of fear and anxiety, but imagine deciding at the age of thirty-two to exchange life as a language teacher for that of a skilled craftsperson. Kerstin Olby knows only too well the difficulty of throwing over an utterly sensible profession for an undying passion, and yet in her calm, ordered way, she stands as a symbol of confident perseverance. Having received a university degree, she spent years teaching Swedish in her home country and abroad, before giving into a longstanding desire to work with wood.

On Kerstin's suggestion, her sister Tina had trained in carpentry and became an accomplished furniture maker. At last, it was time for Kerstin to follow her own advice and pursue the woodworker's art herself. Though two women from one family entering the same field might suggest something of a trend, Kerstin Olby says that carpentry is 'definitely not common for women. Very few women train in carpentry in Sweden and those who do usually continue into something else, like selling or designing furniture.'

But after training for a year with her sister and then following a carpentry course, Kerstin Olby, proceeded to work the wood herself. Though she is interested in design, which is now her main focus, she stresses that the experience of actually making the pieces by hand was invaluable. 'I had to know how to put it together and it's been very helpful having made pieces myself for many years.'

Her pieces then have a lot in common with those she continues to create (which have won numerous awards) for the company she and her sister set up, Olby Design. This is a result of Olby's admittedly Swedish bias. 'I get inspiration from all over the world,' she explains, and from historical sources.

As well as studying Scandinavian houses from the sixteenth and seventeenth centuries, she 'looked at a lot of English carpentry, especially the work of the Barnsley brothers', an architect and carpenter duo who were active in the late nineteenth century. 'But I have very Swedish eyes,' she adds, 'so my work comes out very specific, very Swedish or Scandinavian.'

In terms of the pieces she creates this focus translates into a light, spare quality and clean lines, but with subtle, craftsman-like details, a graduated edge, a slightly canted cornice or a simple geometric motif. The same ardour that convinced her to give up teaching for carpentry inspires her dedication to preserve the material in appearance and texture and to display the beauty of the wood. 'We are lucky in Sweden because we have a lot of different wood and I love to work with it. I also work with other woods like American maple. It's hard and blonde and you can get a nice surface. I treat it with soap flakes to make it even blonder and very dry, rather than the wet look you get with oil. American cherry is good too, very sophisticated.'

In addition to the joy of working with wood, she finds satisfaction in other natural materials, such as linen, metal and stone, which she uses in conjunction with wood. Here too, the penchant for homegrown reigns: the limestone she favours comes from two mountains very near her house. It is a light stone, 'not so stoney,' she says, which is traditionally used for floors or staircases. She had the idea to cut it for tabletops and declares it extremely practical, since it cleans easily in addition to being lightweight.

Though her elegant pieces may appear delicate, she thinks hard about the day-to-day demands of furniture and so looks for 'material that will grow old beautifully and that you can live with and use without fear of destroying it.'

'Most of the furniture we now make,' explains Kerstin Olby, 'was originally made to fit the house.' Dedicated to the use of natural materials, Olby says she designs with 'Swedish eyes', which means that whatever she does is finely finished with clean lines, and the natural beauty of the wood is maintained.

kerstin olby

Opposite: the dining chairs, Olby comments, 'revive the Scandinavian plaiting tradition', with the seat and backrest covered with girth linen. The effect can be altered by creating close or loose plaiting of the cotton bands, letting through more or less light. Dark-coloured carpets create an interesting contrast with light wood and the white of the furniture, floors and walls. One table (below) has a sandblasted granite inlay between solid wood, while others (below centre and right) feature the local limestone. It is a material often used for stairs and floors, but Olby likes it for tables, claiming that it 'takes everything, even red wine you can rub away'.

This is a philosophy she employed when building her own house, which was completed in 1988 and received a prestigious award for wood design. Olby's company, which manufactured the floors, window and door frames and doors for the house, shared the prize with the architect, Thorsten Askergren. 'It was the first time the prize was given to a woman,' Olby comments, and the competition from much bigger names was intimidating, 'so it was very nice for us.'

Her tendency towards understatement can be felt in a house that is modern in its light and spaciousness, but rooted in traditional forms. The furniture and wood details of Villa Olby appear as of one piece, the wood construction of the tables, cabinets, chairs echoing the painted pine of the house. Though created as unique designs, they (including the doors) have since become stock-in-trade for Olby Design. Sitting in a gloriously airy living room bathed in northern light that trips softly on the blonde wood, Kerstin Olby must muse on many things, including the real benefits of change.

The interior woodwork of the house is all pine painted white to keep the space bright. The exterior cladding is fir. The design is modern, but influenced by traditional local architecture. Below right: a bedroom and hallway demonstrate Olby's penchant for practical furnishings. Opposite: the living room's north-facing, semi-circular window is tucked high into the roofline to allow maximum light.

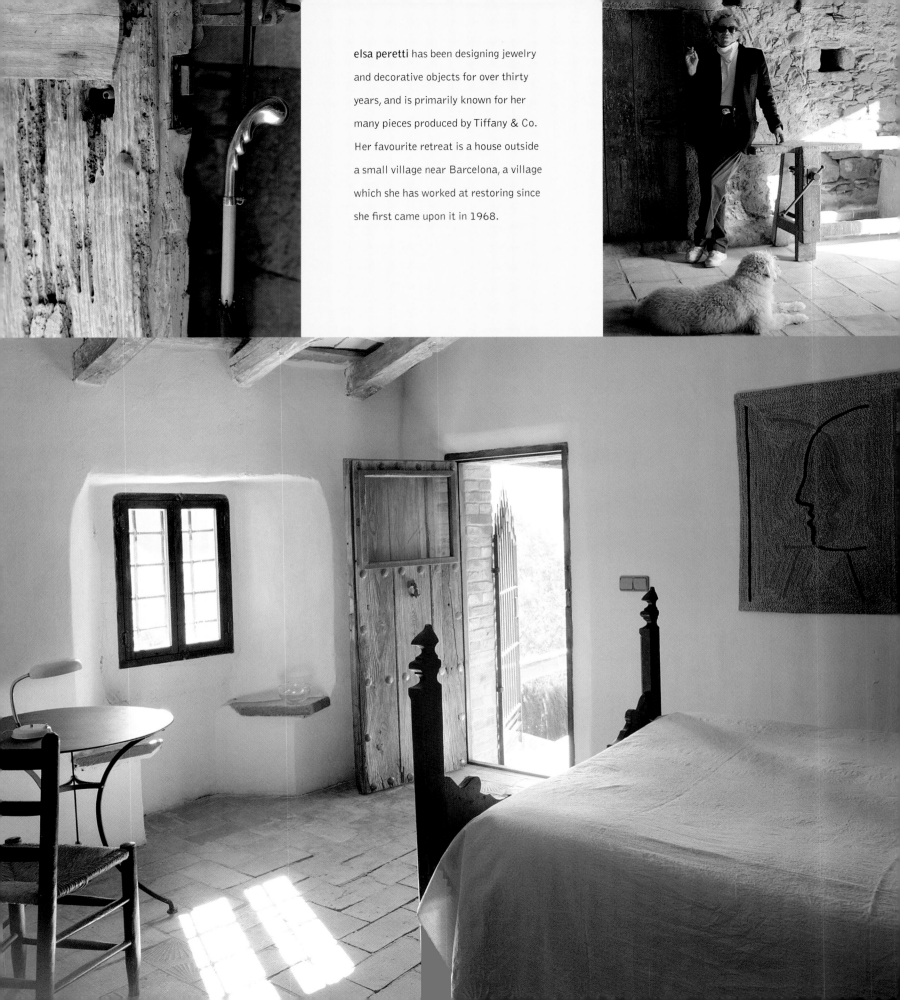

elsa peretti has been designing jewelry and decorative objects for over thirty years, and is primarily known for her many pieces produced by Tiffany & Co. Her favourite retreat is a house outside a small village near Barcelona, a village which she has worked at restoring since she first came upon it in 1968.

Where would we be without Elsa Peretti's heart? or her teardrops or, for that matter, her snakes, beans, apples, bracelets and candlesticks? Her designs spawned a whole generation of what we now call 'organic' form. And the feeling that continues to inspire her is a visceral attraction towards natural lines, texture and material, coupled with a keen sense of zeitgeist. Describing her first design, a bottle to hold a single gardenia, she invokes the excitement of the era – 'Portofino in the sixties was magic,' she declares. But she was as concerned with the nurturing of the flower as she was with the 'beautiful women in Pucci silk, each with a gardenia in her hand', who had partly inspired her.

Elsa Peretti embodies a sense of style that belies her devotion to the natural world and her own sensitivity to her tactile surroundings. She began working with silver in Spain, the place she ran to after leaving home and where, as a young model, she became involved in the heady atmosphere of artists and fashion icons. She held a degree in design and had worked for an architect in Milan. In 1968 she flew to New York and began to use her modelling career to finance her budding designs. Looking to craftsmen she knew in Spain to realize her designs enabled her to exercise her gift of touch.

'The silver was sold in sheets,' she explains, so they would make the form first in wood and then mould the silver around it. 'It's hammered down,' she continues, 'and you can feel the shape already. I think it is important to feel like this, the weight as it is formed.' This is how her shapes, which fit so comfortably in the palm, come into being. It is something she strives for, the smoothness and comfort that comes with wear, and her aim is to 'try to make the smoothness even before it is even worn'.

In the 1974 she began her association with Tiffany & Co., who continue to produce the wide-ranging fruits of her talent. In her bracelets, belt buckles, bags, necklaces, earrings, as well as in decorative objects for the home, sharp edges, hooks and hard lines are anathema. Soft curves and delicate depressions prevail. She has been constantly productive, favouring a certain aesthetic, but never eschewing change. 'If you get hooked on one kind of shape, it is good to keep working around it to try to find the essence in the object.'

Since the late 1960s, it has not only been into her designs that Elsa Peretti has poured her love of material and form. In Spain she became enamoured with a small, centuries-old Catalan village and decided to dedicate herself to its restoration and preservation. 'There was everything to do, I had to transform the place, prevent it from dying.'

In Sant Martí Vell, Peretti bought several small houses which were in a poor state of repair. Some were lived in at the time, but rather than turn out the residents, she worked around them. She has recently restored a house for herself, about one

Elsa Peretti's restored house outside the village of Sant Martí Vell is a haven of simple living. Left and below right: a bedroom with restored plaster and ceiling beams features a woven hanging made in Nicaragua by Robert Llimos, one of many works of art by friends which she displays in the house. A bed from a 'thrift shop' and a café table complete the typically eclectic mix. Top left: the silver handle of the umbrella is an Elsa Peretti design.

elsa peretti

As her 'new' house has no real kitchen, she still uses the facilities in one of the other village houses. Traditional tiles, beams and floor and suitably rustic furniture are given a splash of style with Elsa Peretti's silver bowl and tableware and some modern light fixtures.

kilometre outside the village, which continues to be inhabited by an elderly man, the last of the original residents who, Peretti says, took a long time to convince that she was not going to throw him out.

Elsa Peretti's improvements in Sant Martí Vell have gone beyond restoring houses. She has set up a foundation which she hopes will attract artists and intellectuals to the area. This will be helped by the small museum that she has also established, which exhibits a collection of her work and objects that have inspired her, as well as sculpture and paintings by friends.

The refurbishment of Elsa Peretti's home has meant repairing stone walls and tiled floors, roof tiles and beams, doors, stairs and windows. But it has also

meant that collections of her own work, and that of her many creative friends, are there in the retreat so important to her. She has included electricity, but no heating, apart from fireplaces. She wanted to keep this one home pure.

'My idea was to live simply. I want only the things necessary for me to really think about my life and to get some peace.'

It is hard to imagine someone so associated with timely ideas and the creation of beautiful objects living in rustic isolation, but Peretti insists that a degree of seclusion is vital if she wants 'to keep the soul of the house which gives strength to me'. As in Portofino in the 1960s, Peretti remains in keeping with the times, but not necessarily tied to them.

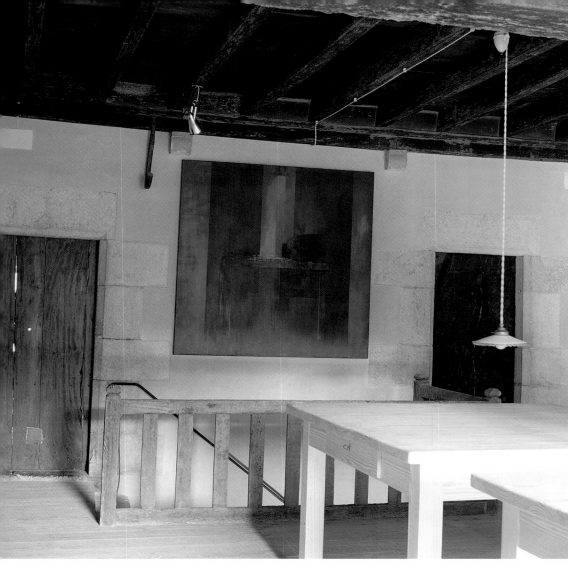

These pages : the restoration has produced a neutral backdrop of warm wood and cool, white plaster for an array of Peretti's signature organic shapes in silver and glass. Left: in the stairway is a painting by another of Peretti's friends, M. Clausells. Below centre: a sheep painting by Robert Llimos overlooks a country picnic spread with Peretti touches in silver and glass. Below right: petit point pillows by Peretti's friend, Ricky. Opposite: the stone wall and crude wooden door of the entrance hall have been lovingly preserved. Opposite below: the old recessed sink provides the only kitchen accessory in the house to date.

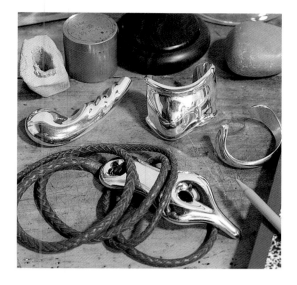

'A house should be comfortable,' stresses Elsa Peretti, 'like a good friend.' Following pages: Peretti is 'trying out' the long, narrow room, (left) as a possible place to work. As elsewhere, Peretti mixes her own objects freely with antique and modern pieces. Right: a sitting room features an African bed, made from a single piece of wood, used as a low table. She first left it outside to weather. The large Polaroids of fighting roosters are by Hiro. In the corner, work is consigned to a small table.

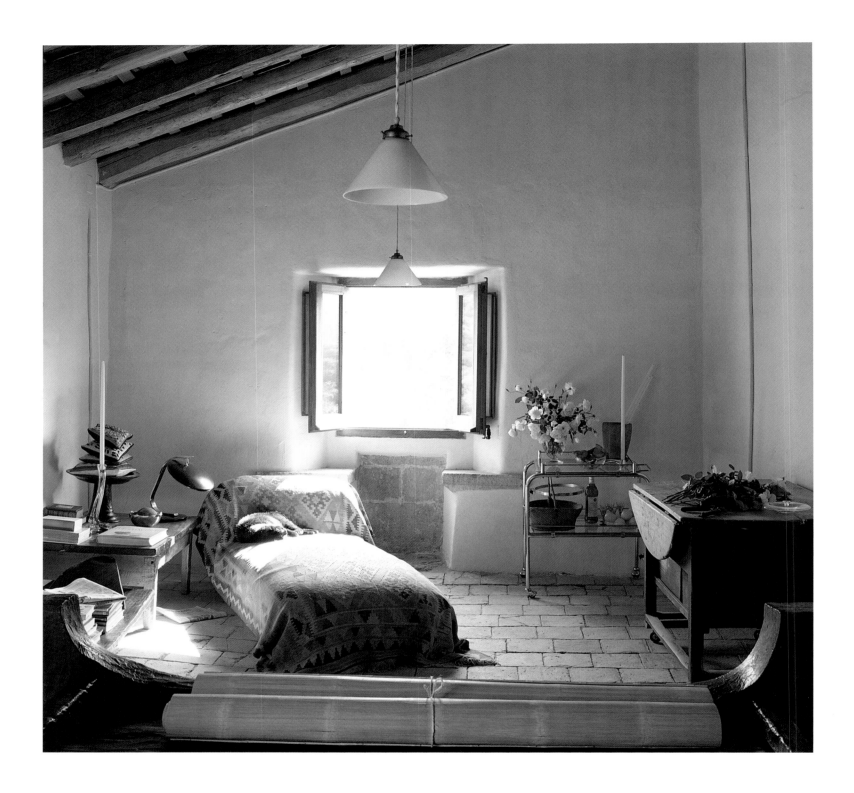

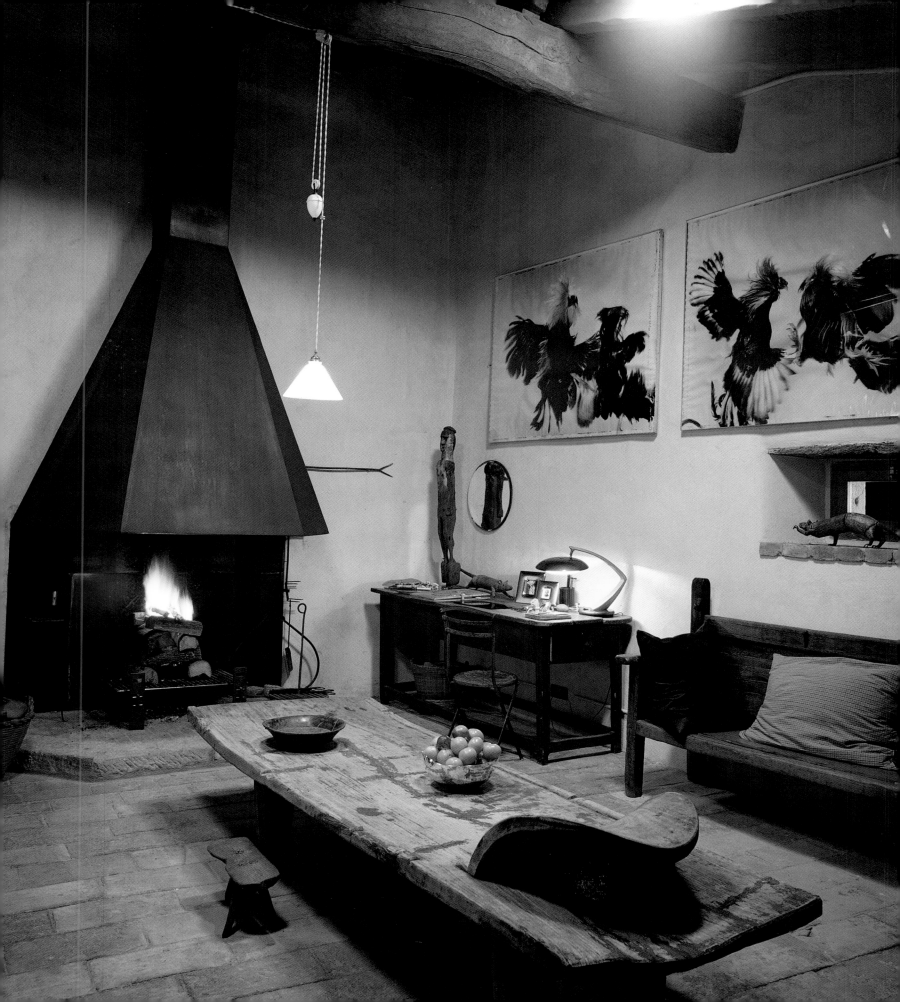

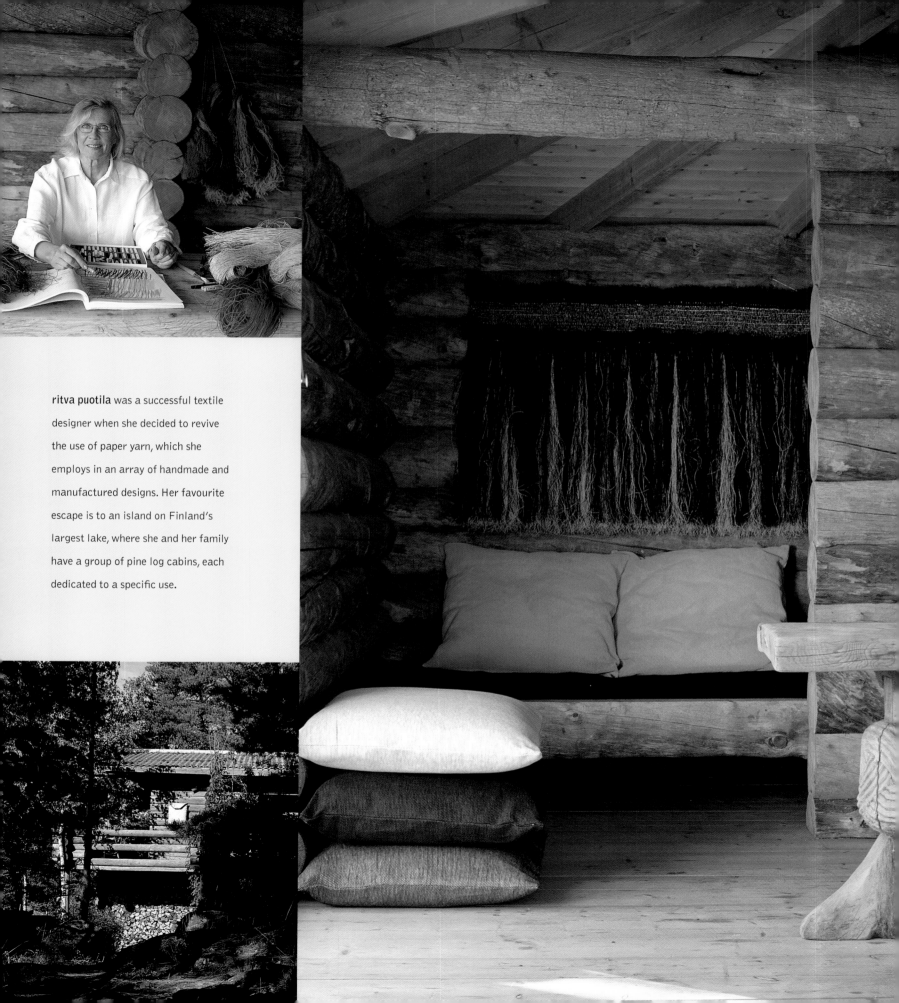

ritva puotila was a successful textile designer when she decided to revive the use of paper yarn, which she employs in an array of handmade and manufactured designs. Her favourite escape is to an island on Finland's largest lake, where she and her family have a group of pine log cabins, each dedicated to a specific use.

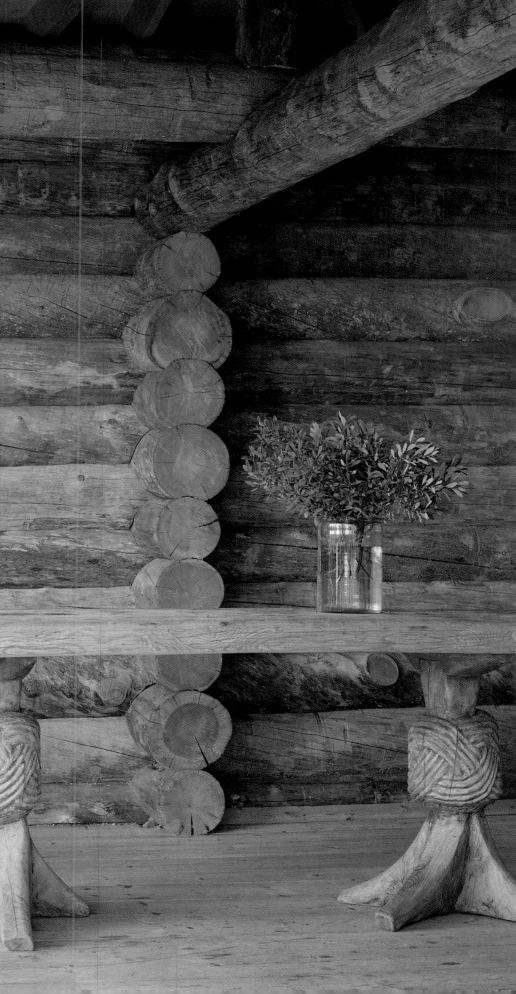

The use of natural materials is often associated with idealized notions of reviving ancient crafts or traditional methods. When artist and textile designer Ritva Puotila decided she wanted to create art objects and household items from paper yarn, she was indeed harking back to a Finnish industry of the past. But it was not a period of history that many Finns were keen to revisit. During the Second World War, when shortages of goods were a way of life and weaving materials such as wool and cotton were scarce, paper became an all-round substitute. When normality returned, it was largely dismissed as an inferior second, and a reminder of a period of want and suffering.

This was a prejudice that Ritva Puotila was determined to overcome when she decided to devote herself to a material that was to her both inspiring and representative of a truly Finnish heritage. But it would not be easy. After achieving early success as a painter she intended to continue painting at a school in Helsinki, but her mother encouraged her to find 'something practical', so she studied industrial design. In that too she demonstrated considerable talent, and not long after graduating from the Institute of Industrial Art (now the University of Art and Design, Helsinki) she won a gold medal at the XII Milan Triennale for her art.

Offered the chance to 'make something special' for an American company she was working for in 1963, she produced a collection of paper objects, 'but it wasn't a big success', she recalls. For more than

ritva puotila

twenty years, while travelling the world and creating award-winning industrial and one-off textile designs, she nurtured the idea of creating with paper, which deepened her desire to produce something that really spoke of Finland. 'I was looking around and seeing that most countries had something that was unique to their country …I wanted to make something of my own.' So she took up the paper idea again, thinking 'that this material was from MY nature; paper to me was from my country.' The conviction grew even stronger, and Puotila's youngest son Mikko took up his mother's artistic cause and offered to help her set up her own company and purchase a mill. Puotila threw herself into the project, designing carpets, drapery, upholstery for commercial production – as well as unique, handmade pieces.

The enthusiasm with which Puotila describes her beloved material makes it is hard to believe that it remained a relative outcast for so long. Created from a special wood mixture consisting mostly of Finnish or Scandinavian fir, the paper is spun into yarn in their specialized mill and woven into textiles. 'It is,'

Puotila says, 'durable, strong and hygienic. If you are allergic, you will like it because it has no dust.' This is because it does not conduct electricity, so particles are not drawn to it. In addition to its hypoallergenic qualities, Puotila continues, 'it is organic, and it has no smell.' What it does have, she enthuses, is an ability to 'take colour very brightly, in a delicious way. I have about three hundred colours I use for my unique pieces.'

Her own home is situated near Helsinki, but her much-prized retreat is on an island in Finland's lake Saimaa, near the Russian border. There, she and her family have a collection of small cabins dedicated to different uses. Beginning in 1965, Ritva and her husband constructed a main house, a 'kitchen house', a sauna house, a house for the children and a guest house. 'We love to be there together and we can also have our privacy,' she says. But there is a more elemental draw for her: 'in Scandinavia we have a lot of forests and lakes and this is where the paper material comes from. This has always been the main inspiration for me: the beauty of the material and the country it comes from.'

Previous pages: in the 'kitchen house', the colourful hanging is one of Ritva Puotila's handmade pieces. The cushions are covered in her bright yellow paper fabric. Opposite and below: the 'kitchen house' is about five years old and consists of a wood-burning stove (there is no heat or electricity), a large dining table, and sofas for relaxing on after a meal. Family and guests sleep in the main house, in the children's house or in the guest house.

Previous pages: a paper-yarn hammock and a throw are both unique handmade designs. Right and below right: Ritva Puotila's artistic creations demonstrate the appeal of the paper yarn which takes dye particularly well. Below: carpets made from paper yarn. Opposite: a day bed in the main house with antique striped pillow coverings. Most of the cabins, which Puotila and her husband began building in 1965, are made from dead standing pine.

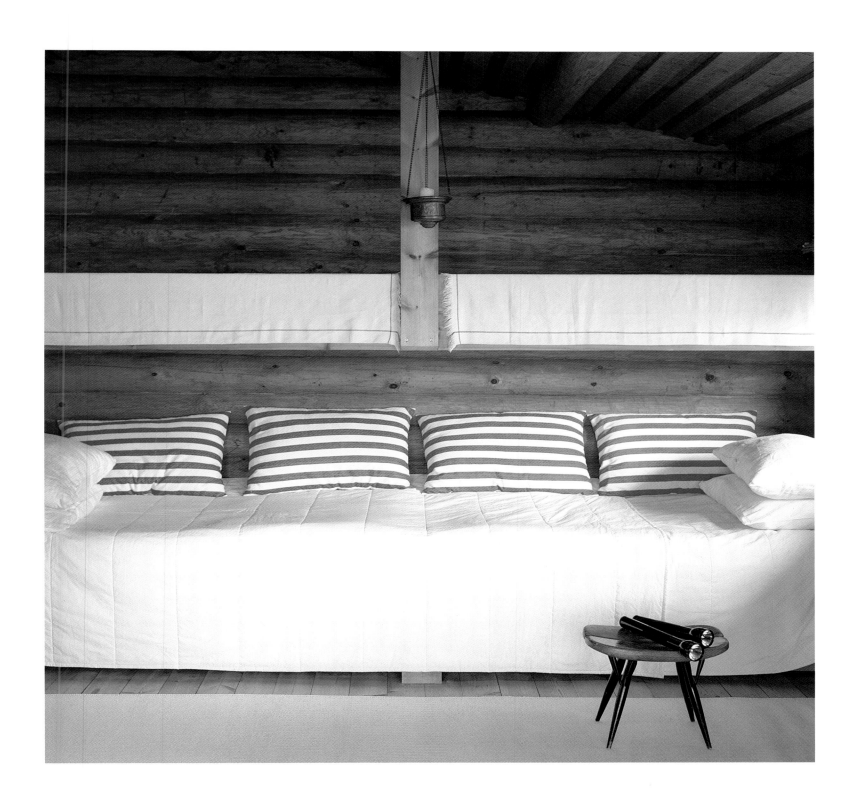

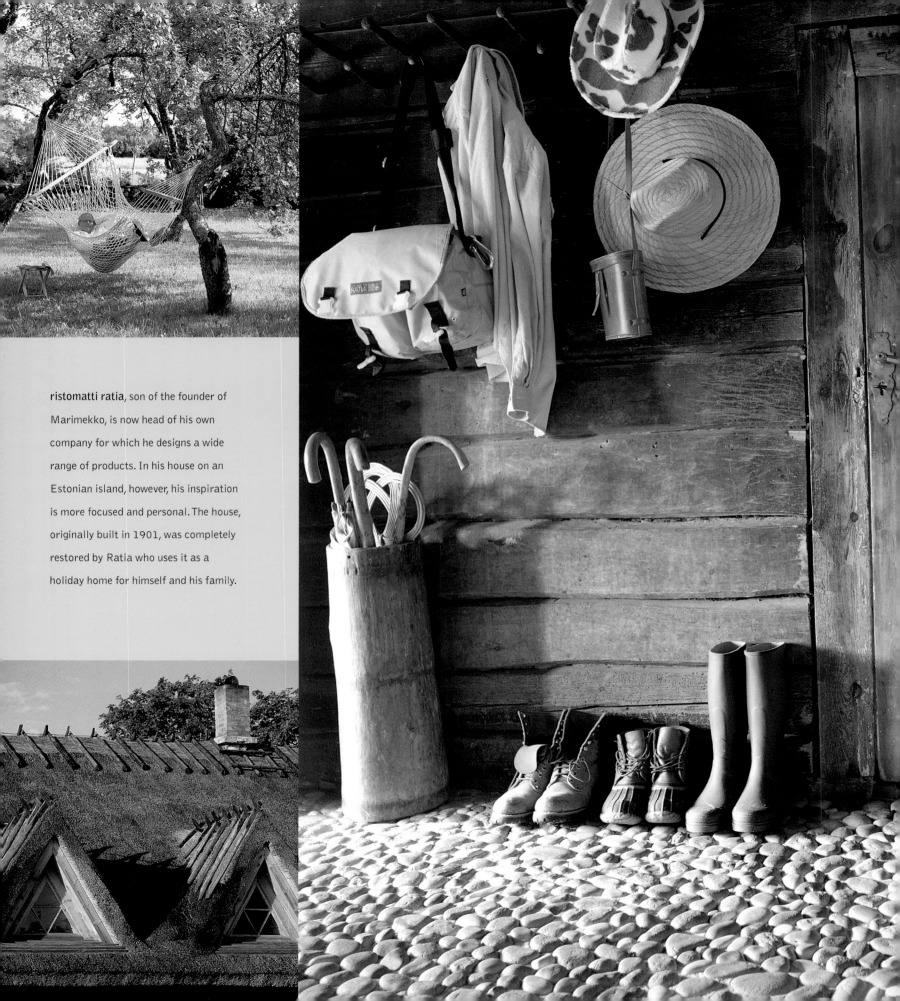

ristomatti ratia, son of the founder of Marimekko, is now head of his own company for which he designs a wide range of products. In his house on an Estonian island, however, his inspiration is more focused and personal. The house, originally built in 1901, was completely restored by Ratia who uses it as a holiday home for himself and his family.

having a mother who established one of the most well-known design companies in Finland would seem a hard act to follow for any burgeoning creative, but Ristomatti Ratia demonstrated at a young age that he was capable of making his own mark. At fourteen, in an effort to convince his parents to let him have his own room, rather than share with his brother, Ratia sketched a complete bedroom design. It impressed his mother, the founder of the textiles and clothing company Marimekko, so much that she entered the plan in a contest and it was published in magazines. Needless to say, Ratia won the argument.

After studying interior architecture at Leicester Polytechnic in England, Ratia began designing for Marimekko in 1967. He created a line of high-quality plastic products for the home which he and his team humourously called 'Decembre', because, he laughs, 'we wanted to bring a revolution in December.' And revolutionary it was, as he invented new ways of working with the material.

A number of later designs also won awards in Europe and America, and in 1977 he became head of design and licensing for Marimekko, Inc. in the USA. However, in the 1970s, after his mother's death, Ristomatti and his siblings sold Marimekko and he embarked on his own design career.

Today his company produces everything from stackable wood storage boxes to handbags, glass and children's clothing. He also designs decorative objects for the home, pots and pans and the thing no Nordic home should be without: a sauna stove.

ristomatti ratia

In recent years, something has turned Ristomatti Ratia's head away from product design and back towards the complete environment. But unlike his teenage bedroom, his latest project possesses, as Ratia puts it, 'its own style, its own language. It's not my language,' he says modestly, 'I am the translator.' The 'language' of which he speaks is that of a collection of small thatched cottages on the tiny island of Saarenmaa in Estonia. Ratia has converted his cottages back to a more natural and 'romantic' style. Within, he has experimented with decorative ideas, but the focus is on wood and other natural and naturally abundant materials.

It began with the logs. All of the island's inhabitants use wood for fuel and consequently, each house or apartment is adorned with a neat pile of cut logs arranged beside the building. Ratia took this idea from the exterior, covering entire walls with stacks of logs, to the interior, where he has used smaller bundles and arrangements to fill gaps or create decorative elements.

It is not, Ratia explains, that he has chosen only to work with wood here, but that the style of the place has chosen him and, as any fortunate guest might discern, that he has become rather enamoured of his natural retreat. He is determined that any elements he adds should be part of a pure aesthetic. Therefore, he puzzles over every aspect of the cottage's rooms and uses. 'I haven't yet designed my own glasses, plates, forks, knives for the house, but I will,' he promises. He calls his efforts to remain true to the style and existing materials 'talking to the landscape'; it is a conversation that begs to be overheard.

Previous pages: the restoration of the thatched roof is one of the projects of which Ratia is most proud. He laid the floor with pebbles collected on the beach.

These pages: there are a few of Ratia's popular design objects, but most of the elements were created specifically for this house. Stacked logs are ubiquitous on an island with no electricity or gas, but Ratia has made a virtue of necessity with his artful pilings. Opposite: in the kitchen he filled the ceiling with twigs from a type of chestnut bush. He thought of the idea when he saw people using woven twigs for drying fish and for fencing. 'It's decorative,' he explains, 'but I also thought I could hang things from it.'

145 RISTOMATTI RATIA

Ratia purchased several structures on
the island and is in the process of
painstakingly restoring them all. Above
and left: glass bottles designed by Ratia.
Top: brightly coloured textiles contrast
with the dry stone walls that Ratia loves.

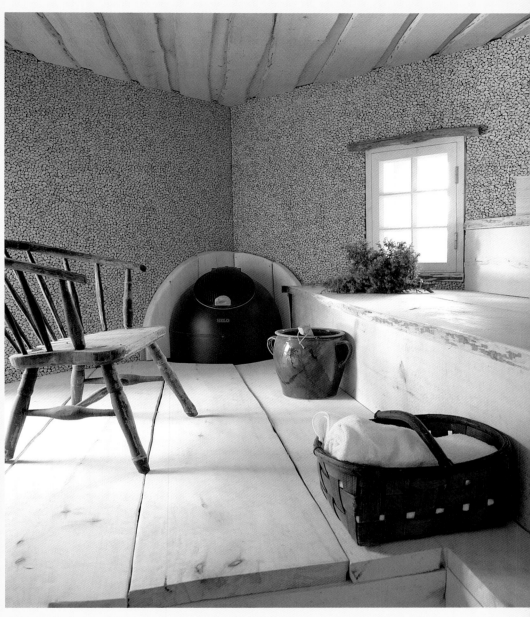

isabelle roux watched her husband make pottery for more than ten years before she decided to try to create something for herself. She is now an established ceramic artist living in the Basque country in the house that her husband began building in 1993 to accommodate two separate studio spaces and their four children.

She studied law, but then stopped to have a family. For years she watched her husband, a skilled and fully trained potter, make and sell his hand-thrown pieces. And then, after law studies, after raising four children, she decided to give something else a try. And though she suddenly felt 'an urgent and unpremeditated desire to create ceramics' herself, she was not about to follow in the footsteps of her husband or employ any of the techniques she had observed and absorbed over the years.

Modelled on traditional farmhouses, Isabelle Roux and Jean-Marie Thuilier's house near the Pyrenees is a family and artistic haven. Plank walls and stone floors complement the sombre tones of her large, incised pots, which she creates using the coil method. The irregular shapes and delicate traces of fingerprints are testimony to the thoroughly hand-worked nature of her pieces.

Still determined to render her thoughts and feelings in clay, she decided to reconsider a method she had once come across, the coil technique, and then, she says, 'my story with clay began.' Their house in the foothills of the Pyrenees, accommodates two separate studios and space for exhibiting their work, an opportune development, as both continue to be prolific and Isabelle Roux's work achieved wide popularity and critical appreciation in such a short space of time.

Her pieces have a manifold appeal in their hand-worked shape and surface texture. In some cases, where the clay's thickness is reduced to mere millimetres, the clay is given the apparent suppleness of leather. This appearance is enhanced by the sombre hues created through the use of metal oxides, applied after the first firing, and the high temperature at which she bakes the clay, turning it to stoneware. The signature aspect of her works, however, lies in the detail cross-hatching around a rim or lip, delicate lines hand-etched with the point of a stick or small knife.

Her dark vessels, still bearing the marks of both the potter's caress and her 'writing', respond to a fundamental idea of beauty and creation. It is an idea that is also captured in the rooms of the house, hand-built against the Pyrenees, which rise up into view behind it, heightening both the sense of connection with the earth that the artist feels compelled to follow, and the sense of satisfaction.

isabelle roux

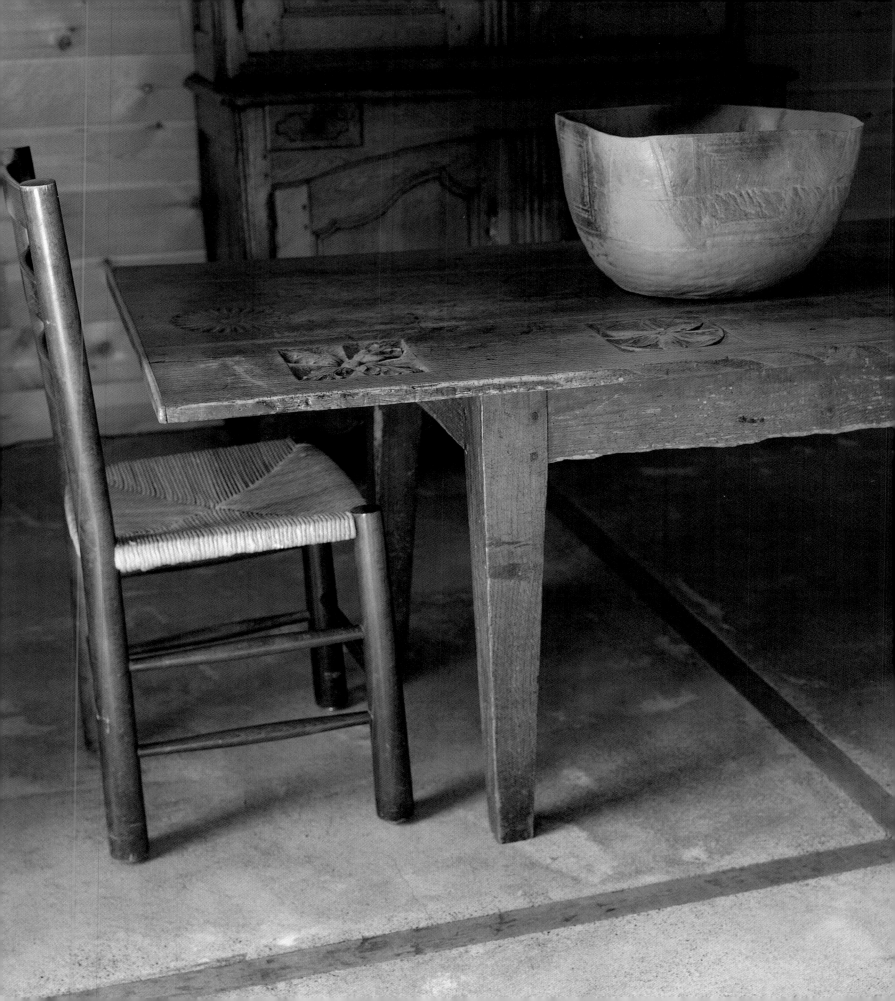

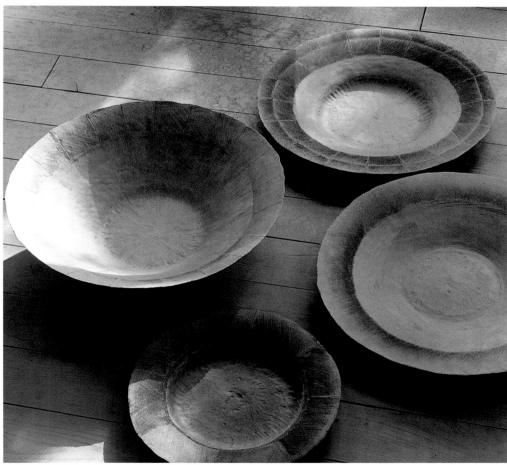

'Each piece of pottery is a moment in my life,' reveals Isabelle Roux. 'The search for beauty is not aesthetic, but also composed of other elements: the work of the spirit, the material and nature, which is the centre of life.' In a household focused on creation, not surprisingly, furnishings are minimal but full of character. Opposite: a wood-burning stove and a Louis XVI-style *fauteuil* present a striking composition with one of Isabelle Roux's large stoneware vessels.

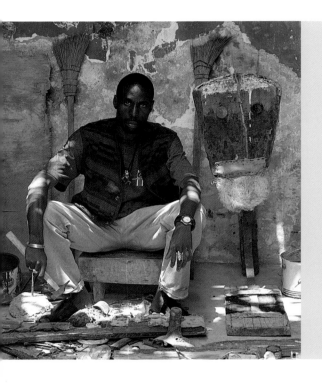

djibril sagma works in a small, open-air studio on the Senegalese island of Goré, which was once famous for its prison, but is now renowned for its artistic community. Amid picturesque ruins, he produces paintings and sculptures from mostly recycled local materials.

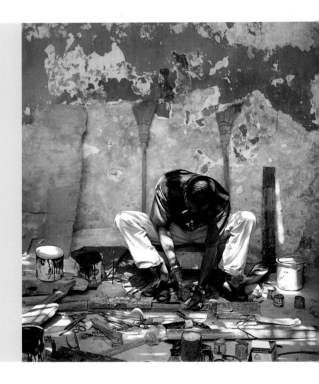

Peeling paint and bare concrete are enlivened by Djibril Sagma's anthropmorphic sculptures and the outspread materials of his work. His work is closely tied to his environment, as he finds inspiration in the same place he retrieves most of his materials, 'from the island, facing the sea'.

djibril sagma

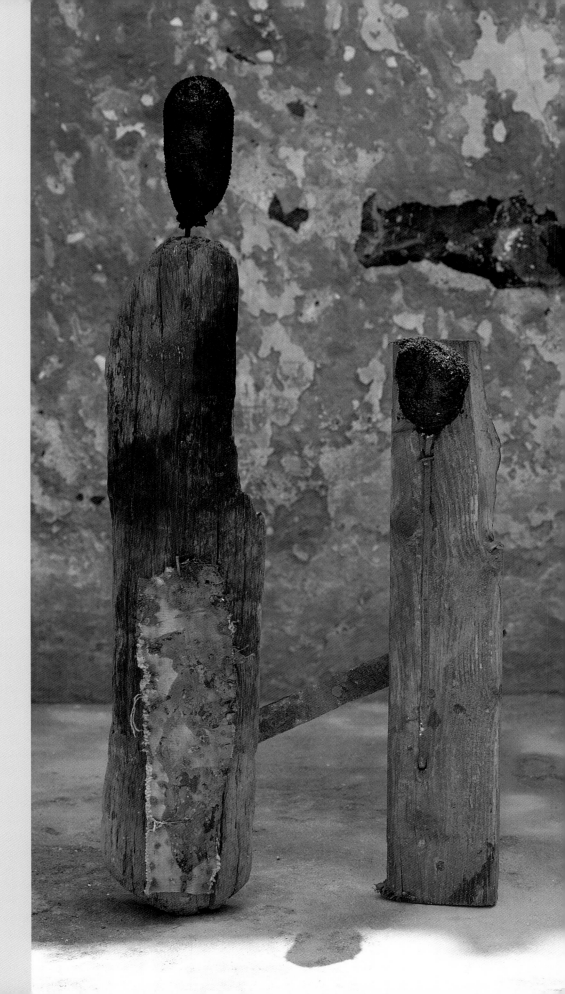

From the bohemian painter in his unheated attic to the sculptor in the disused factory loft, images abound of artists turning run-down spaces into meccas for creative thought. In the outdoor island studio inhabited by Senegalese artist Djibril Sagma, you could either notice the peeling paint and absence of a roof, or you could appreciate how the brilliant blue and yellow paint has worn away leaving vibrant swatches of colour. Against this fading palette, you could admire how the open space allows sunlight and shadows to play softly over the artist as he paints and sculpts from 'driftwood and tin cans', as he describes his material, but also from broomsticks, pieces of rope, cloth and discarded metal objects with which he shares his home.

Before he began creating art with his mentor, Amada Sow, Sagma was a labourer. For the last fifteen years, however, he has devoted himself to paintings and sculpture that address ideas about 'human relations' and 'mutual respect'.

Sagma's method is to preserve the natural shape of the silvery bleached driftwood pieces and sparsely ornament them with other found materials. His sculptures are human and abstract. Eyes and mouths or something that suggests a human head are used to animate the principal piece of wood. It is almost as if he is humanizing the material, adding character with each small recycled gesture of hair or facial features. They, in turn, people his environment, the small space in which he lives and works, bringing a lively purpose and artistry to a space that would otherwise be devoid of both.

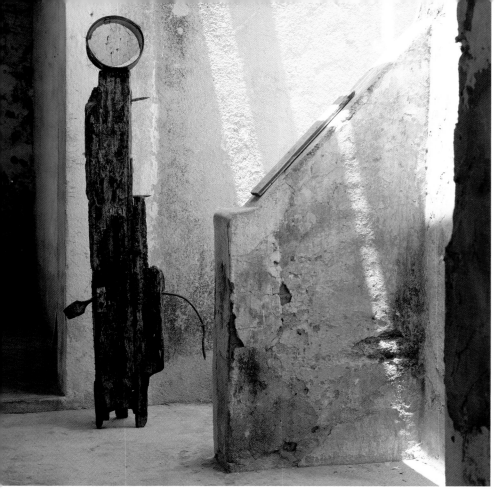

Djibril Sagma's studio and open-air exhibition space once belonged to his friend and mentor, who now lives and works primarily in Vienna. It is now home to Sagma's many creations made from driftwood, reclaimed objects and other materials that help him express links with his social and physical environment

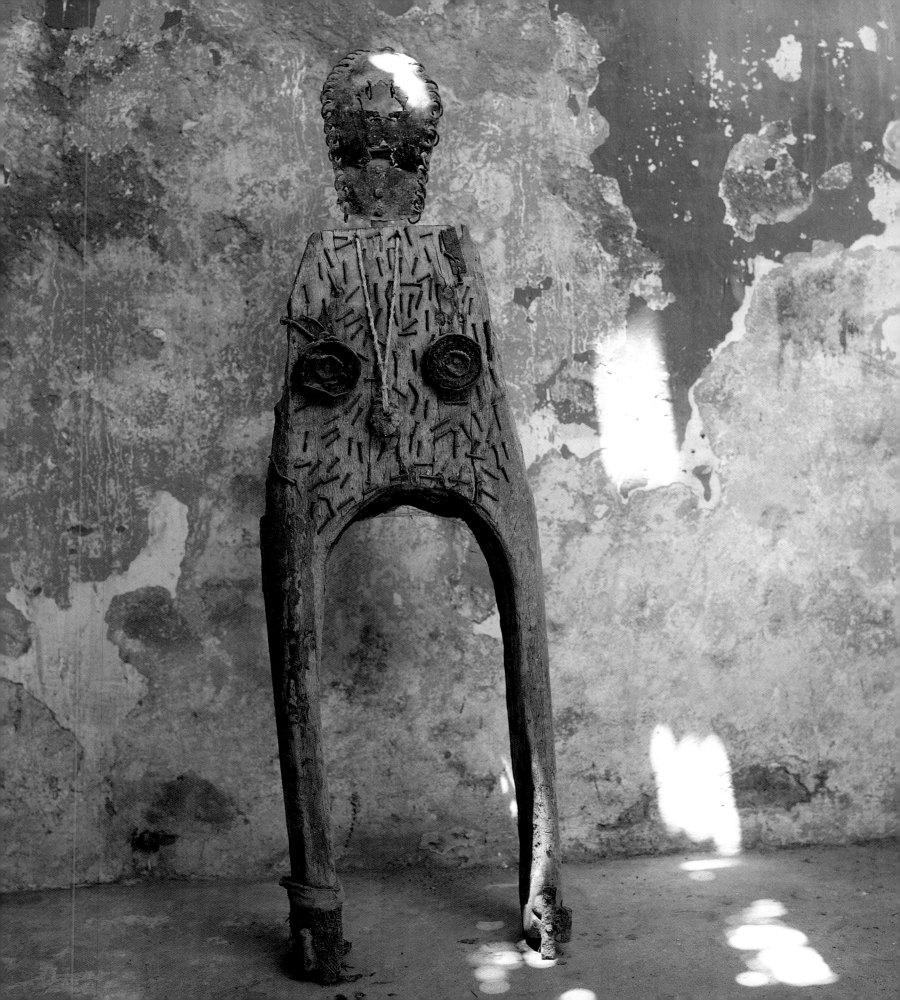

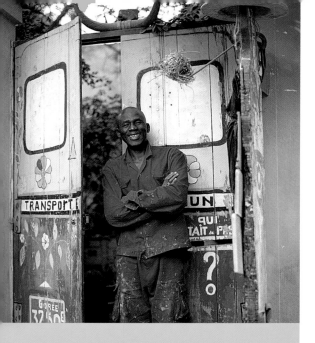

moussa sakho is a self-taught artist who lives on the small island of Goré, but has exhibited his work in Dakar and Paris. His courtyard studio space allows ample room for the creation and display of his large works of recycled objects and materials.

'I was born an artist,' declares Moussa Sakho without reserve, 'I have it in my blood.' Despite having won awards in his own country and in Paris exhibitions, he approaches the world of art and his choice of media in a similarly matter-of-fact and instinctive manner. As to what kind of art interests him he says, 'art, in general, interests me' and 'all materials' are worth his regard. For Moussa Sakho all the world's a canvas, a sculpture, an assemblage waiting to happen, or simply waiting to be recognized for the art that it is.

Installed in his picturesque atelier on the charming island of Goré off the coast of Senegal, Sakho collects materials locally and from afar. He is something of a magpie perhaps, but he is also a consummate conservationist. He believes fervently in giving materials 'a second life'. His motto is in keeping with his direct and determined nature, succinct and provocative. Believing that 'it is important to keep materials and to reuse them', he says that the message or theme of his work is 'throw nothing away'.

Sakho's open-air studio on an isolated island brings a spirited resonance to the term 'reuse'. A colourful jumble of recovered objects and pieces sit alongside, and sometimes give structure to, his own paintings or assemblages. Art objects fuse into furniture and vice versa. Industrial springs function as the base for a table or for circular stools, as well as for a wooden model of a television with a painted screen, one of Sakho's many commentaries on his own and world culture.

moussa sakho

The striking juxtaposition of his bright paintings against the unfinished wood crates, cable reels, planks, against rusting metal implements and the trees that grow naturally inside the studio space, is wholly unplanned and uncontrived. As such, it appears an accurate reflection of both the artist's aims and work, mixing artistry and the everyday in a natural and, seemingly at least, effortless way.

Yet Moussa Sakho is not only after a successful blend of materials. His achievements reach beyond the creation of beautiful, inventive works for aesthetic pleasure. He considers himself 'an artist at the service of children' and uses his art and the teaching of art to inspire schoolchildren and children in hospital and to help troubled youths through art therapy. Perhaps because some of his work, for example the simple figures against a bright backdrop, has a childlike air; this vocation seems in tune with the overall tone of his art: particular and yet touching on larger concerns.

It is art that appeals to a sense of colour and harmony, to an appreciation of possibilities in objects, in art, in attitude. Living on what Moussa Sakho in characteristic candour calls 'the most beautiful island in the world', must contribute towards such a positive disposition. Or maybe it is just something else he was born with.

Opposite: Senegalese artist Moussa Sakho in the characterful studio he has inhabited for the last ten years. He is surrounded by the pieces of art and furniture produced from recycled materials. His aim is to 'give materials a second life and sometimes a third life,' amd his motto is 'throw nothing away'.

jérôme abel seguin lives the escapist's dream. The artist and furniture maker swapped his flat in Paris for an island home on Sumbawa in Indonesia. He did not want merely to imitate the local architecture, but to absorb the surroundings into his life and work, making the structure simple, 'as much like a barn or hut as possible'.

Above: Jérôme Abel Seguin at work in his home in Indonesia, which he built mindful of traditional building techniques, but focused on open space. Opposite: the open roof structure and tall white walls form an airy setting for Seguin's monumental wood pieces.

d escribing the allure of island life, Jérôme Abel Seguin invokes Robinson Crusoe and the characters of Robert Louis Stevenson, childhood heroes whose adventures greatly influenced him. Yet, looking at his pared-down approach to island living, one is reminded of another literary escapist, Henry David Thoreau. 'I went to the woods so that I could live deliberately,' was Thoreau's great declaration against the burgeoning machine age, and his exhortation to 'simplify, simplify' is something with which Seguin probably sympathizes.

His materials, pre-shaped and otherwise, seem to Seguin to possess a life and spirit of their own that will speak to him as long as he has the patience to wait. Sometimes he will keep a piece of wood for two to three years before he thinks 'yes, this is the right idea'. Then with his team of native workmen – 'who have no habits and can sometimes have a more creative approach' – he sets about the painstaking task of hand carving and fine polishing.

This dedication to an end result of luxury is inspired by 'noble materials, space, time, freedom, realizing exceptional things in very rare materials.'

It was while studying at the Ecole Boulle and the Ecole nationale supérieure des Beaux Arts in Paris that Seguin discovered his affinity for primitive art. In Indonesia, while searching out primitive art, Seguin's fascination with wood and nature began to seriously take hold and he became captivated, at least in spirit, by the island existence and, he says, by the idea of Paradise.

Seguin brought some large pieces of wood back to Paris and started working alone there, but then decided to move to Indonesia to be close to natural sources and local workers. On seeing the islands off Indonesia, he muses, 'I started to dream because it reminded me of my childhood', which he spent 'on the beach and in the forest,' around Cap Ferrat in France.

jérôme abel seguin

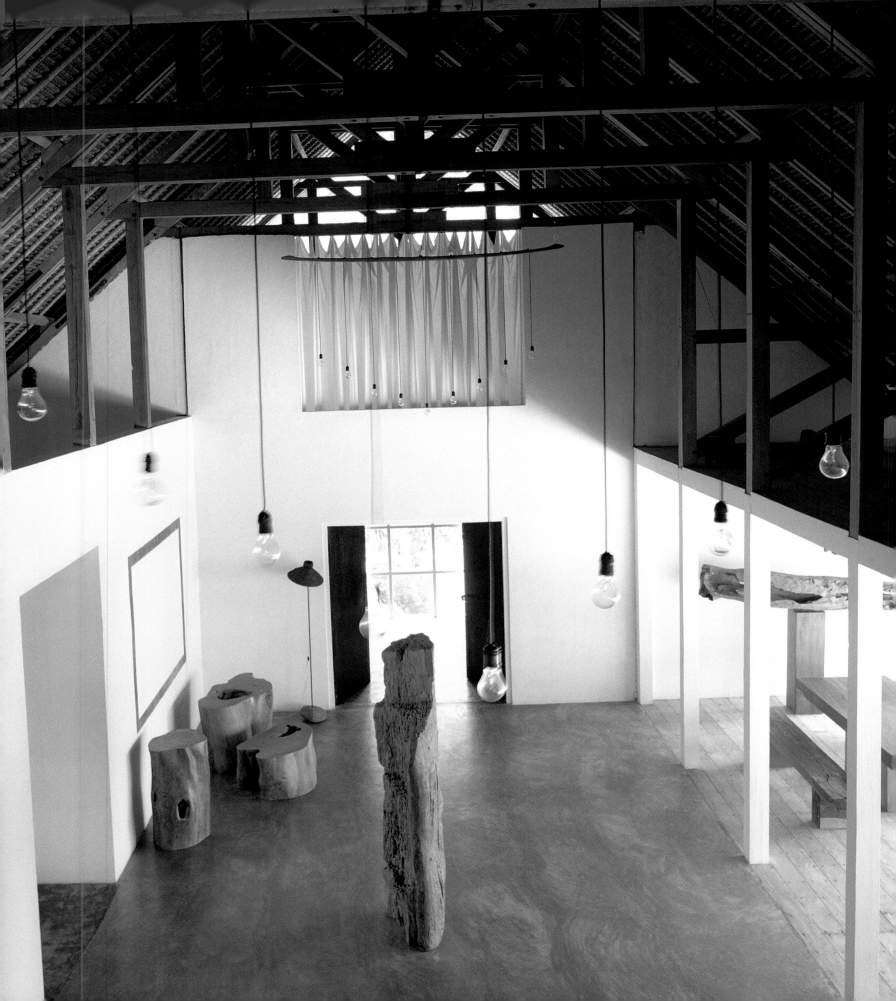

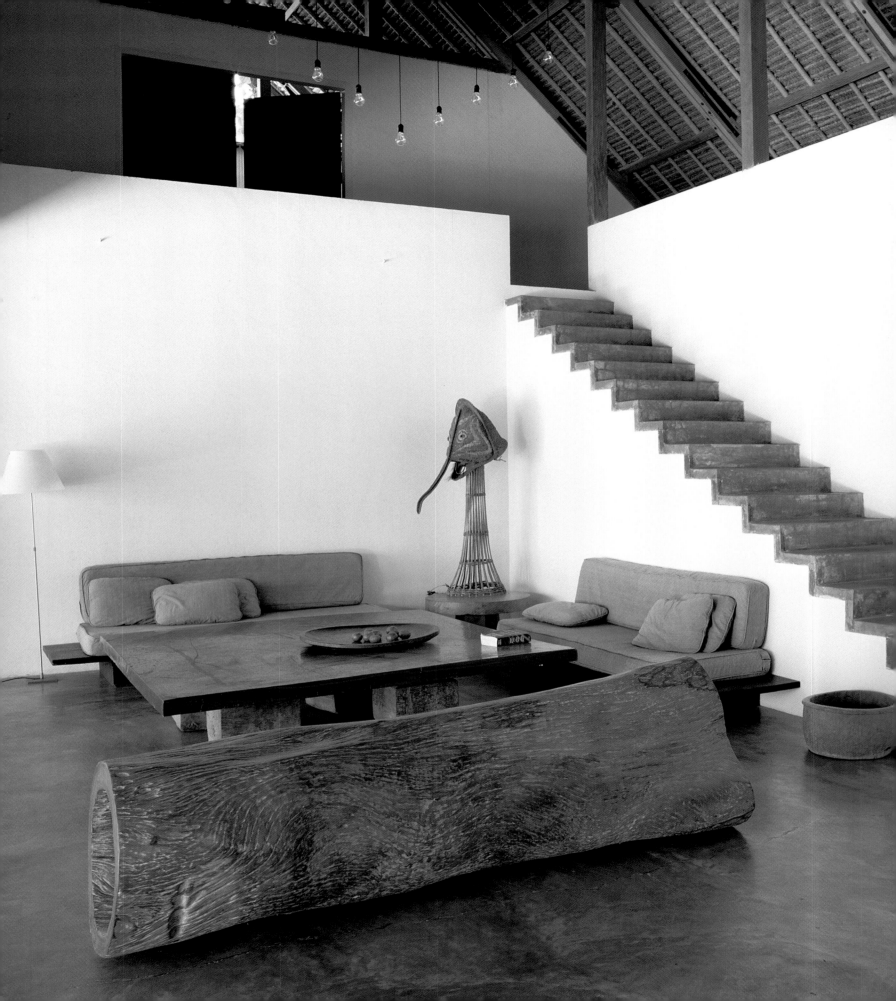

Seguin found the ideal location on the island of Sumbawa, where he built his modern house using traditional materials, and he has never looked back.

His understanding of the material is intimate: 'In opposition with the vines, which are in fact like the bones, and represent death and eternity, a solid piece of teak is like flesh which represents sensuality, life and living time.' For him a tree resembles the human body – roots, trunk and branches symbolizing bones, body and appendages – and the 'memory of time' found in the layers of rings.

Finished pieces in polished, bleached or roughly cut forms articulate and set off the otherwise clear, white spaces of a house designed to be open to the elements. His work and living areas are somewhat separated, but always the mood of creation pervades, creation that is not aided by shutting out the outside world, but by heartily inviting it to enter, resulting in an inspired simplicity that many an avowed escapist would admire.

Seguin uses his house 'to check pieces', keeping them around so he can decide 'if they are right'. Left: a large hollow tree trunk has been finely polished on the outside but left raw on the inside as a reminder of its natural state. The stairs and table are also polished wood. Below: some of the large wooden mortars which are widely used in the area for grinding and which Seguin has reclaimed.

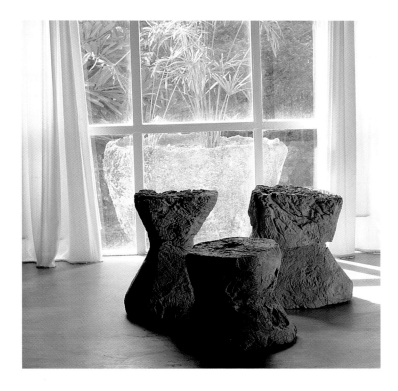

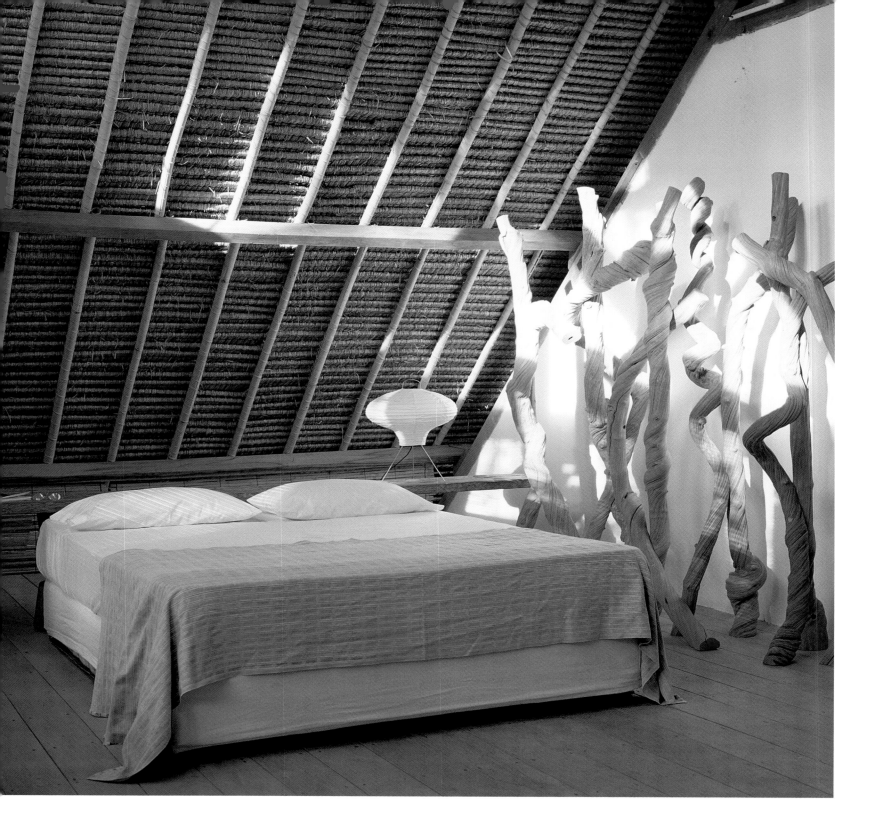

Opposite: in a bedroom giant jungle creeper vines, which have become hardened into wood, create a textural backdrop for plain linens and plank floors. The traditional Indonesian bamboo and grass roof construction is clearly visible. Right: a table comprising a mortar base and teak surface is paired with a Javanese chair of which the seat and back are erected from a single piece of polished wood.

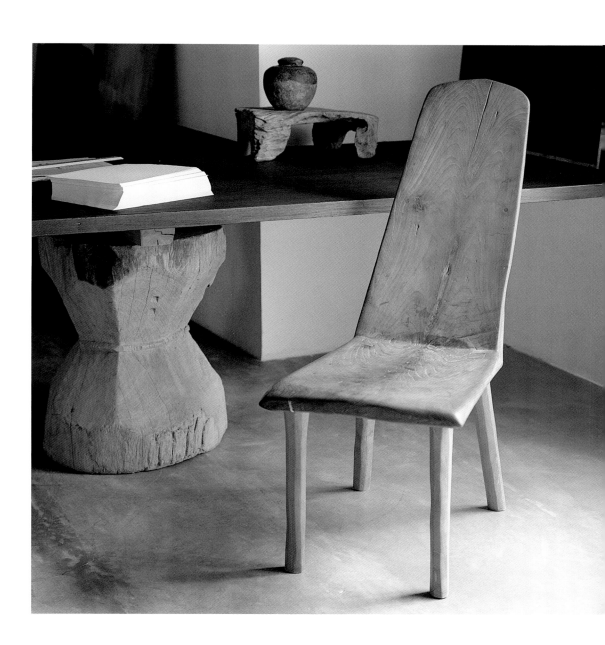

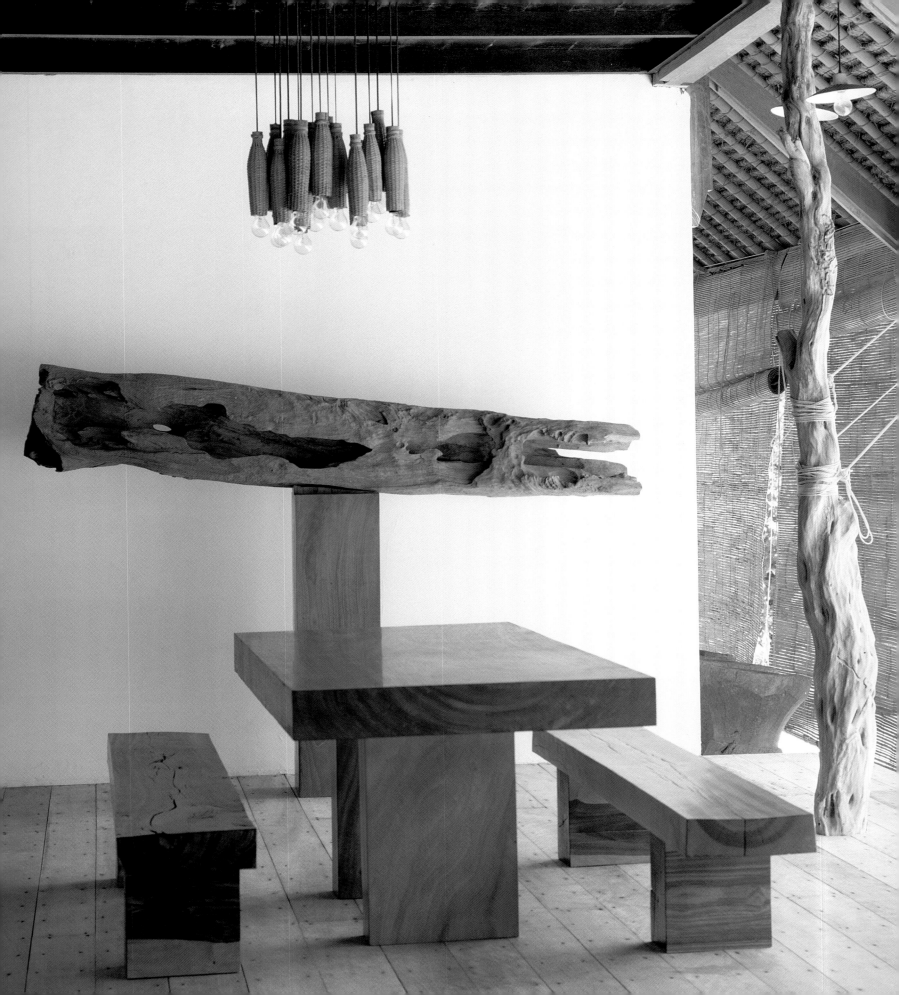

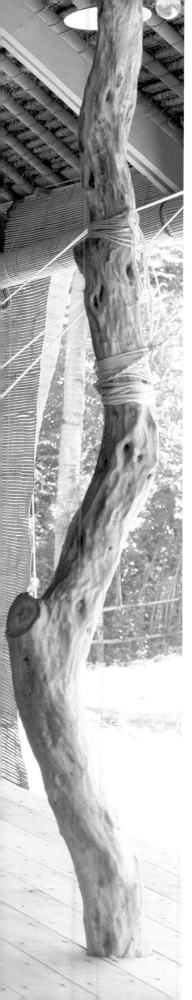

The house has few exterior walls. Only grass shades enclose the space at night. Left: rough and smooth: the luxurious finish of the table and benches is highlighted by an unfinished piece of wood which Seguin has mounted as a sculpture. Posts are also made from unfinished wood and the light fixtures were created from woven bamboo fish traps. Below: 'This piece is like part of a human trunk', Seguin comments of the large hollow trunk for which he has yet to find a direction or use.

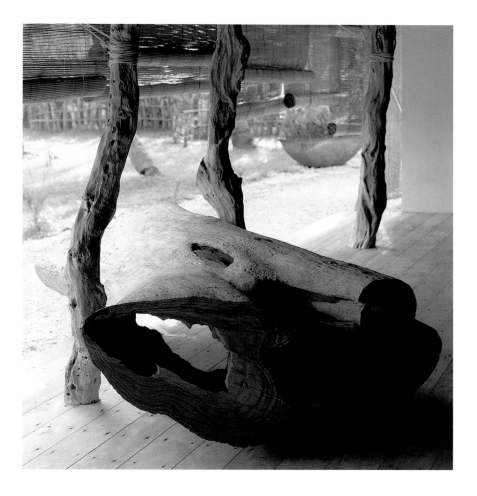

kay sekimachi and bob stocksdale
make their 1895 house in Berkeley,
California, a gallery of their work.
His fine wood-turned bowls and her
multi-layered weavings embellish
a pleasantly light-filled interior.

In 1993 they were honoured with a retrospective of their individual careers, titled *Marriage in Form*, which was held in Palo Alto, California. Though Kay Sekimachi and Bob Stocksdale have always worked in different media and do not collaborate, except in mutual support, the title is apt, as it suggests their remarkable unity. When they were married in 1972, both had been working in their chosen forms for decades, but they shared a common artistic origin, as each had taken up art during a period of incarceration in the Second World War: Sekimachi as a teenager in Japanese internment camps in California and Utah and Stocksdale as an internee in a Conscientious Objector camp.

It was in such a camp in Michigan that Stocksdale turned his first bowl. After leaving the camp, he bought the house in which he still lives and built a shop. He began experimenting with exotic woods, such as thuya burl from the Atlas Mountains in Morocco, which was once used for the dashboards of Rolls Royce cars, snakewood from Suriname in South America. He has made remarkable pieces from Mexican desert ironwood, Russian masur birch and South African pink ivorywood. Stocksdale also found beauty in more local woods, such as the common American (wild) persimmon.

Hailed as a 'traditionalist' and a 'pioneer' Bob Stocksdale is credited with refining the art of turning bowls in America. Both utilitarian vessels and art objects, his bowls seem almost unreal in the clarity and distinction of wood grain and swirling natural patterning revealed through his methods. He is also a conservationist. Though he has fashioned more than two hundred bowls a year for some time, the wood used in his lifetime, he says, will have come from less than an acre of land. This is partly because he endeavours to take the interior material from one bowl to create another, resulting in some of his beautiful sets of graduated bowls.

'One thing we have in common,' comments Kay Sekimachi, 'is that we both like working with one

kay sekimachi & bob stocksdale

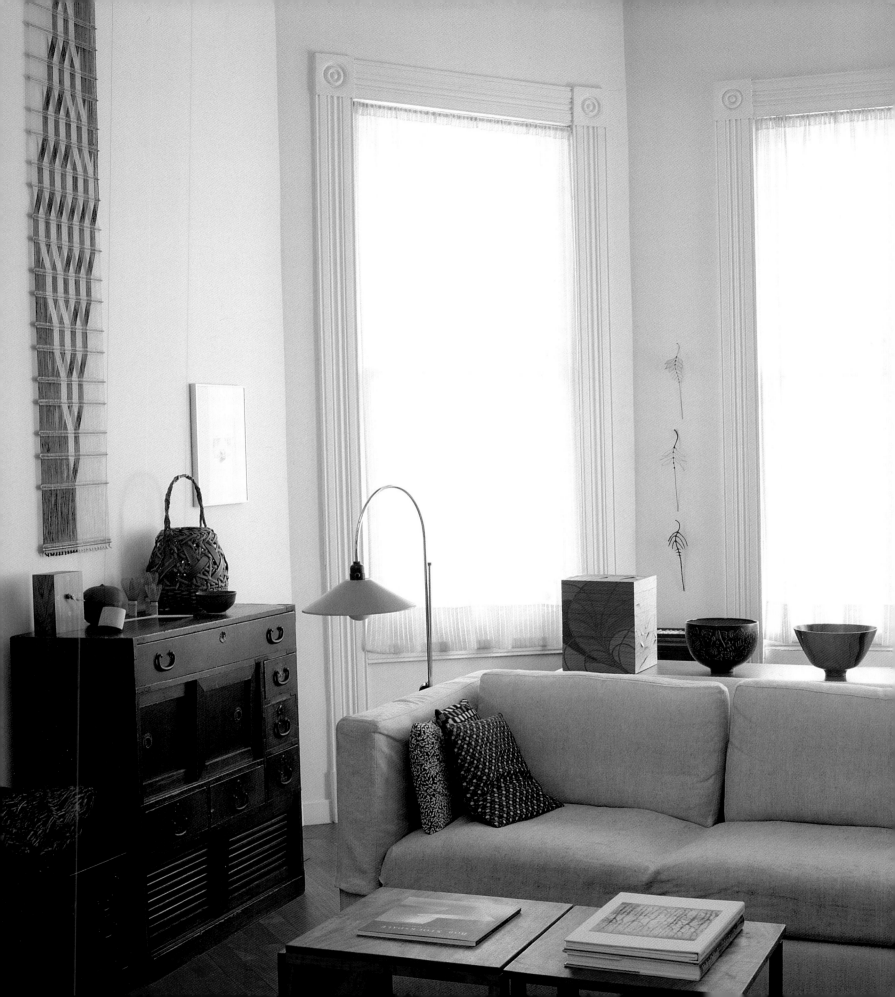

material at a time. Bob works with one block of wood…If I'm using linen, a piece is all linen.' The closest she comes to her husband's work is in her own bowls, some of which are made from undressed flax, long fibres finer than hair. This she shapes around one of her husband's bowls, using a gel medium to stiffen it. The result is a structure that is astounding in both its delicacy and its sculptural form. She has even made a bowl from the paper of a hornets' nest, a unique and unexpected material.

But even these virtuoso creations do not crown Sekimachi's oeuvre, for, she says, 'I still like to think of myself as a weaver.' After her family's internment, Sekimachi studied at the California College of Arts and Crafts, where a fellow student introduced her to weaving. 'I went to the weaving room and I became fascinated by watching the rhythm: you throw, you beat, you change.' So with her last $150 she bought a loom and committed herself to learning this rhythmic and intricate art.

Since then, Sekimachi has experimented with and become proficient in a number of weaving methods and her work, like her husband's, has become widely admired. She began to create multi-layered weavings and sinuous vertical hangings, which vary from long, tubular shapes to the more ethereal forms that reveal her love of the ocean and marine life. Some of these appear as if they could waft away in a sudden current of air, while others are truly collapsible and can take on different forms.

In their 1895 house situated east of San Francisco, California, Kay Sekimachi and Bob Stocksdale have achieved a peaceful blending of their work, which is in many senses complementary. Bob Stocksdale's pure, handworked surfaces, in which layers of growth and change become visible, and Kay Sekimachi's hand-woven patterns of warp and weft demonstrating the beauty of patience and fine craft, generate a harmony that is more than cliché, it is wholly natural.

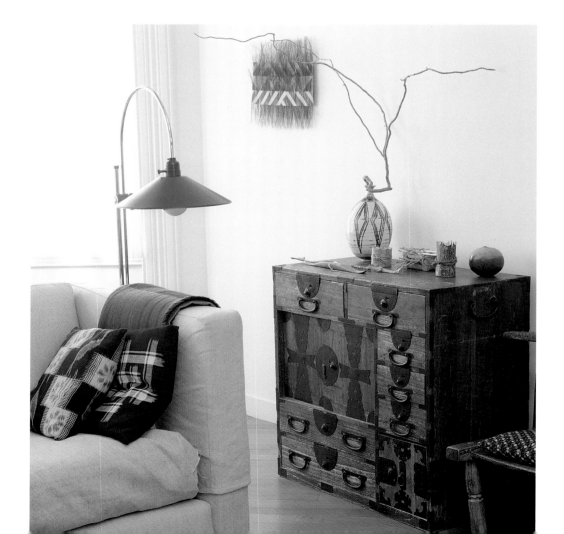

Previous page: the craftsmanship of the Japanese *tánsu* (chest of drawers) makes it a fitting complement to the couple's own pieces. The wall hanging is by Peter Collingwood. Left: another *tánsu* holds a bottle with a geometric design by Antonio Prieto. Right: the cherrywood *tánsu* belonged to Kay Sekimachi's father and holds works in ceramic.

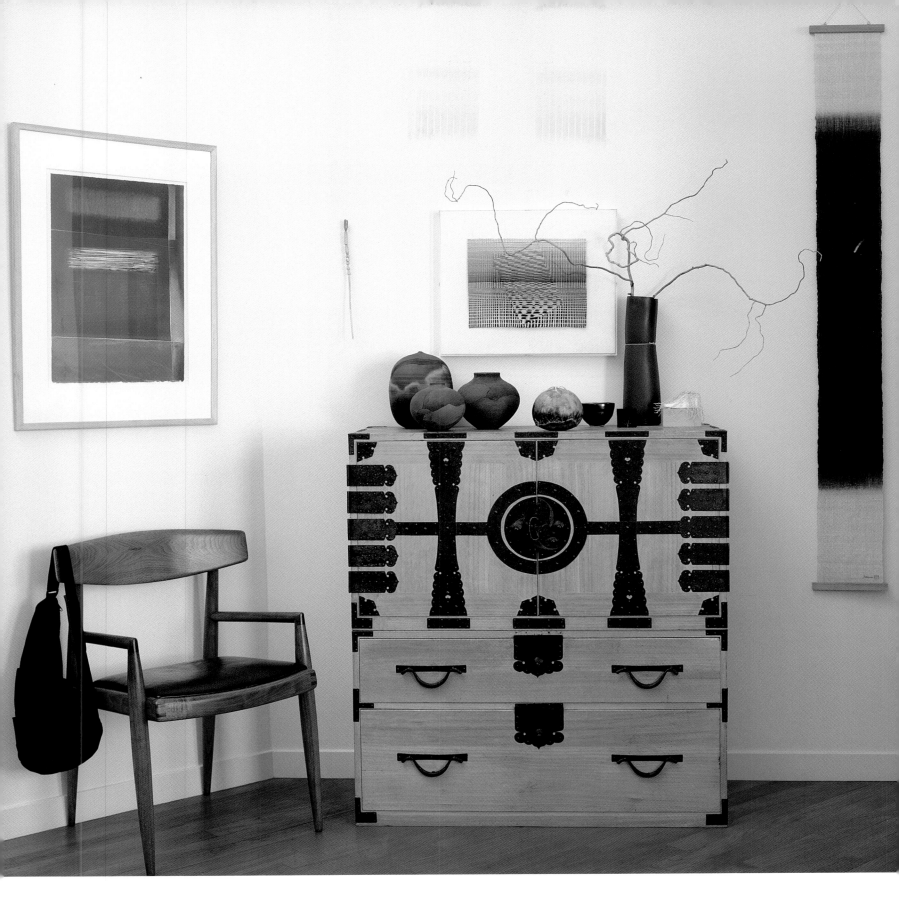

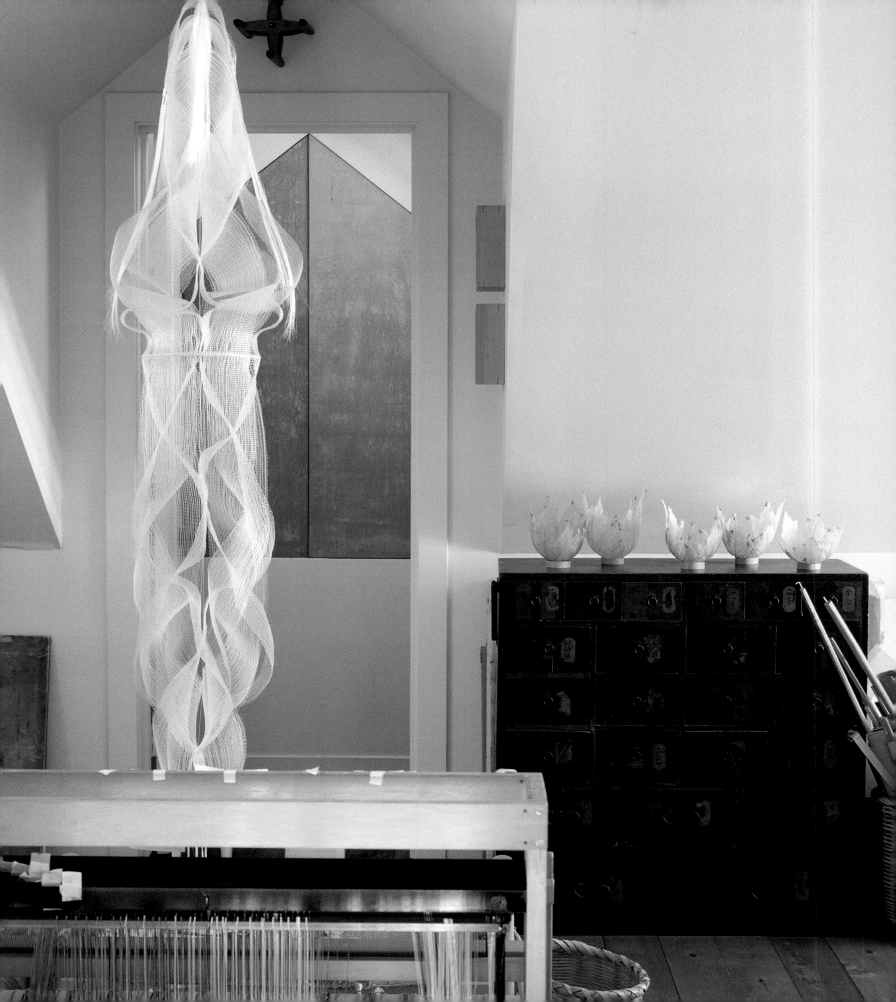

Above: Bob Stocksdale's wood tray of
black walnut is a fine example of how his
pieces reveal the beauty and intricacy of
the grain. Opposite: Kay Sekimachi's
three-dimensional hanging in translucent
monofilament creates an ethereal
presence. On top of the *tánsu* her 'leaf
bowls', made from the 'skeletons of maple
leaves', have a similarly delicate and
weightless quality.

rupert spira set up his first pottery in Hampshire, England, but then relocated with his wife, Caroline, to this Shropshire farmhouse. Part of the house dates from the early seventeenth century, and the cattle sheds, which Spira converted into a studio and gallery space, were built in the late 1700s. After respectful renovation, the house retains an air of warmth and solidity.

Rupert Spira's present fascination is linear, or, more precisely, with lines. For over twenty years he has been throwing pots, working towards an increasingly refined result that many would happily describe as 'simple' in reference to the purity of form, but which speaks of a multitude of adjustments, realignments, rethinks. His recent pieces are anything but simple, except perhaps in their fundamental appeal. One only needs to examine the surface at close range to appreciate the true nature of the work, which is, if not immediately complex, then certainly more profound than adjectives such as 'simple' or 'minimal' have come to suggest.

The cleanly shaped bowl is glazed white and then covered in black pigment. Using a sharp needle, Spira begins the painstaking task of scratching fine lines in the pigment to reveal the white glaze beneath, taking care not to press too hard. Each pot requires several days of concentrated labour, for the artist has to make sure that each scratch of the needle has the right feel, 'like walking on snow'. While his aim is not to produce something overly precious, Spira does hope that 'the intensity required in the making process is somehow communicated in the finished piece'.

And this intensity of expression can be sensed, whether following the neat row of lines with your finger and feeling the satisfyingly irregular ridges of raised enamel, or standing back to appreciate the abstract image that brings to mind both primitive and technologically advanced art forms. Perhaps it is this wide-ranging aspect that first attracted Spira to ceramics when, aged sixteen, he saw a retrospective

rupert spira

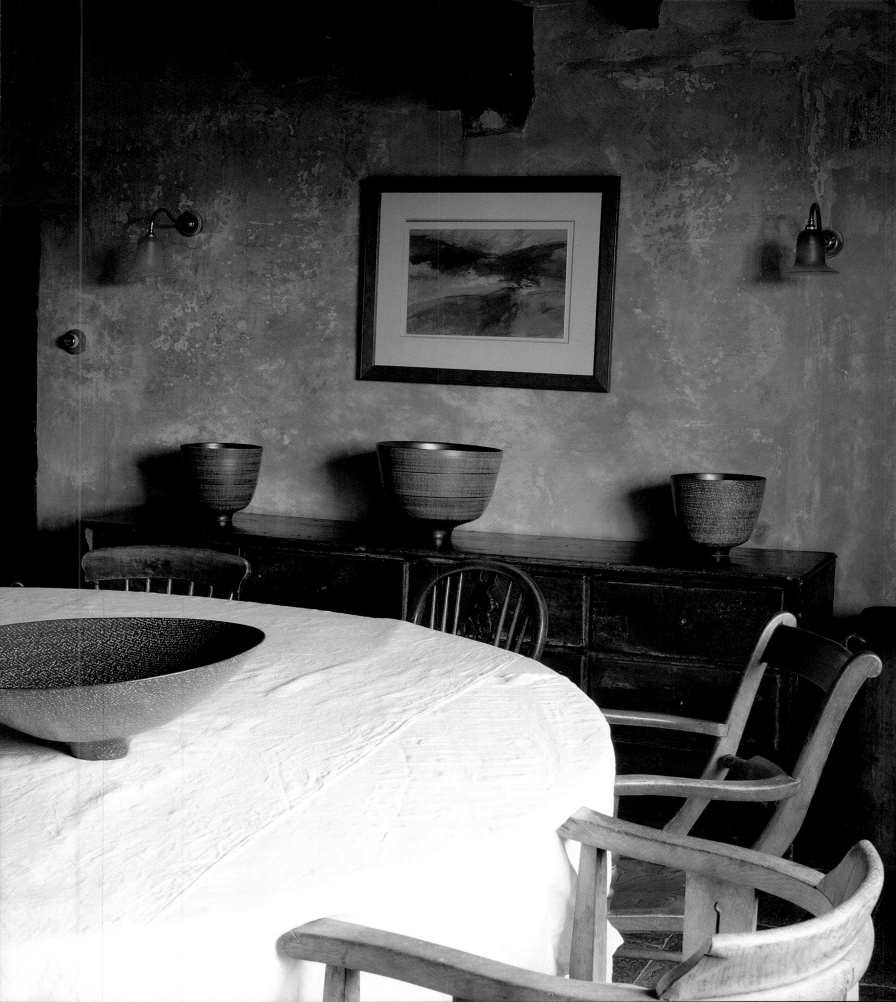

of the work of renowned English artist Michael Cardew. Rather than finding his way to his art through the love of the medium, through working the clay, Spira confesses he was deeply impressed by what Cardew had achieved. 'It was so very powerful, very simple but very powerful,' he sighs. 'And I thought, "I've never seen anything like this before", it had this potent elemental, raw feeling about it.'

The same could easily be said of the younger artist's work twenty years on. Spira spent two years as apprentice to Cardew, the last two years of Cardew's life. What he learned, apart from the practical necessities of firing kilns and the chemistry of clays and glazes, was an understanding of art through Cardew's demanding criterion that 'everything was art'. 'Art was not a special category for him,' Spira recalls, 'he once said that "a teapot was a poem in form"'. From this, Spira developed his own philosophy of being 'sensitive to the possibilities that form can communicate'.

For Rupert Spira those possibilities are endless. The enigmatic incised pots and jars represent the culmination of years of refinement. He has achieved an even greater level of intensity with his 'poem bowl', of which the entire surface is engraved with the text of Spira's long poem exploring the nature of consciousness. With the exception of his tableware collections and some variations in shape, Spira comments, 'I've always made bowls primarily, some a little more open, others a little bit closed. I've been exploring the shape for twenty years and I'm sure I'll go on exploring it for the next twenty. My repertoire gets smaller and smaller,' he adds with a certain satisfaction.

While that may be true, his handling of the repertoire has no known or stated boundaries, or finite aims. 'What I really enjoy is the rare occasion when I see a piece of work that I've made and I think "yes". Those moments are very rare,

but they are so inexplicably compelling and so unequivocal that they keep you going.'

He 'keeps going' in a studio and gallery of a converted cow barn and hayloft attached to his Shropshire farmhouse in the English countryside. Spira set up his first pottery in Hampshire, and he and his wife Caroline came to live on the Welsh border in the mid-1990s. A house dating back to the the early seventeenth century necessarily required improvements, but these were kept to a minimum. Now, bare plaster walls and heavy wooden beams provide such a beautiful framework for the subtly coloured pots and vases, that the entire juxtaposition appears clearly intentional. It may be a backdrop for work of great intensity, but the overall feeling is one of warmth and relaxation, and remains aesthetically pleasing. Though Rupert Spira's own work may have evolved to a point where links with his apprenticeship are no longer evident, the environment he has cultivated for his artistic life still resonates with at least one idea he absorbed in his early training, that 'anything you make is a valid receptacle for your intelligence and sensitivity'.

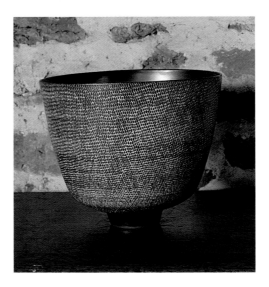

Previous page: Rupert Spira's 'poem bowl' adorns the dining-room table. Here, walls were stripped back to the plaster and then left alone. Right: Spira's workshop and gallery space is in the newly converted outbuildings. These pages: the bowl (left) and tall vases (opposite) have incised lines that recall primitive pottery and basketry.

In the dining room, plates that Spira has collected line the shelf above the door, while his white-glazed 'cylinder' vases are grouped on the windowsill. Right: a stone wall and rough wood bench complement the pure forms and subtle hues of the stoneware pots. The large earthenware vessels are aged olive jars from Crete.

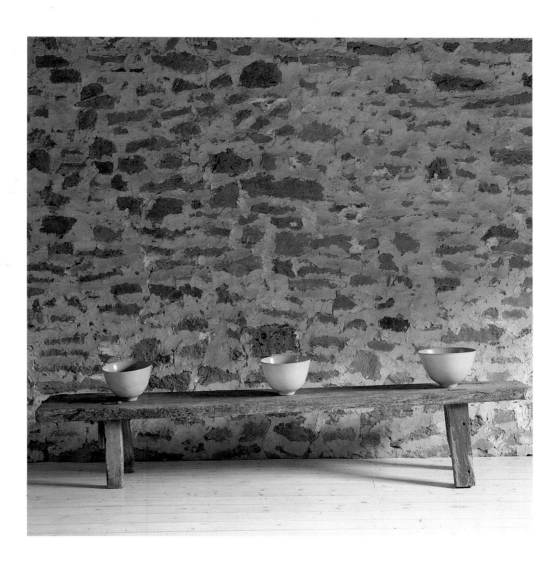

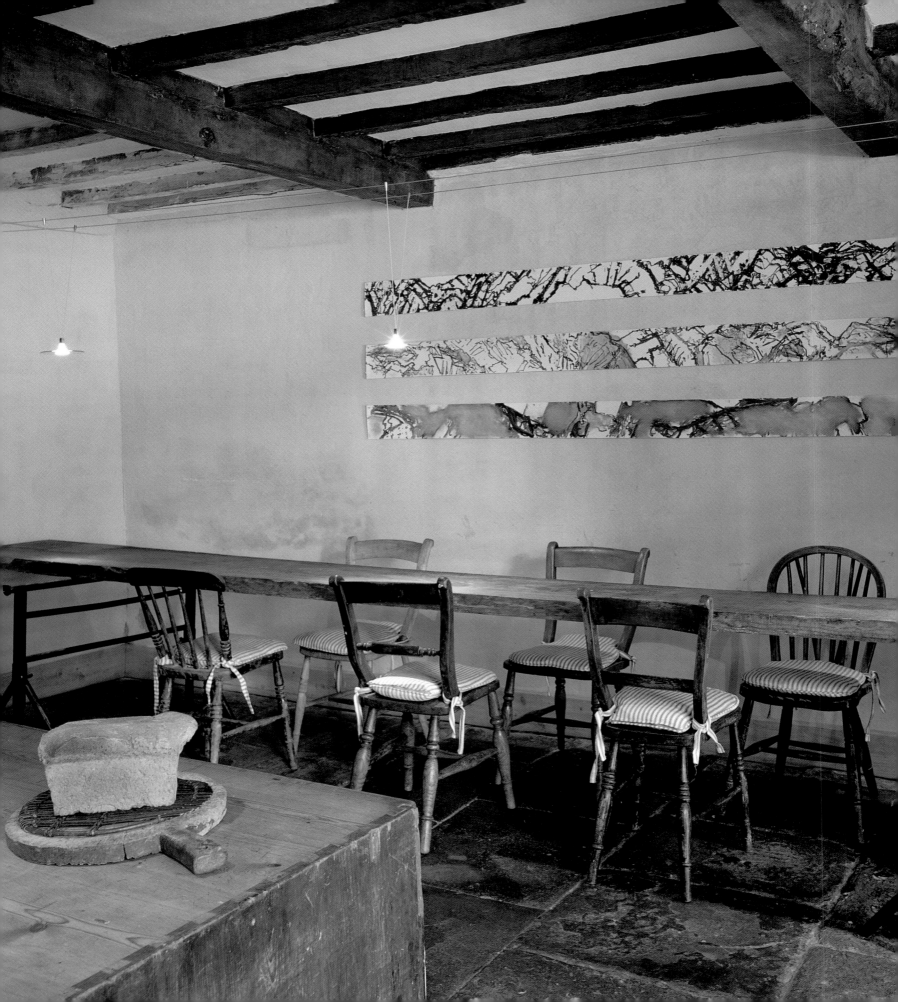

Left: three 'scroll' landscape drawings by a friend, Flora Natapoff, present a modern contrast to the stone floor, plaster walls and open beams of the original farmhouse kitchen. Below: in the renovated gallery space, more of Spira's graceful, white-glazed vases adorn a shelf.

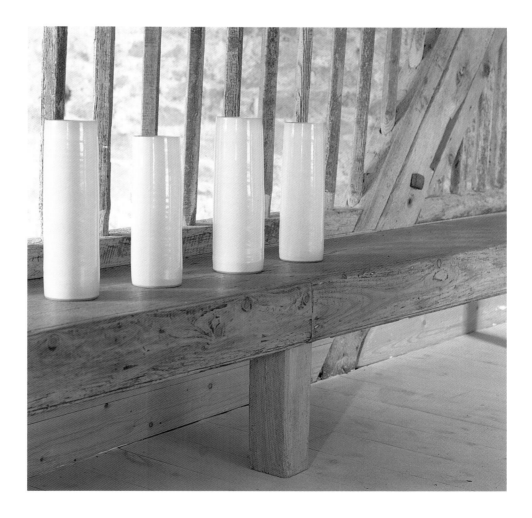

erna steina is an Icelandic textile designer known for her lamps made from the fibres of pineapple and banana plants. Her light-filled apartment is in a 1940s building in the centre of Reykjavik. She and her husband took down walls to create a more open space, but the unusually large windows were already in place to frame the northern sun.

there is a handwoven cloth made from the fibres of the pineapple plant that is so sturdy it stands on its own without starch or paste, but so fragile that the fibres splinter and break like tiny fragments of wood. Textile designer Erna Steina discovered this contradictory material when she was studying textile design at the academy of arts in Reykjavik. 'I decided that I had to do something with this,' she explains. So she began making lamps.

'I guess it was a defining moment that derived from the fabric,' she says of the development of the form and the introduction of light onto the surface. She also began employing fabric made from banana plants. 'They have a similar texture, though the pineapple is slightly finer than the banana,' Steina adds. 'They both have a special quality, the stiffness, which is like linen, but even stiffer, like wood almost, and the shine,' which is what really caught her eye.

Years later, in her Reykjavik apartment, the columnar lamps demonstrate the fulfilment of an idea. They were designed to highlight the fabric's light-reflective quality. A base of compressed wood, which she decorated by hand, holds a spotlight which shines up through a tunnel of fabric, mounted on steel poles which measure just over two metres in height. The result is an almost ghostly presence. 'I like the illusion,' she muses, 'you can't tell where the light comes from.' And you cannot tell exactly why the effect is so much more atmospheric than direct or even muted light, except that the handwoven fabric mediates the glow by also enhancing it.

The colours Steina chooses are restricted to certain hues – red, grey, black and natural white – as these appeal to her and she finds them most suited to the natural off-white of the plant fibre. While at art college, Steina specialized in printing, so even with a limited palette she achieves variation, for example by dying a section of cloth and bleaching out stripes, or by painting directly onto the material.

Elsewhere in the apartment is revealed more evidence of Erna Steina's talent with pattern and colour. A series of six panels constituted from the same compressed wood as her lamp bases feature variations in the grey and beige stripes that appear on one of the lamps. The panels are all drawn by hand, using only a modest graphite pencil. Steina originally devised them as an exhibition backdrop, but then decided she liked them well enough to display in her living room, 'like paintings. I like to change things around,' she comments on retaining her own designs in the house. 'I keep a lamp in my living room for a while and then it goes away and I get another one. I figure if I don't tire of having these things around then other people won't either.'

This standard is not as casual as it appears, since it relates to a certain 'timelessness' that Steina tries to achieve with her designs. Since 1999, she has become engrossed in fashion design. Along with two other Icelandic women, she has helped form the company ELM (from the first letters of their names), which produces clothing made primarily from Peruvian alpaca wool and pima cotton. This venture, too, was driven by material; 'alpaca,' Steina enthuses, 'is second only to cashmere in softness.'

erna steina

'I don't want to make things that are just fashionable,' she argues. 'One of our goals is to use quality materials, natural fabrics to make things that are simple and timeless.' This is possible, according to Steina, 'if you are working with a material that you respect and you want people to have it for a long time.'

It is a clear design philosophy, which, looking at Erna Steina's home, she applies to herself as well as to her clients. Having lived and studied in Sweden, Portugal and Mexico, she has found great sources of inspiration abroad. Yet these have been distilled to a careful mix of ethnic objects which are highlighted by the elegantly refined rooms and complemented by works of her own design. It is no surprise that Erna Steina started out in interior design, but she has nevertheless avoided adherence to an obvious style or a studied pastiche.

Architecturally, Steina and her husband have created an unusually bright space in a 1940s building by taking down walls and preserving sightlines. Philosophically, too, they have shown a reverence for the ideas of light and space, two elements that are timeless indeed.

Previous page: Erna Steina's Reykjavik apartment is filled with the natural tones of her textiles and decorative work. The striped panels were created as a backdrop for an exhibit and were made by drawing directly onto wood. Their pattern was meant to complement the stripe of the woven cylindrical lamp. Left: wood floors and classic furnishings are accented with a few objects that Steina picked up on her travels. Right: stripes continue in a sweater from Steina's line of alpaca clothing made in Peru.

MATERIALS

The glory of pure polished or unfinished wood is almost
universally accepted. Touching a monumental sculpture
created from a tree trunk or root structure, we are struck
by a sense of awe, not just in the size, but in the natural
pattern and surface produced during the life of the tree.
Many who work with wood claim to be directed by the
material itself. In creations large and small, rough and
smooth, it is easy to see why.

wood

Of all the natural materials, there is something particularly elemental about clay. It is not only to do with its extraction, but with the hands that shape it. Getting your hands dirty is a lost art, some would say, but there are still those for whom making something with the hands is a vital part of the creative process. From the basic shape to the finished highly wrought or raw texture, the work is a direct result of interaction between artist and medium.

clay

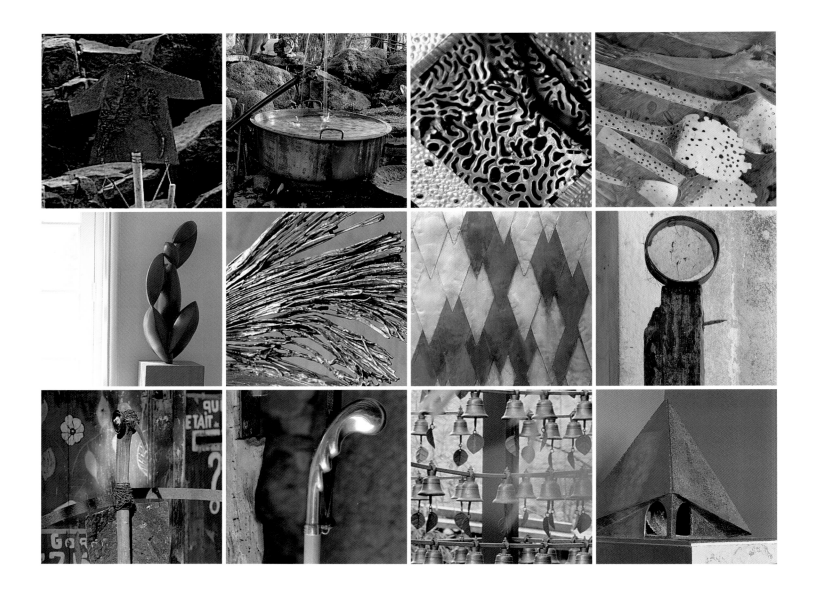

Metals are not always immediately associated with nature, but their origins and methods of handworking make them distinctly 'natural' materials with an extraordinary textural range. From the smooth, supple grips of a Peretti handle, to the apparently porous quality of Michele Oka Doner's pitted tableware, silver takes on a range of textures and appearances. Whether beaten from sheets, casted from wax models or recycled, metal, too, is of the earth.

metal

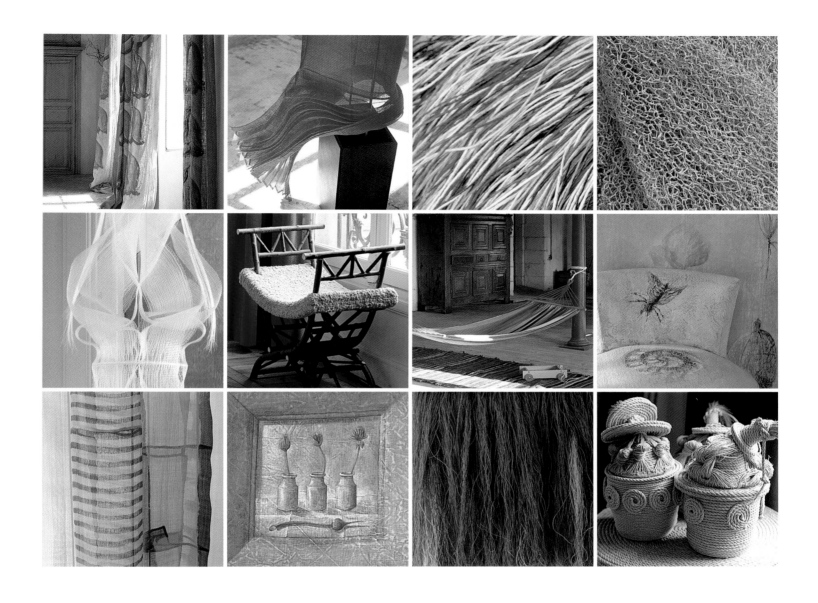

Plant fibres, in all their seeming delicacy, have been used for centuries to create durable objects. The variety of fibres employed bears witness to the abundance of nature's resources and to the artist's ingenuity. Pineapple fibre can be handwoven into a fabric stiff enough to stand, hemp rope can be cut to make strong, comfortable upholstery. A finished product, such as linen, is only one much-refined example of a truly fruitful yield.

fibre

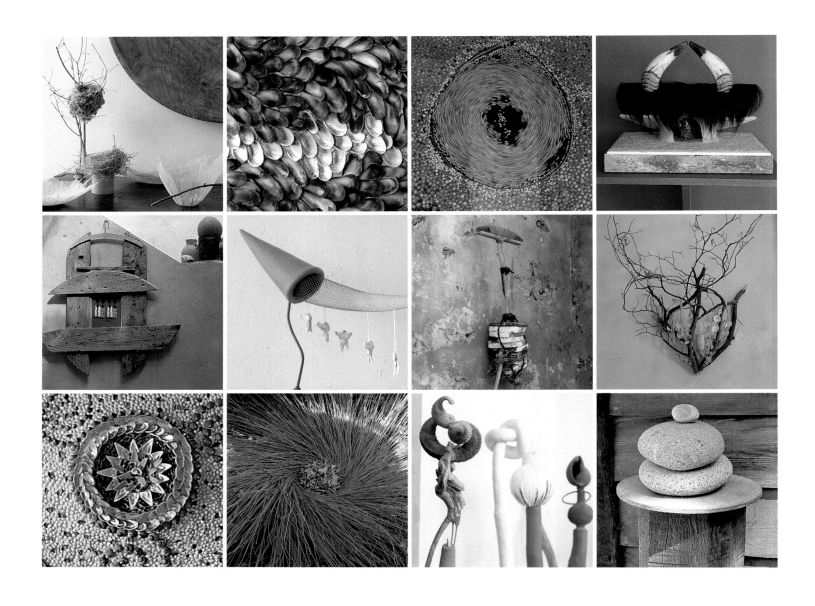

A found object seems a poor cousin to the strength and
purity of wood, clay or metal, but there is beauty in
abundance and variation. Shells, pebbles, feathers, leaves,
as well as pieces of recycled wood, metal or furniture, give a
scope to the natural artist that takes in the diversity of the
modern world and encompasses the spirit of reuse. It is
the art of revealing beauty in the unwanted objects
that surround us.

found objects

CONTACT ADDRESSES

aboudramane

GALERIE PETER HERRMANN
Schlüterstr. 42
(Kurfürstendamm/Olivaer Platz)
D-10707 Berlin
Germany

T 00 49 (0)30 88 62 58 46
F 00 49 (0)30 88 62 58 47
www.galerie-herrmann.de

henrik allert

Ängen Säter
54191 Skövde
Sweden

T 00 46 500 461 227

christian astuguevieille

STUDIO
10 rue Portalis
75008 Paris
France

T 00 33 (0)1 44 69 91 40
F 00 33 (0)1 42 93 80 31

j. b. blunk

christine nielson
COYUCHI
PO Box 845
Point Reyes Station
CA 94956
USA

T 001 415 663 8077
F 001 415 663 8104
E coyuchi@svn.net

francesca tempora casana

T 00 39 (0)2 5512 236
E francescatempora@yahoo.com

axel cassel

LA BALLETIERE
14290 St Martin de Bienfaite
France

T 00 33 (0)2 31 32 79 16
F 00 33 (0)2 31 32 27 37

michele oka doner

94 Mercer St
New York
NY 10012-4425
USA

F 001 212 334 9236
E okadoner@aol.com
www.micheleokadoner.com

pierre fuger

GALERIE ETOFFES
38 Boulevard Paoli
20200 Bastia
Corsica

T 00 33 (0)4 95 31 37 52
F 00 33 (0)4 95 34 11 04

VACHON ANTIQUITES
131 Avenue Paul Vaillant Couturier
94250 Gentilly
France

T 00 33 (0)1 47 35 26 30
F 00 33 (0)6 80 85 01 88

GALERIE F. DE NOBEL
2 rue Bourbon le Chateau
75006 Paris
France

T 00 33 (0)1 43 26 08 62

catherine gouny & juliette marange

T 00 33 (0)2 33 73 08 11
F 00 33 (0)2 33 73 13 37

gilles hoang

GRATAY
71700 Ozenay
France

gabriel kemzo

FORT PORTUGAIS
BP24
Goré
Dakar
Senegal

T 00 221 654 3987

blott kerr-wilson

4 chemin du Moulin
79210 Mauze sur le Mignon
France

T 00 33 (0)5 49 35 22 56
F 00 33 (0)5 49 35 22 56
E blottkerrwilson@aol.com

yuri kuper

'LE MONT-CHATOU'
27560 La Poterie Mathieu
France

mauro mori

3 via Compagnoni
20129 Milan
Italy

T 00 39 (0)2 7012 4518
F 00 39 (0)2 7012 4518
E morimauro@tiscalinet.it

rosa nguyen

45 Handforth Road
London SW9 0LL
United Kingdom

T 00 44 (0)20 7237 9360

nils-udo

Parmsberg 58
D-83083 Riedering
Germany

T 00 49 (0)8036 7730
F 00 49 (0)8036 3455
E nils-udo@t-online.de

kerstin olby

OLBY DESIGN AB
Magasinsgatan 2
54134 Skövde
Sweden

T 00 46 500 427 400
F 00 46 500 427 410
www.olbydesign.se

elsa peretti

www.nandoperettifound.org

ritvo puotila

WOODNOTES OY
Tallberginkatu I B
00180 Helsinki
Finland

T 00 358 9 694 2200
F 00 358 9 694 2221
E woodnotes@woodnotes.fi
www.woodnotes.fi

ristomatti ratia

RATIA BRAND COMPANY OY
Kapteeninkatu 1 E
00140 Helsinki
Finland

E mailbox@ratia.com
www.ratia.com

isabelle roux

15 route d'Argèles
65400 Beaucens
France
Galerie Christophe Delcourt
125 rue Vieille du Temple
75003 Paris
France

T 00 33 (0)1 42 71 34 84
F 00 33 (0)1 42 71 53 78

djibril sagma

rue de Battais
Goré
Dakar
Senegal

T 00 221 648 6635

moussa sakho

T 00 221 652 7429
E moussasakho@hotmail.com

jérôme abel seguin

30 rue de Candale
93500 Pantin
France

T 00 33 (0)1 48 10 80 29
E jseguinacd@aol.com

kay sekimachi & bob stocksdale

BROWNGROTTA ARTS
276 Ridgefield Road
Wilton
CT 06897
USA

rupert spira

T 00 44 (0)1588 650 588

erna steina

ELM
Laugavegur 1
101 Reykjavik
Iceland

T 00 354 5110991
F 00 354 5110993
E elm@islandia.is
www.elmclothes.com

First published in the United Kingdom in 2002
by Thames & Hudson Ltd,
181A High Holborn, London WC1V 7QX

www.thamesandhudson.com

Text and layout © 2002 Thames & Hudson Ltd,
London. Photographs © 2002 Solvi dos Santos

British Library Cataloguing-in-Publication Data
A catalogue record for this book is available
from the British Library

ISBN 0-500-51092-X

Printed and bound in Singapore by CS Graphics